PROVENCE
AND THE CÔTE D'AZUR

DISCOVER THE SPIRIT
OF THE SOUTH OF FRANCE

Text and photography by

**JANELLE
McCULLOCH**

CHRONICLE BOOKS
SAN FRANCISCO

CONTENTS

Introduction:

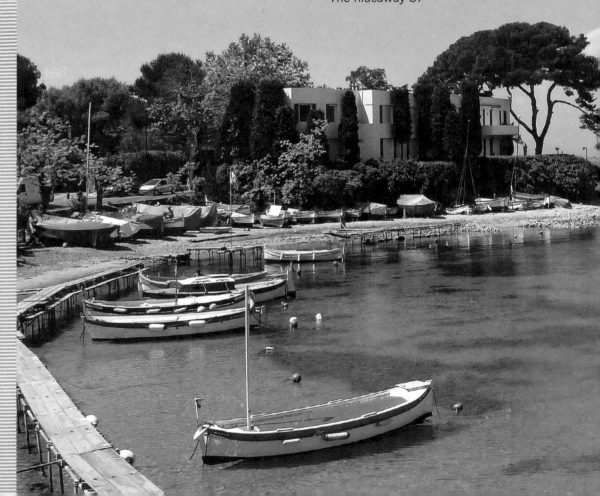

Discovering the Spirit of
the South of France 8

**PART ONE:
PROVENCE 17**

L'Isle-sur-la-Sorgue:
The antiques lover 21

Ménerbes:
The reluctant star 31

Lourmarin:
The gourmet lover 41

Saint-Rémy-de-Provence:
The aesthete 51

Aix-en-Provence:
The elegant beauty 59

Avignon:
The arts lover 69

Arles:
The historical beauty 79

Uzès:
The hideaway 87

PART TWO:
THE CÔTE D'AZUR 95

Nice:
The grande dame 99

Cap Ferrat:
The aristocrat 109

Beaulieu-sur-Mer:
The secret delight 119

Èze:
The escapist 127

Menton:
The garden lover 133

Saint-Paul-de-Vence:
The artist 141

Cannes:
The film star 149

Antibes and Cap d'Antibes:
The lit wit 157

Juan-les-Pins:
The beach beauty 167

Saint-Tropez:
The glamour puss 175

PART THREE:
DIRECTORY OF
INSPIRING PLACES 183

Hotels and guesthouses 185

Must-see destinations 199

Major museums 205

Art galleries, decorating stores, and
other design destinations 211

Markets and flea markets
(a selection) 221

Captions 226

Index 246

Merci 254

Note: Apologies to French speakers and Francophiles, but we've decided to follow the English convention of capitalizing street names, geographical place names, days of the week, etc. Thus, Place du Général de Gaulle (not place du Général de Gaulle), Baie des Anges (not baie des Anges), and Gare de Nice Ville (not gare de Nice Ville).

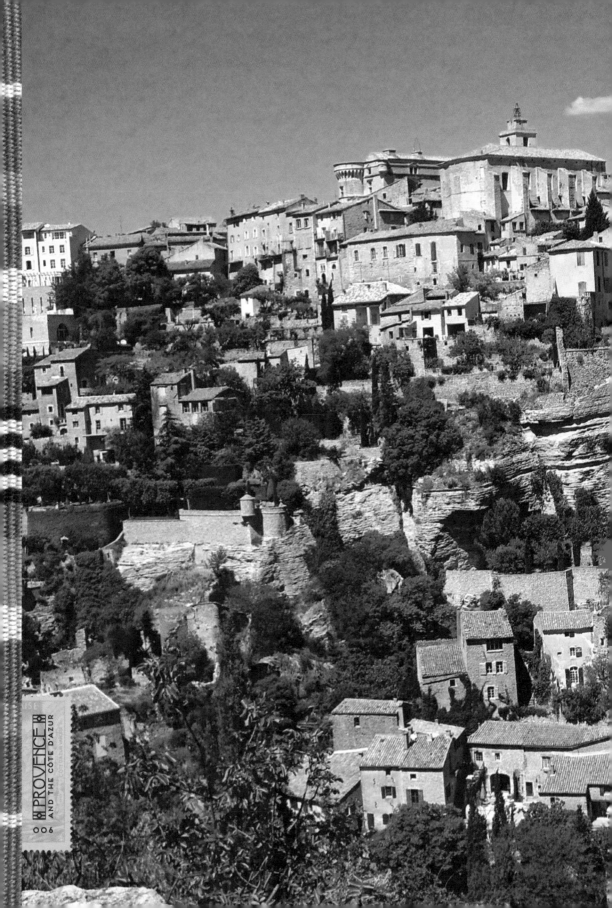

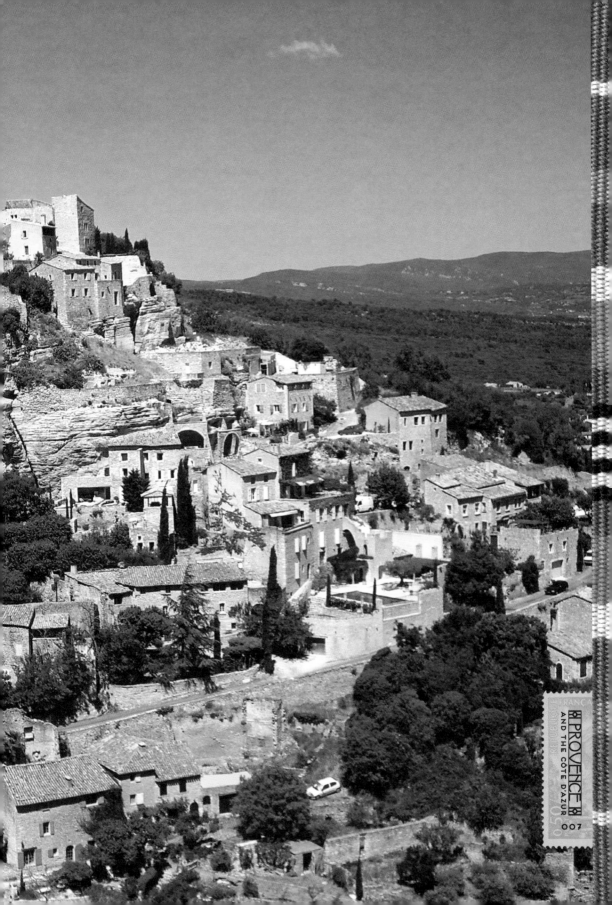

DISCOVERING THE SPIRIT OF THE SOUTH OF FRANCE

The South of France is the stuff of travel hyperbole. The region may not have invented the word *glamour*, but it has certainly adopted it as its mission statement. This famous part of the Mediterranean coast is a glorious, almost painterly swirl of spectacular, sun-filled landscapes, seductive villages, sublime beaches, secret coves, scented gardens, high-octane cars, beautiful people, and a blissful climate.

Adding further interest is the fact that there are two sides to the South of France. There is the coast, an area that encompasses the Riviera, with its charming coves, bobbing yachts, Belle Époque architecture, bougainvillea-draped lanes, grand villas, and waterfront promenades buoyant with life.

PROVENCE AND THE CÔTE D'AZUR

And there is the countryside, an area that includes Provence—a gentle and charmingly photogenic scene of winding roads, weekend markets, sleepy villages, Roman ruins, enchanting châteaux, fields of lavender and sunflowers, babbling fountains, and dapper gentlemen chatting or playing boules in ancient squares, all enveloped in a light that seems almost Impressionist in quality.

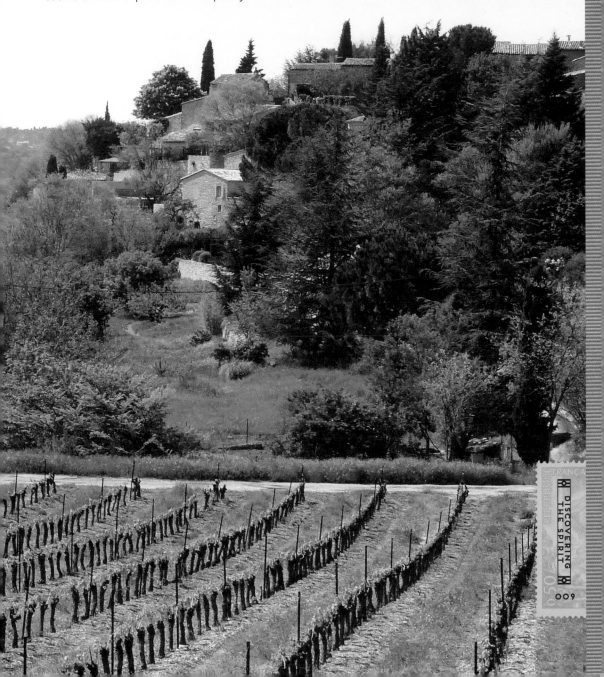

SAY HELLO TO PROVENCE AND THE CÔTE D'AZUR

Now something needs to be clarified before we tie our hair in a silk Hermès scarf and start our sky-blue Sunbeam convertibles. The terms *Côte d'Azur*, *Provence*, and *the French Riviera* are not so much strictly defined geographical areas as they are states of mind: each a shift in spirit that happens once you get past a certain point on the road from Paris to Nice. The official name for this region is Provence-Alpes–Côte d'Azur. But as that's a bit of a mouthful, shorter phrases have crept into the vernacular. Some people like to use Côte d'Azur or the French Riviera if they're visiting the Mediterranean coastline along the southeast corner of France, or they'll say Provence if they're visiting the hinterland and countryside further inland. Other people see the entire southeastern corner of France as Provence. It's complicated, I know.

To be precise, this region comprises six major *départements*. However, for the purposes of this book we have decided to simply split the region into two areas: Provence and the Côte d'Azur. Easy.

That's the admin done; now for the short history and glamorous anecdotes. Like much of Europe, the history of this part of France is long and complicated. It begins 40,000 years ago with prehistoric settlements, Greek colonies in 600 BC, Roman influence from around the third century BC, endless "barbarian" invasions, and the incredible fortifications of the medieval period that form the core of many of the region's breathtakingly beautiful villages. Unfortunately, space does not permit me to delve deeply into such a complex past, but I will attempt to offer some insights into the history of each town as we go.

For now, let us focus on the more recent legends who have passed through this area: F. Scott and Zelda Fitzgerald in Juan-les-Pins; Picasso and Graham Greene in Antibes; Matisse in Nice; Béatrice de Rothschild, David Niven, and Somerset Maugham in Cap Ferrat; Cocteau and Chanel in Menton, and Bardot in Saint-Tropez. They came for the garden parties, the soirées, the people, and the experiences they'd later immortalize in print or with paint and canvas. They came for the sun and fun, the decadence and indiscretions, the swimming coves and beaches, and all the sights in between.

Yet it wasn't always like this. The South of France only really became popular at the end of the eighteenth century when the British and northern European upper classes saw its potential as a winter resort. When the new railway arrived in the mid-19th century, the area rapidly became the playground of the European well-to-do and, soon after, the wealthy American set. And it is still one of the most popular places in the world for stars to escape to. Elton John loves it so much that he bought a home in the hills above Nice. Bono has one on the beach at Èze-Bord-de-Mer. Sting and his family like to come here and hang out each year, as do Naomi Campbell, Kate Moss, and Giorgio Armani. And Jack Nicholson often cavorts here, although it's usually on a yacht with a few beautiful models. Some days, particularly in May during the Cannes Film Festival, half of Hollywood seems to have decamped to the Riviera.

The South of France does, however, have a flip side. Overdevelopment has ruined some of the beautiful coastline, and in the height of summer the roads are often jammed with

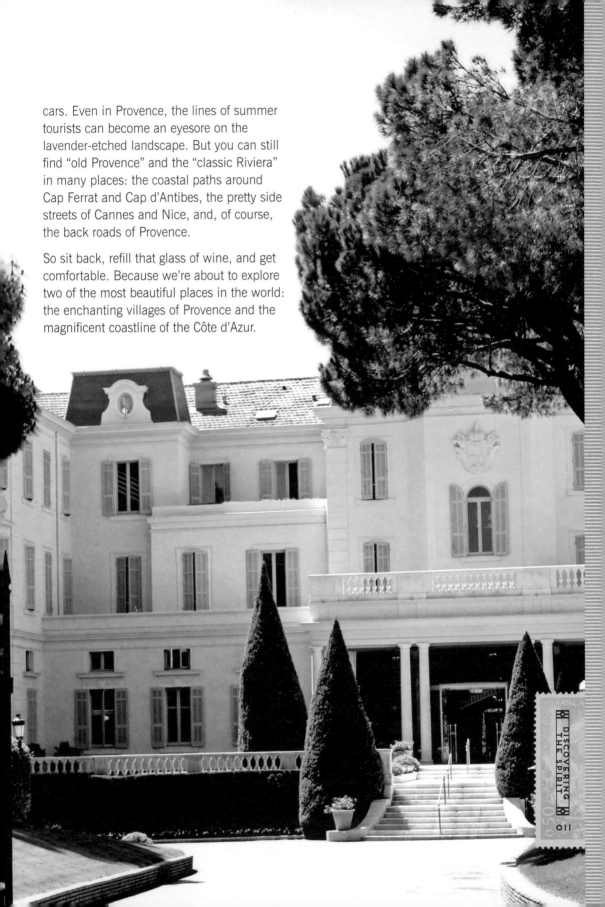

cars. Even in Provence, the lines of summer tourists can become an eyesore on the lavender-etched landscape. But you can still find "old Provence" and the "classic Riviera" in many places: the coastal paths around Cap Ferrat and Cap d'Antibes, the pretty side streets of Cannes and Nice, and, of course, the back roads of Provence.

So sit back, refill that glass of wine, and get comfortable. Because we're about to explore two of the most beautiful places in the world: the enchanting villages of Provence and the magnificent coastline of the Côte d'Azur.

INDIVIDUALIZING YOUR ITINERARY

The key to enjoying the South of France is to focus on what you love. Although tempting, it is not a good idea to try to cover all of the South of France in one holiday: You'll just become exhausted. The distances are greater than you think. Instead, go to just two or three areas that offer what you really want and explore them in depth. So if you prefer the quiet of the countryside, the winding lanes without traffic, the fields of wild-flowers and lavender, and the quaint ancient villages, then spend most of your time in Provence. If you love lively streets, shopping, sheltered swimming coves, and an endless view of yacht sails and the elegant blue of the Mediterranean, stick to the coast.

Wherever you go, don't discount the lesser-known parts of the region. Cap Ferrat is extraordinarily beautiful; and Menton, with its Italian feel, brightly colored architecture, and profusion of gardens, will charm and delight. So go off the beaten path if you can; you may be surprised.

Another thing to consider is your level of expectation—some of the so-called famous places may not quite live up to their reputations. When I first saw what one friend described as "the sexy, sybaritic village of Saint-Tropez," I wondered if I'd missed something. Where were the celebrities? The chic sidewalk fashions? The famous Saint-Tropez spirit? Admittedly I was visiting in early May, before the season was in full swing, but I was still slightly taken aback by the empty, windblown beach and the incongruous sight of dozens of übercruisers from the Cayman Islands squished into a tiny harbor. Don't be too disappointed if parts of the Riviera don't look as you imagine they did in the glamorous heydays of the 1950s and '60s. Things do change.

This leads me to an important consideration: timing. Just as some places have looked better in the past, some will be more appealing at certain times of the year. Provence looks glorious in spring and summer, when all the flowers are out. Cannes seems to sparkle in May, when the film festival brings the stars to town. Ditto Monaco during the Grand Prix. Many other places have festivals throughout the year that turn the streets into one long party, so if you love a festive atmosphere try to time your visit with these. Personally, I prefer the quieter coves and villages, which is why I fell in love with Paloma Beach and the coves of Cap d'Antibes. But you'll no doubt find your own favorite hideaway.

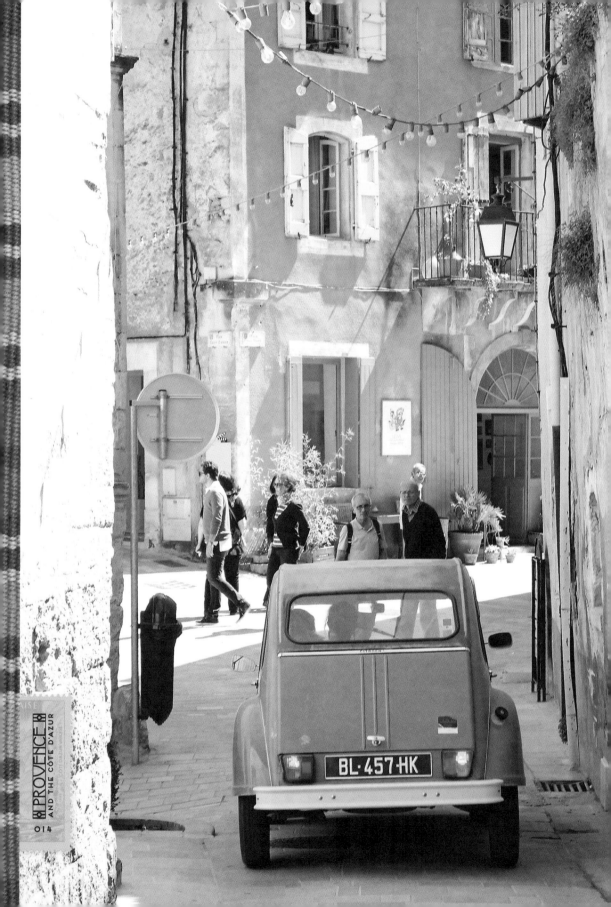

HERE ARE SOME WAYS TO SEE THE GLAMOUR AND GRANDEUR OF THIS GLORIOUS PART OF FRANCE

By foot. Some of the most beautiful parts of the coast and countryside in this region are off the main roads and even off the village lanes. Look for the many walking paths (they'll usually be marked *sentier*). Be sure to take lots of water and proper walking shoes, but even if you want to stroll along in casual sandals, there are plenty of paths along the coast that offer a quick walk and fantastic views. The path from Nice to Villefranche and Cap Ferrat is one such walk. If you prefer to stay in the towns, there are many great walks, such as the one along Nice's famed Promenade des Anglais that follows about three miles/five kilometers of stunning Belle Époque–era architecture and azure blue sea.

Follow the stars. Many parts of the Riviera attract big Hollywood names in May during the Cannes International Film Festival. Hang around Cannes during the festival and you'll likely see a few famous faces. Or head to Saint-Tropez in July and August for some more celeb sightings, where they often sail in on mega-yachts before lunching in town. Some places, such as Les Caves du Roy and Club 55 in Saint-Tropez, are perennial star-pleasers, so the odds of seeing a "name" there are high.

Follow the artists. Many painters have made their names while settling in the South of France and capturing the light and landscapes on canvas. You can still see where many of them lived and worked; and, if you can't visit their villas, there are museums (*musées*) that showcase their lives. These include the Musée Matisse in Nice, the Musée Picasso in Antibes, the Musée Marc Chagall in Nice, and the Fondation Maeght in Saint-Paul de Vence. Some people even opt for a "painting vacation," where they bring their watercolors and spend leisurely afternoons trying to capture the gentle light and landscapes on paper. I can't think of a better way to experience this place—or to remember it.

Explore it from behind a wheel. The South of France has long been known as one of the world's great driving destinations. There are the famous corniches (the roads that hug the cliffs along the coast), the touring roads of Provence, and all the lanes in between. Hire a classic car or even a convertible (but make it a small one—some roads can be tiny). This is the way to see the coast as it's meant to be seen: from behind the wheel of a beautiful car.

See it from two wheels. Cycling holidays are an increasingly popular activity in Provence (no doubt influenced by the Tour de France), though less so on the Riviera, where the traffic is horrendous and drivers are downright scary. But on the back roads, cyclists are a common sight—and what better way to see the countryside? Sure, there are hills and mountains, but they only mean that the bottle of wine at the end tastes even better.

LE HAMEAU. *Saulieu*

PART ONE

PROVENCE

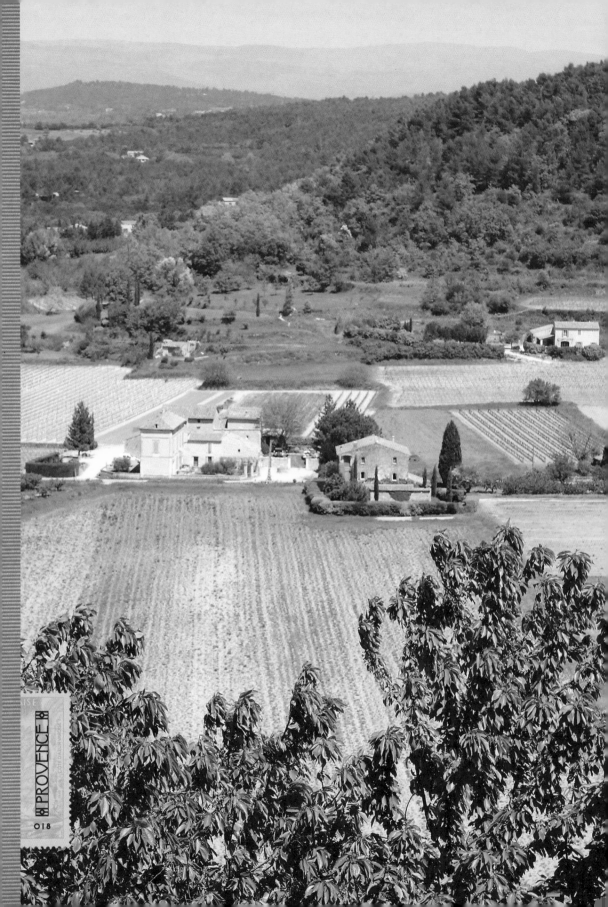

Quiet squares shaded by canopies of gnarled plane trees. Old stone fountains ringed by clusters of rustic shops. Atmospheric cafés on cobblestoned sidewalks. Church bells pealing while pigeons murmur in their ancient towers. Faded terra-cotta houses topped with duck-egg-blue shutters. Secret gardens hidden behind elaborate iron gates and old stone walls. Long avenues of cypress trees standing like steady sentinels in the sun. A landscape of medieval villages, castles, and bell towers, threaded with neat lines of vineyards and fields of lavender.

This is Provence, widely regarded as one of the most beautiful places in the world. To come here is to be seduced by sun-saturated landscapes, spectacular scenery, and an idyllic way of life that charms you into thinking you, too, could possibly leave your nine-to-five existence and move here for a year. Thousands do. Provence beckons like few other places. The scents, the sunshine, the food and wine, the walks through the hills, the views . . . Just try to come to Provence and not feel a twinge of "what if?"

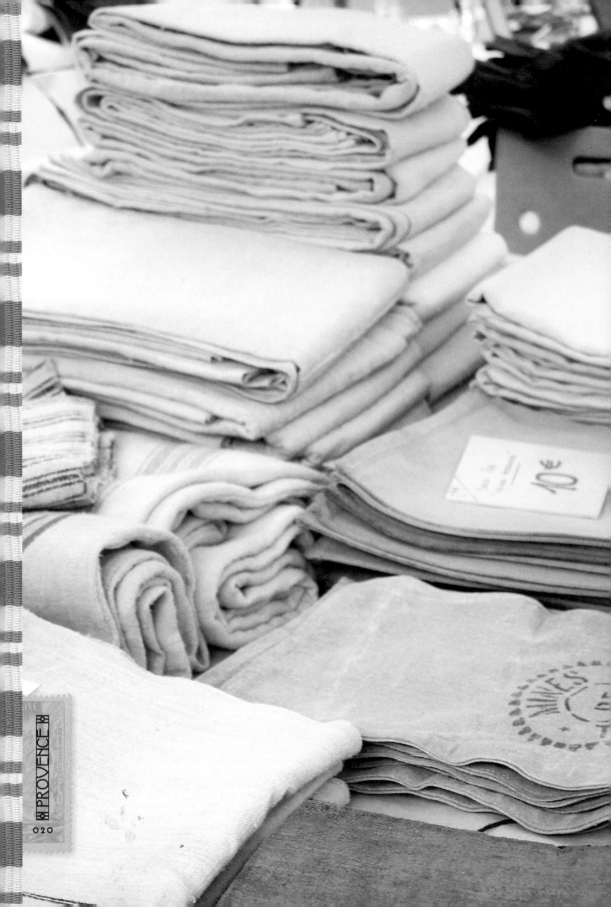

L'ISLE-SUR-LA-SORGUE

THE ANTIQUES LOVER

Market stalls full of whimsical bric-a-brac, antique shops filled with eclectic furniture, and winding streets dotted with dainty bridges

Known simply as "L'Isle" by the locals, this pretty Provence village is often dubbed "The Venice of the South." While that's a bit of a stretch, the curious canals that run through the town—five mini-tributaries of the river Sorgue—do make for a watery oasis.

L'Isle is a truly lovely place, although (and this is going to get me into trouble) it used to be lovelier. Before the masses of tourists came, and before the famous Sunday markets began to attract the cheaper dealers. Yet it's still wonderful. You just need to ignore the tacky pockets and focus on the beautiful parts, of which there are plenty. Let me show you.

First, L'Isle is a naturally pretty town, so it doesn't really matter how you approach it. Simply find your way to the city center and follow one of the five waterways. You can cross and recross the various bridges (all very Venetian). In fact, the tiny bridges are one of the nicest ways to explore the place. You'll soon see how the river is the heart and the soul of the town.

L'Isle was originally known as Insula and grew from a medieval settlement on the river Sorgue. The river, whose source is at Fontaine-de-Vaucluse a few miles away, served a defensive purpose as a moat around the settlement and a valuable source of both food (fishing) and industry (artisan mills for paper, silk, and other materials). In 1890, inspired by the waterways, the town officially adopted the name L'Isle-sur-la-Sorgue. Over the next century, the town's chiefs took pains to preserve a great deal of the town and its river tributaries, knowing their importance for L'Isle's survival. Look out for the lovely waterwheels scattered around town, some of which still turn.

The main reason people visit L'Isle is for the **markets**. There have been markets here since the 16th century, but the modern ones are so well known that they attract buyers from all over the world. Every week, regardless of the weather, there are stall holders here on Thursdays and Sundays, but summer attracts a larger crowd of both stall holders and tourists. Stretching from Place Gambetta all the way along Avenue des Quatre Otages there are stalls full of delicious produce from local farms and providers—walnuts, olives, cheeses, breads, spices, charcuterie—all of it great picnic fare if you're heading off to the countryside afterward. There are also stalls selling typical Provence-style wares—bright tablecloths, candles, soaps, and so on. However, what most people really come for is the antiques. L'Isle has become the antiques capital of the south.

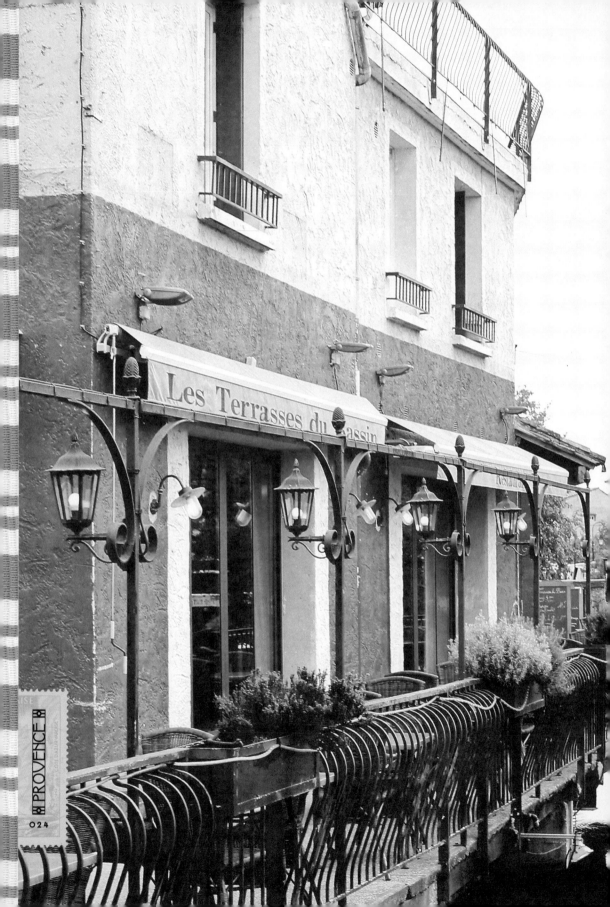

Some even believe it has the largest *marché aux puces* (flea market) outside of Paris. While I can't verify that, I was amazed at the range of goods. There was even a stand devoted to antique greenhouses and conservatories.

If you want to see the markets on Thursdays and Sundays, the key is to arrive early, ideally before 9 a.m. Most of the stalls will be set up, or in the process of setting up, and at that time you'll be able to find a parking space more easily, as well as stroll along without the crowds.

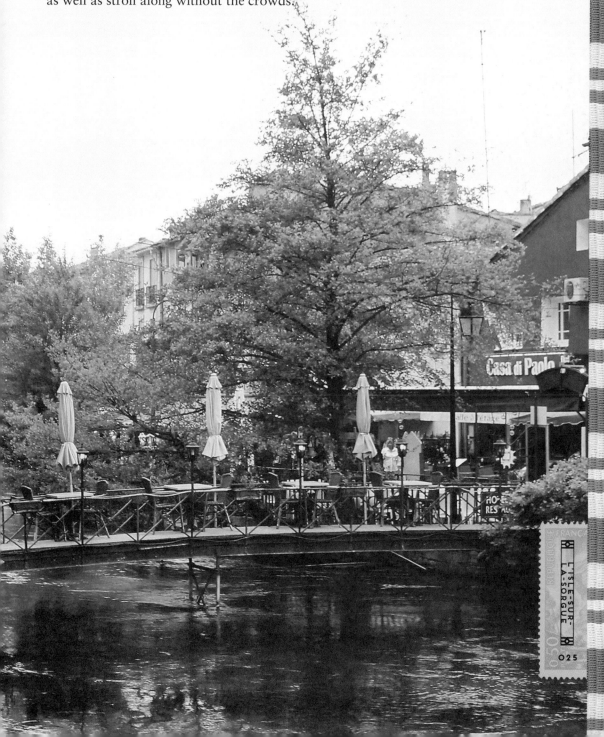

A good plan is to start at the Tourist Office on Place de l'Église in the middle of town. (A word of warning: the Sunday market can become especially crowded, so watch your bag.) If you need a coffee to kick-start the day, the beautiful Café de France is around the corner, on 14 Place de la Liberté, behind the church. This is a showstopper of a café that also offers a great position from which to enjoy the sights.

Walk east a few blocks along Rue Raspail, and you'll soon reach Le Bassin ("the basin"), where the river splits into four canals. It's a truly lovely scene, and the swift current is a reminder of how powerful the water is, and how it could generate so much industry.

Cross the northern bridge, stopping for a photo if you need to, and then you have two options. The first is to continue forward and follow the tourist throng along Avenue Fabre de Sérignan. This will lead you through some of the market stalls. If you desire some tranquility, turn left onto one of the tiny footbridges that cross the river and you'll be on the quieter side. Stroll along the quays of the river Sorgue and admire the waterwheels (at one point there were around 70). There are always some bric-a-brac dealers around here, but if you want more "serious" antiques you'll have to head for Avenue des Quatre Otages and Avenue de la Libération. Most of the antique stores are along these streets and in courtyards behind them.

There's a good group of antiquarians at Hôtel Dongier (15 Esplanade Robert Vasse; hoteldongierantiquites.fr), and yet another group at Passage du Pont (formerly L'Isle aux Brocantes) at 7 Avenue des Quatre Otages. There is also a good range at Le Quai de la Gare (4 Avenue Julien Guigue).

Some antique stores are open all year, others only from April to October. If you really want to be sure of finding some great antiques, time your visit to coincide with the Foire Internationale (foire-islesurlasorgue.com) at Easter and in August.

If you want a break from shopping and browsing altogether, wander back to the basin where the river splits, and walk north across the bridge again. This time, head east on Avenue du Partage des Eaux as it follows the river. The little road rambles past waterfront homes and beneath shady trees all the way to Hôtel le Pescador, where there's a lovely riverside café.

L'Isle doesn't just do bric-a-brac, antiques, and other home furnishings. There's a book market on the last Sunday of each month, and a floating market the first Sunday in August. In July there's also the Festival de la Sorgue (music, theater) and a parade on the canals.

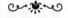

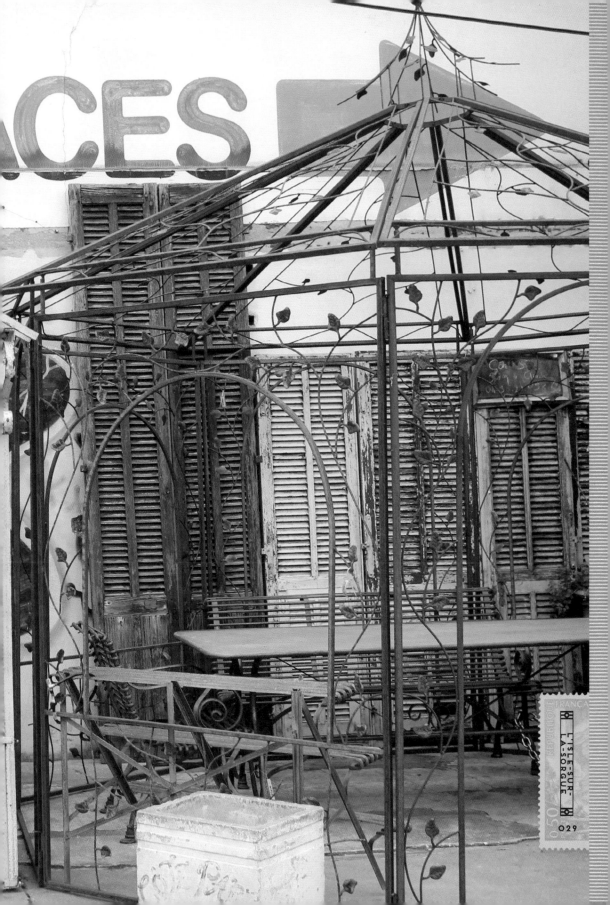

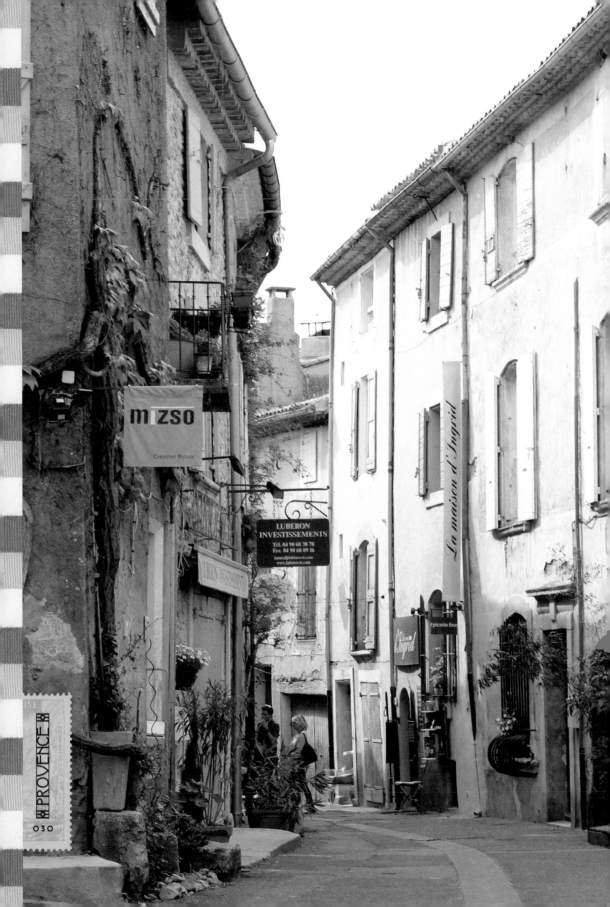

MÉNERBES

THE RELUCTANT STAR

A quietly beautiful walled village enclosing quietly beautiful lanes, rising like a curious island above a sea of vineyards

You may not have heard of the tiny remote village and commune of Ménerbes, but you may have heard of the man who made it famous: British writer Peter Mayle.

Mayle's books about living in Provence as an expat, the most well-known of which is the best-selling *A Year in Provence* (later adapted into the 2006 film *A Good Year* starring Russell Crowe and Marion Cotillard), have propelled this town to the top of many a traveler's to-do list. Ménerbes has become something of a mecca for disillusioned souls seeking a new existence.

The story of how Mayle—and by association Ménerbes—became famous is the stuff of legend. In 1987, burned out by his years living in London as an advertising exec, Mayle decided to move to the South of France with his wife. They had only enough money to last for six months. They found a 200-year-old farmhouse, and Mayle began writing a novel. But life intervened, and in the process of renovating his house, the wannabe author discovered reality was more interesting than fiction. So he wrote about the village and its characters instead. To the surprise of everyone, including the author, *A Year in Provence* became an international bestseller, tapping into all our desires to live a more idyllic life.

Unfortunately, neither Mayle nor Ménerbes were prepared for the onslaught of visitors, and the writer eventually packed up and moved to the Hamptons for a few years to escape the fans peering down his driveway. He has since moved back to Provence, but to a village farther south, leaving Ménerbes to face the dreamers alone.

Fortunately, the village and surrounding area seem able to cope. The commune has even put on its commercial hat to take advantage of the sudden influx of tourist money. There are new boutiques selling French linen and designer clothes from the likes of Valentino, an ice-cream store that does a roaring trade, and charming restaurants, including Le Galoubet and Café Veranda.

If you want to see what all the fuss is about, take a drive to the dramatic Luberon mountains, then approach Ménerbes from the north. You'll soon see it high on the stony cliff above the farming landscape: a walled village rising like a curious island above a sea of vineyards and orchards. The village itself is a lovely jumble of ancient medieval towers, churches, and stone streets. At one end is the **Citadelle**, a miniature fortress dating from the 16th century, and at the other end is the cemetery, along with **Château du Castellet**, where the painter Nicolas de Staël once lived.

There's not much in between—the village is tiny—but the cobbled lanes and steps elegantly link each terrace. And as you step up through the levels you'll see the glorious Provence countryside spread out before you: a spectacular mix of mountains and farmland.

There are photo opportunities everywhere, but one of the best is through an arch at the top square beside the ancient *mairie* (town hall), where you can see the distant villages including Gordes. Other outlooks will allow you to glimpse the far-off ruins of the Château de Lacoste, the country residence of the notorious Marquis de Sade.

This area is also famous for its wild truffles, lavender, mushrooms, and red wine, and there is a store in the Place de l'Horloge called the Maison de la Truffe et du Vin ("House of Truffles and Wine"), which is set inside a large and beautifully restored village home. It offers truffle and wine appreciation courses—important lessons in the art of French cuisine.

If you're a writer or an artist you may be interested in the fellowships offered at the Brown Foundation Fellows Program based at **Dora Maar**'s former home. Dora Maar was one of Picasso's much-loved models and an artist herself, and her beautiful home (which also has sumptuous views) now offers residences of one to three months for creative professionals to dedicate themselves to a project.

Outside Ménerbes, there is much to be inspired by. If you love lavender, make for the ancient **Abbaye Saint Hilaire,** less than two miles/about three kilometers southeast of the village. In the height of summer, the fields around the abbey explode with lavender, and the monks themselves go out and pick it when it's ready to be harvested—a truly memorable photo if you're there at the right time to capture it.

There are also many other villages in this region—far too many to detail in this book. However, I'll touch upon one other gorgeous place in the next section. (Peter Mayle knows a lot about this spot, too. He moved here to escape the literary fans who were following his every step around the South of France. The trouble is, many found out he'd moved here, and simply drove on down the road to see it.)

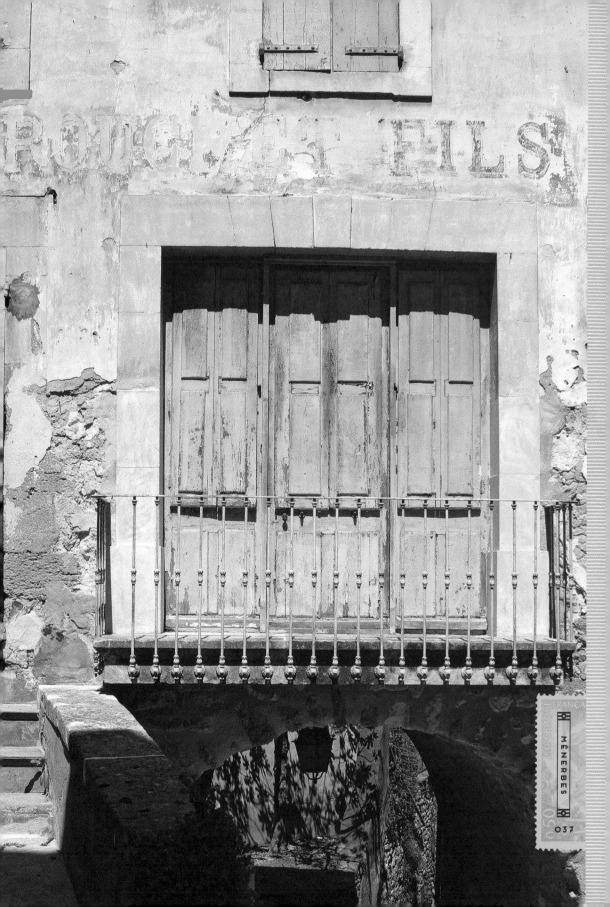

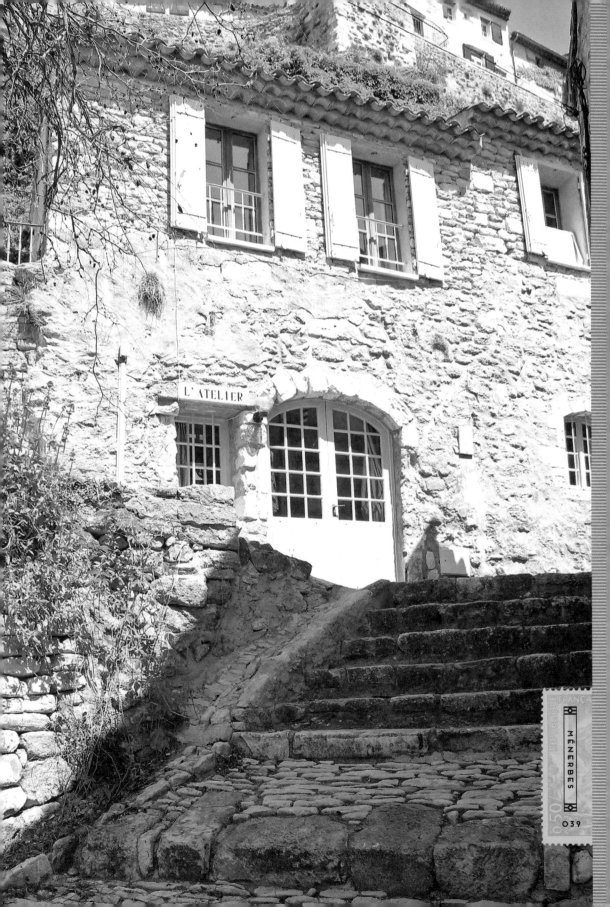

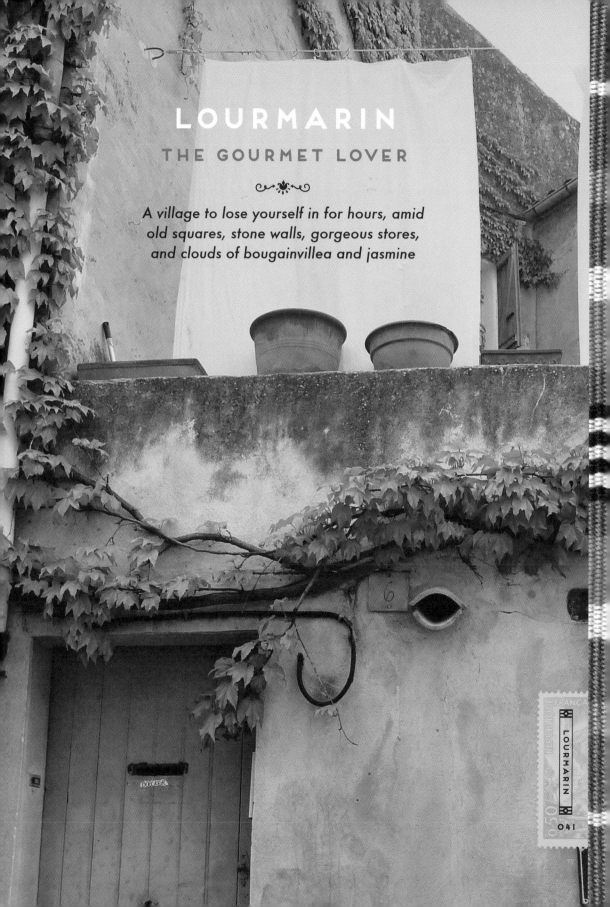

LOURMARIN

THE GOURMET LOVER

A village to lose yourself in for hours, amid old squares, stone walls, gorgeous stores, and clouds of bougainvillea and jasmine

The trick to seeing the two villages of Ménerbes and Lourmarin is to visit Ménerbes first. It's smaller, more intimate, and you can see it in a morning, with an ice cream in one hand and a camera in the other. Larger Lourmarin is a delightful parade of shady squares, beautifully restored old houses, great shops, and inviting cafés spilling out onto sunny terraces. So it really should come after, as it's perfect for a lazy, languid lunch followed by a long afternoon walk around town. Ménerbes may have the landscapes and views, but Lourmarin will entice the palate and the purse. (You can prop your partner up at one of the many cafés and tell him or her to wait with some good local liquid while you wander through the boutiques. That way, you're both happy.)

Here's a quirky fact about this village: Its inhabitants are called Lourmarinois. That's a lot to get your tongue around after a few tall glasses of red. What's easier to comprehend is the layout. Lourmarin is pleasantly situated in a relatively flat landscape, surrounded by fields, vineyards, and olive groves, with the forests of the Luberon to the north. Unlike the hilltop villages, it's not high on a ridge with staggering views so, in order to compete, it has had to up the aesthetic factor in its urban landscape. And what a pleasing urban landscape it is.

Much of the village is set around the central bell tower, which was built on the remnants of the medieval moated castle that once defined Lourmarin. The rest of the village fans out around it—a pretty mix of old fountains, stone walls, cute houses with cuter staircases running up to the front doors, clouds of bougainvillea and jasmine drifting over terraces, and some truly captivating town squares lined with lovely cafés. There's also a handsome 16th-century castle, the **Château de Lourmarin,** part of which is open to the public. It's worth a visit to see the furnished apartments, the library of 28,000 books, and the magnificent stairway.

The shops here, too, have made an effort to be more than just the standard tourist deal, with stores selling lovely gardening goods, others offering fabrics, and yet others specializing in toys to delight adults and children alike.

It's a quiet town off-season, but when the weather warms up in June it becomes a magnet for both the French and for foreigners, who love to come here for a stroll and a wine. In fact, Lourmarin is notable for its large number of great restaurants and bars. No wonder Peter Mayle moved here. On a sunny weekend you can barely get a café chair in any of the squares.

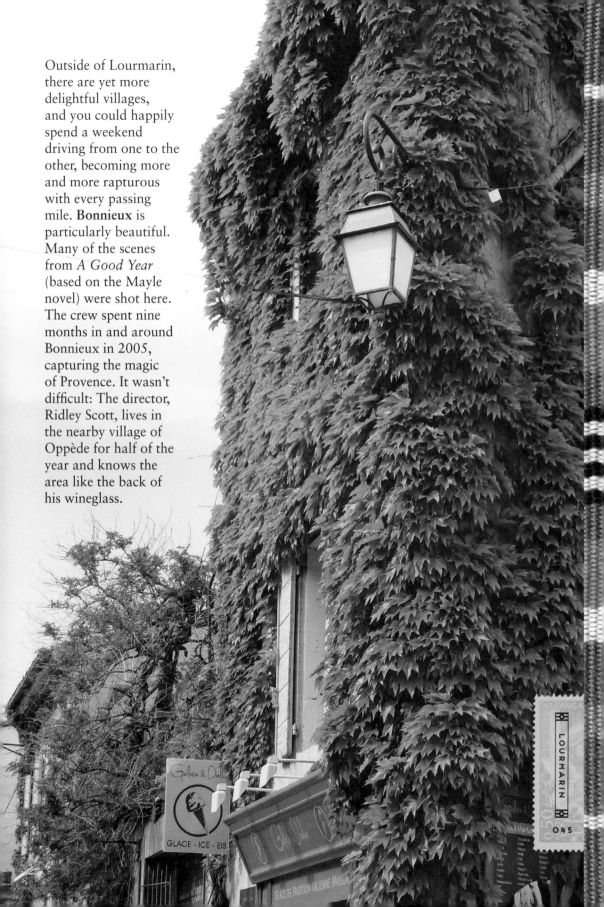

Outside of Lourmarin, there are yet more delightful villages, and you could happily spend a weekend driving from one to the other, becoming more and more rapturous with every passing mile. **Bonnieux** is particularly beautiful. Many of the scenes from *A Good Year* (based on the Mayle novel) were shot here. The crew spent nine months in and around Bonnieux in 2005, capturing the magic of Provence. It wasn't difficult: The director, Ridley Scott, lives in the nearby village of Oppède for half of the year and knows the area like the back of his wineglass.

Just outside Bonnieux is the acclaimed **Côtes du Luberon** wine-growing region. Also nearby is the village of Lacoste, better known for one of its famous—or infamous—residents, the writer and, er, sexpert, the Marquis de Sade. This village was where Sade retreated to his château to indulge his wicked ways. Sade wasn't exactly a happy man, or a well-balanced one, and his strange sexual exploits are well documented in his novels. Perched rather scarily on a hill, his former home is said to be haunted by his ghost, although I don't think it's wise to reflect on what he might be doing.

In 2001, the Marquis de Sade's château was purchased by French fashion designer Pierre Cardin, who then proceeded to buy up much of the rest of the town and set about restoring his new properties.

Lacoste has some lovely sunny lookouts over the countryside, the prettiest of which is from the Café de France. Its terrace is a beautiful spot, and a perfect place to pause for a coffee and gaze out at the glorious vista across the valley to Bonnieux.

Gordes is another interesting and extremely scenic place. Although it's perched on a rocky cliff, it's far less intimidating than Lacoste. Indeed, it's so much like a fairytale that tour buses stop, almost daily, on the bend on the way up to the town so that travelers can alight for the requisite photo op. The town is regularly listed among the most beautiful villages in France, and it's easy to see why: It's a picture from a distance and just as beautiful inside its walls. Tuesday morning is the best time to visit, when the town square fills with market sellers and shoppers. Look out for the Hôtel la Renaissance here, which is tucked away in the corner of a small square near the entrance to the tourist office: It was also featured in the film *A Good Year*.

If you have some time, try to fit in a visit to the **Château de Gourdon**. It features four glorious gardens, including a terrace designed by André Le Nôtre, a medicinal herb garden, an Italian terrace, and a Mediterranean garden.

The **Cascade de Courmes** is also worth a stop. Located inside a gorge about two miles/four kilometers from the D2210 road, the 130-foot-/36-meter-high waterfall originates near the tiny, hidden village of Courmes, and is perfect to visit on a hot Provence day.

Lastly, there is the village of Roussillon. I've left it until last in this chapter because **Roussillon** isn't like other villages in this region. It stands out, quite literally, as it is painted in some of the boldest colors you're likely to see outside the Caribbean. Almost every house features an eye-opening, Pantone-esque splash of blood red, dusty pink, or tangerine. For full effect, photograph it in late afternoon, when the place glows like a lantern on a stone terrace.

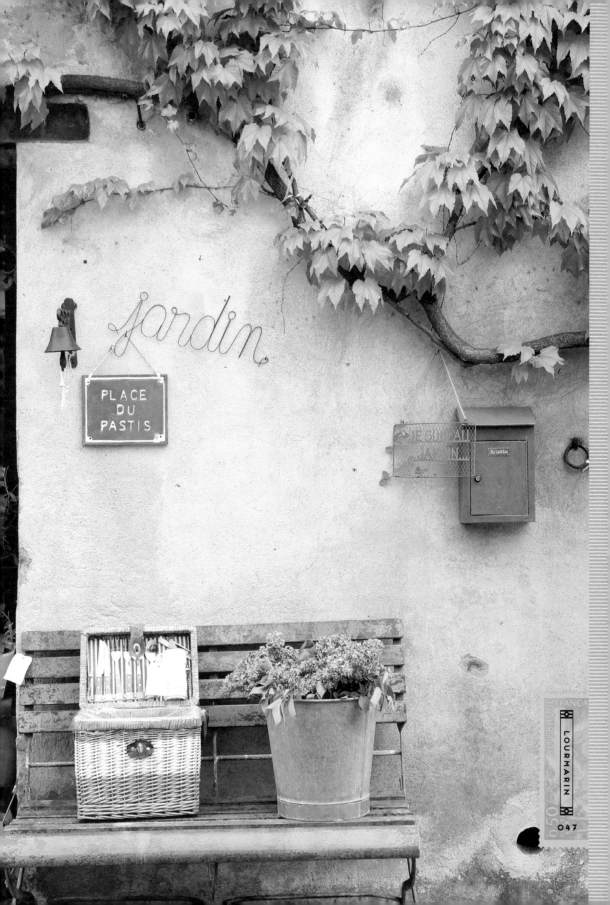

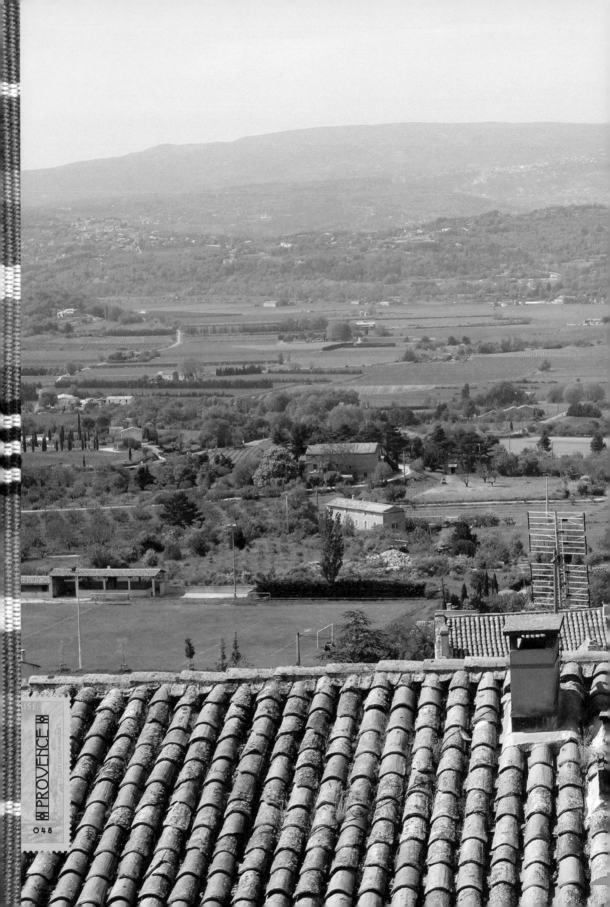

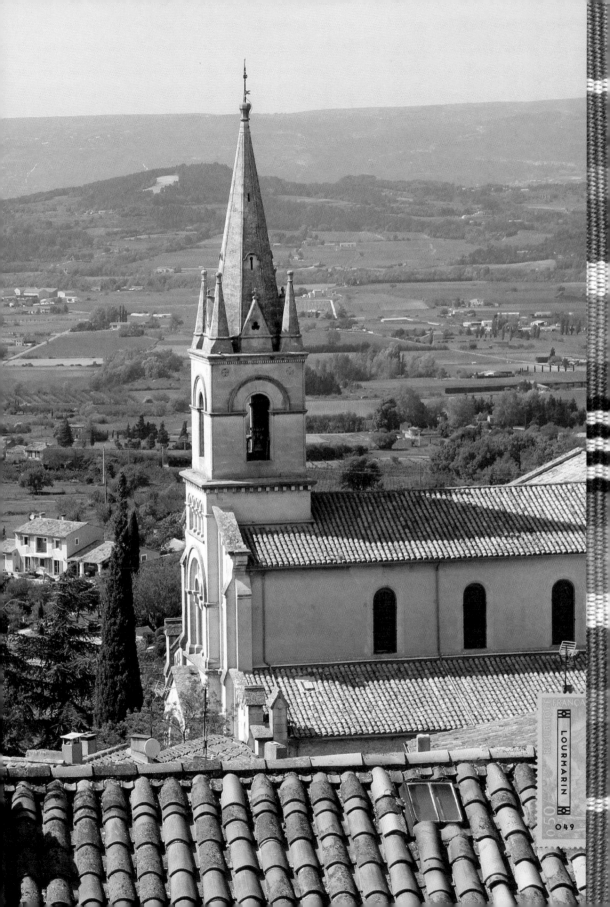

SAINT-RÉMY-DE-PROVENCE

THE AESTHETE

A shopper's delight, with charming lanes and delightful squares encircled by elegant boulevards and striking landscapes

Is there a prettier town in all of Provence? Perhaps, but few are as captivating or as full of alluring pockets as the perennially delightful Saint-Rémy-de-Provence. No wonder foreigners flock here. It's what you imagine a perfect Provençal village to be.

The first clue that you're approaching a rather photogenic place is when you turn off the A7 toward Saint-Rémy and begin driving up the scenic road lined with glorious plane trees. You may also notice the hills around the town, which create a dramatic backdrop to this picture-perfect place.

Saint-Rémy-de-Provence is actually at the center of Le Massif des Alpilles, the rugged limestone hills that dominate this region, so its setting was always going to be spectacular. Add to this the fact that it's one of the oldest towns in France (it was founded by the Celts more than 2,500 years ago), and that its design has been carefully planned, with elegant boulevards and narrow streets opening onto pretty squares and fountains, and you can see why this place has attracted aesthetes and creative types for centuries.

The center of the town itself is quite small, making it easy to wander around the circumference in less than an hour—once you find a parking spot, that is, which can also take an hour.

Now this is a dignified settlement—it doesn't have the riffraff that blows into places like Saint-Tropez. But underneath the dignity is a friendly and occasionally cheeky personality. The locals are cheery, the bars and cafés are convivial, and the weekly market is an absolute joy. Saint-Rémy-de-Provence is a thoroughly pleasing place in every respect.

The first record of Saint-Rémy-de-Provence is between the fifth and sixth centuries; at that time it was very near a Gallo-Roman city known as Glanum. There are still some beautiful Roman remnants from this period, including a mausoleum and the oldest Roman arch in the region. The altogether prettier name of Saint-Rémy-de-Provence came about when, in order to protect it, the village was given to the monks of the abbey of Saint-Rémi-de-Reims. Remnants of 14th-century fortifications still remain in the town, and are actually used—rather enchantingly—as entrances to the town center. You can find these at the northern edge of town near Rue Nostradamus and at the opposite end of the Old Town near the Rue de la Commune, which leads to the main square, Place Pelissier. If you enter near the Town Hall, look for the lovely dolphin fountain dating from the early 19th century.

Most people associate Saint-Rémy-de-Provence with Vincent van Gogh. The artist found great inspiration here after he admitted himself to the Saint-Paul asylum from May 1889 until May 1890. During most of his stay he was confined to the grounds of the asylum, but that didn't prevent him from painting close to 150 works inspired by the light, hills, buildings, and flowers he saw.

You can still visit van Gogh's asylum, **Saint-Paul-de-Mausole**. The route begins at the Tourist Office and is marked by reproductions of van Gogh's paintings. It's a moving experience, seeing the two small rooms where the artist lived and imagining the peace and stability he found within their walls, and then, when you emerge, seeing the irises and lilacs of the garden, and the wheat fields, vineyards, cypresses, olive trees and hills beyond that inspired him to take brush to canvas in such a prolific manner. (His legacy is still evident today in the bright sunflower-patterned plates and homewares you can buy in the town.)

Once you've seen Saint-Rémy through van Gogh's eyes, it's time to look at it through your own. If you are here on a Wednesday, start with the market—a celebration of life and outdoor living. You won't be able to miss it: Its stalls sprawl through squares and along streets, proffering produce, clothing, soaps, flowers, and art.

Once you've strolled through the stalls, go wander through the myriad lanes of the Old Town, most lined with modern boutiques. Saint-Rémy is a shopper's town, with stores that are both interesting and upscale. There are interior design stores, linen stores, and shops that sell striped French canvas fashioned into deck chairs, bags, seats, and awnings. There are luxury food stores, stylish fashion stores, and, of course, ceramics stores with designs as bright as van Gogh's canvases.

The most charming part of Saint-Rémy-de-Provence is the fact that you can park your car and walk everywhere—most of the good shopping finds are tucked away down pedestrian lanes—and afterward find a café in the sun for lunch. It's as if Saint-Rémy has worked out the secret of a good life and designed the town around it. Certainly, the mix of beautiful Beaux-Arts buildings, medieval walls, shady tree-lined streets, and elegant squares creates a charm that isn't lost on all those who visit, or those who stay for good. Princess Caroline of Monaco was so enamored with Saint-Rémy's peace and timelessness that she settled here with her family following the death of her second husband.

Nostradamus, too, was rather fond of it. The French physician/astrologer was born here in 1503, and you can still see the remains of his birthplace in Rue Hoche. Who knows whether even he would have been able to predict the popularity of this lovely place?

AIX-EN-PROVENCE

THE ELEGANT BEAUTY

Defined by a stately avenue lined
with beautiful arching plane trees
and dotted with grand 17th-century
mansions, ancient fountains, and
marvelous architecture

AIX-EN-
PROVENCE

059

PROVENCE

Dubbed "the Paris of the South," Aix is a city with both grace and pace. The main street—the Cours Mirabeau—is lined with beautifully arching plane trees, 17th-century mansions, and side-walk cafés, but off this gentle thoroughfare are pockets of bustling activity with gorgeous stores, buzzing bars, busy squares, and other delightful finds. There's a distinct energy to the place, which per-haps emanates in part from the significant student population. Whatever the reason, this city of some 143,000 inhabitants (known as *Aixois* or, less commonly, *Aquisextains*, after the town's original Roman name), is a wonderful place to spend a day, a week, or a long summer month.

Discovering Aix and its splendor and sophistication isn't difficult: You can walk down any of the streets in the center of town and be rewarded with gracious lines of sight, from the elegant architecture to the ancient fountains. The town is famous for its watery displays (there seems to be a fountain on every corner), and the sight of them on a hot day is always soothing.

The best place to begin your tour is the beautiful **Cours Mirabeau**, the city's stately avenue. Framed with double rows of the famous plane trees and embroidered with cafés, fountains, and classical-style buildings (many of which have delicious histories), the Cours is the throbbing heart of this surprising city. The boulevard is actually built along the line of the old city wall and divides the town into two sections. The new part of town extends to the south and west; the Old Town, with its irregular streets and centuries-old mansions, lies to the north.

Perch yourself on a chair in front of one of the Cours's many cafés and watch the locals go by. It's all very civilized and chic, but with a decidedly animated pace.

If you want a café with history and soul, head for **Les Deux Garçons** at the eastern end of the Cours, which was Cézanne's local. (His dad's hat shop was next door at number 55.)

Once you're caffeinated, keep walking on the same side of the Cours until you reach **Passage Agard**. Walk through until you emerge at **Place Verdun** on the other side. This is Aix's **Old Town** (Vieil Aix) and is chock-full of bars—you'll need to remember it later when you're searching for an aperitif.

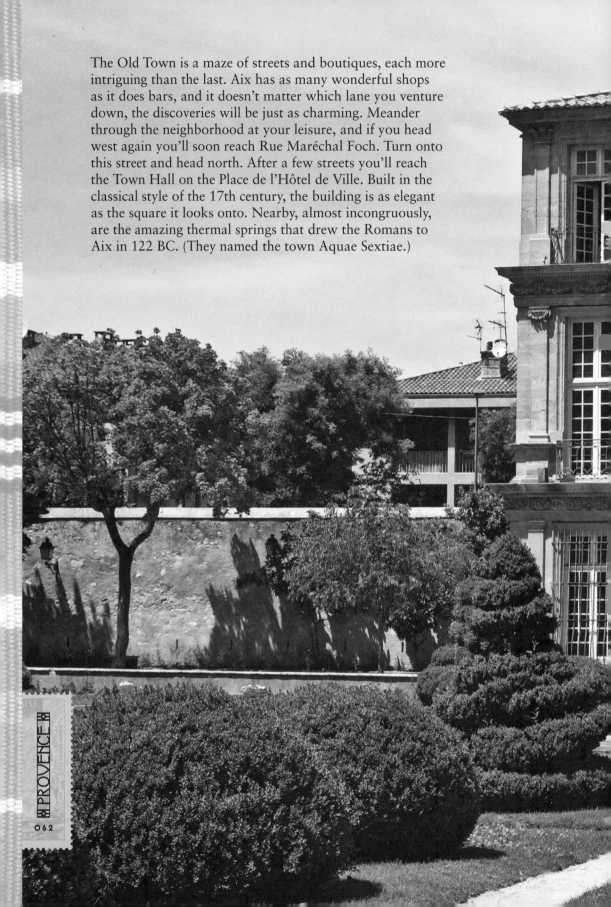

The Old Town is a maze of streets and boutiques, each more intriguing than the last. Aix has as many wonderful shops as it does bars, and it doesn't matter which lane you venture down, the discoveries will be just as charming. Meander through the neighborhood at your leisure, and if you head west again you'll soon reach Rue Maréchal Foch. Turn onto this street and head north. After a few streets you'll reach the Town Hall on the Place de l'Hôtel de Ville. Built in the classical style of the 17th century, the building is as elegant as the square it looks onto. Nearby, almost incongruously, are the amazing thermal springs that drew the Romans to Aix in 122 BC. (They named the town Aquae Sextiae.)

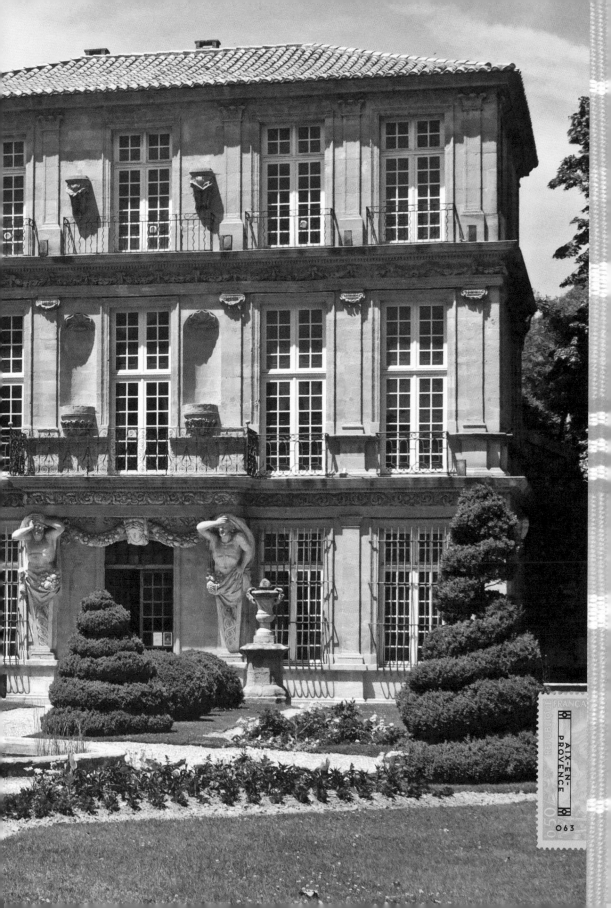

Keep walking and, after a few streets, you'll reach the neighborhood around Rue Gaston de Saporta, which will reward you with more impressively ornate town houses.

Once you're done admiring the architecture, you have two options. The first is to go for a bit of an urban hike (about 20 minutes) and weave your way to Avenue Paul Cézanne and the **Atelier Cézanne** (page 205). A beautiful tribute to Monsieur Cézanne, it will seduce you with both artworks and moving personal mementos of the artist's life. Even his beret, paint-spattered smock, and still-life objects are all in place. The other option is to return to Cours Mirabeau, and cross over to Rue Mazarin, the street that runs parallel to the Cours on the southern side. This is the **Quartier Mazarin**, which contains more superb examples of 17th- and 18th-century town houses. This neighborhood was originally conceived as a residential area for the gentry, and features several notable *hôtels particuliers* (private mansions) and grand residences.

When you've walked until your feet are numb, grab a baguette or some lunch and take a taxi to 13 Rue de la Molle. This is the site of the magnificent **Pavillon de Vendôme** (pictured on previous page), a lovely place for a casual picnic. The interior of this historic 1665 house, once home to both aristocrats and artists, isn't as gorgeous as the exterior, so don't shell out to see it. (And besides, it's often closed.) Instead, find a bench under a shady tree in the stunning walled garden and take in the peace and calm. Regarded as the best park in Aix, it's a genuine oasis in the middle of the bustling town.

One of the things you'll notice, as you're meandering around the town, is the number of fountains. Often referred to as "The City of a Thousand Fountains" (although it has nowhere near that number), Aix is a town built on bubbling water. Some of the most beautiful are the 17th-century **Fontaine des Quatre Dauphins** (Fountain of the Four Dolphins) in the Quartier Mazarin, and three fountains in the Cours Mirabeau. The favorite for many visitors is the natural hot water fountain in the middle of Cours, where the water temperature is around 93°F/34°C, and the fountain, dating back to the Romans, is covered in moss. It may not make you cool on a hot Aix day, but it will certainly give you an appreciation for this ancient and extraordinary place.

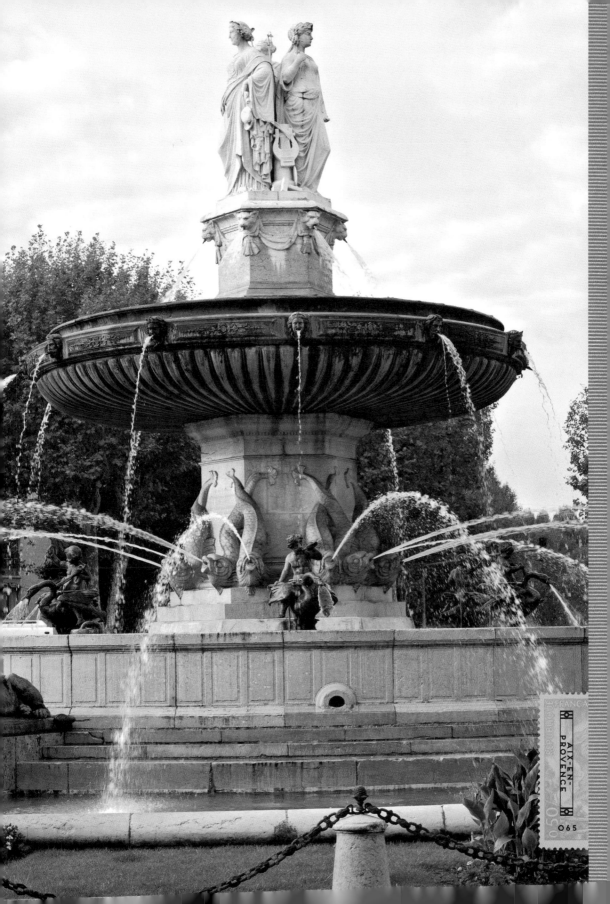

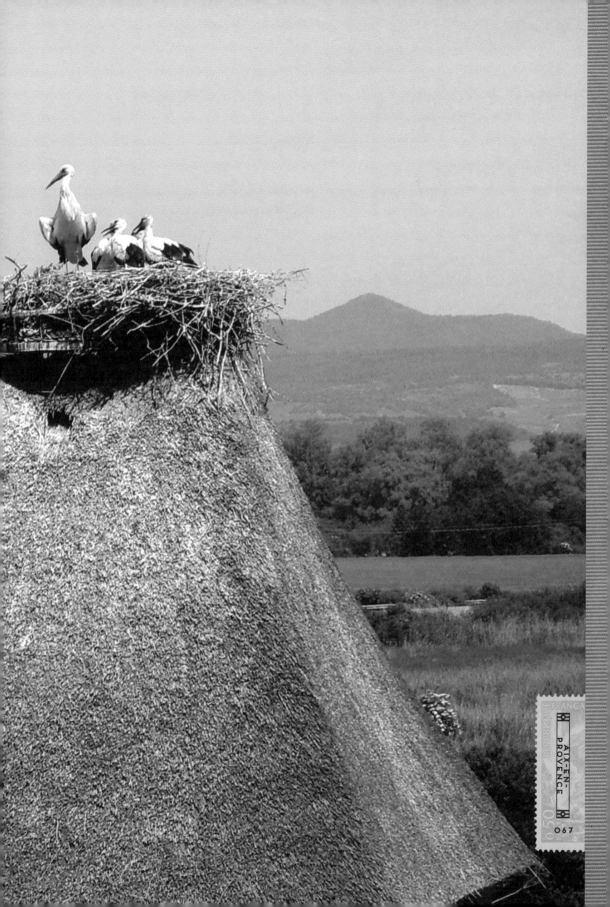

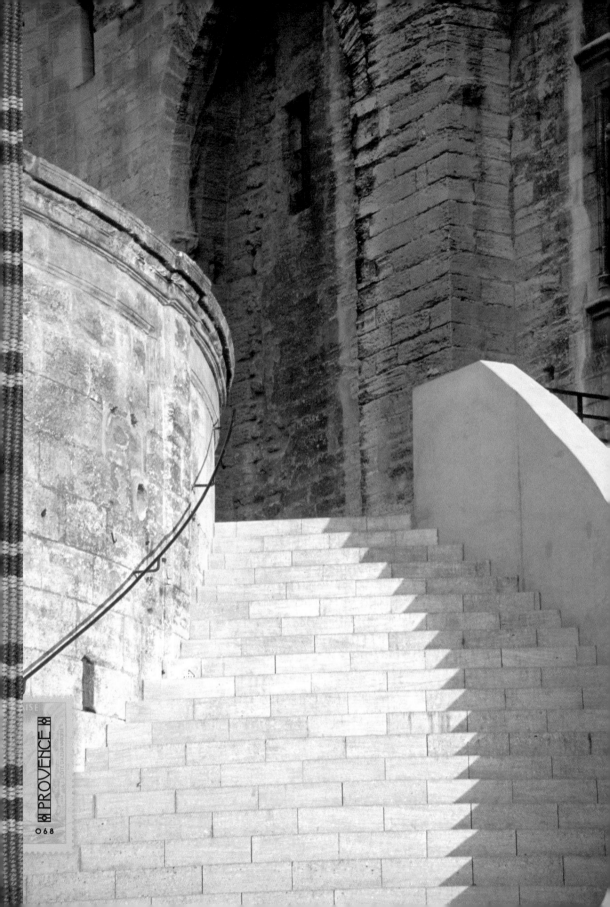

AVIGNON

THE ARTS LOVER

*Colorful, culturally rich, full of
artistic, architectural, and gourmet
pleasures . . . a lovely place to catch
your breath and let the Provence
breezes blow the city stresses away*

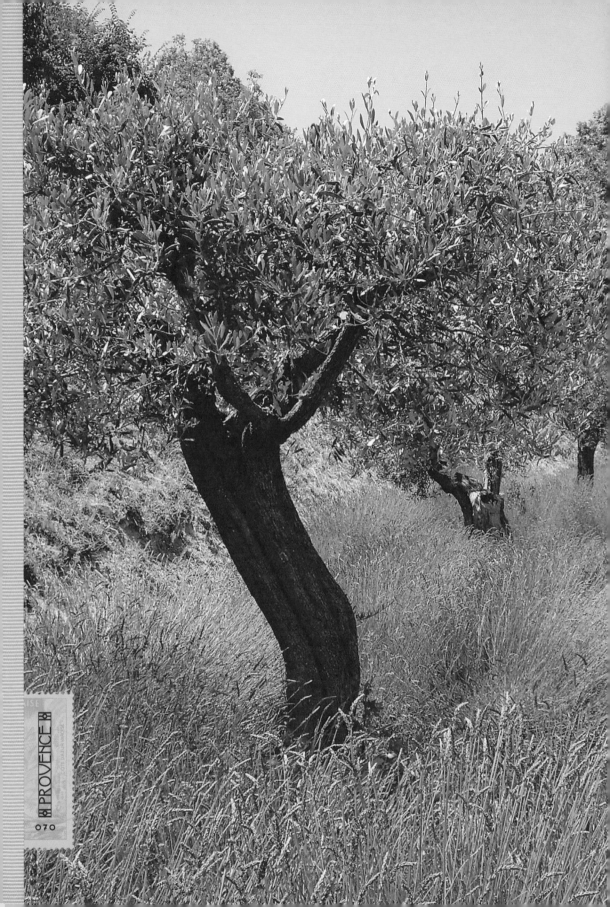

Avignon is regarded as the gateway to Provence. When you drive the road from Paris to the Riviera, or hop aboard a southbound train, Avignon is the first sign that you're finally reaching the land of sunlight, lavender, fine wine, and good times. And, like the region, the city is colorful; culturally rich; full of artistic, architectural, and gourmet pleasures; and worth idling in for longer than you'd anticipate. In fact, many people pause in Avignon on the trip from Paris to the coast: It's a lovely place to catch your breath and let the Provence breezes blow the city stresses away.

The city is bordered to the north and west by the mighty Rhône, a river that provides a dramatic backdrop. Rising above this grand waterway is a beguiling town comprising 39 towers, seven gates, and about three miles/five kilometers of walls. The massive ramparts that enclose Avignon give it a sense of mystery. You can't help but feel there's something worth seeing here. The UNESCO chiefs thought so too, and since 1995 the historic center of Avignon has been classified as a World Heritage Site.

Inside the ancient city walls are broad, tree-lined streets and intriguing passageways leading to picturesque squares, shops, galleries, churches, and museums. It's a town full of historical buildings, and although you can suffer from historical overload here, it's still a mighty impressive place.

To explore Avignon, begin at **Rocher des Doms**, the quiet hillside park on Montée du Moulin off Place du Palais. This park is the site of the city's first settlement and is considered the unofficial center of the town. It's a tranquil pocket of greenery in which to shake off the travel exhaustion and take a deep breath, but, more than that, it's a great place to get your bearings. From here you can get a feel for the layout of the city. If you hike up to the top, there are beautiful views over the city's tiled rooftops and Provençal countryside, including the Rhône, the famous Pont d'Avignon, and Villeneuve-les-Avignon on the other side.

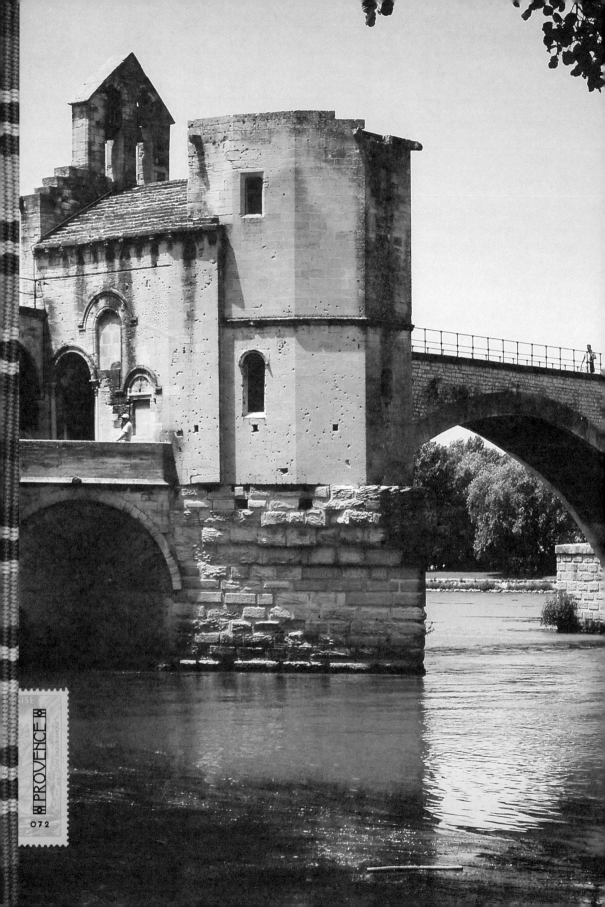

The **Pont d'Avignon**, also known as Pont Saint-Bénézet after the local shepherd boy who was told by an angel to construct the bridge here (and proved his divine inspiration by lifting a heavy stone block), is rather famous, not only in Avignon but around the world. The 12th-century bridge originally had 22 arches spanning about half a mile/900 meters across the Rhône and was regarded as an architectural marvel. However, the bridge collapsed frequently and had to be reconstructed multiple times. The bridge was an important strategic crossing between Lyon and the Mediterranean Sea (and between Italy and Spain) and was therefore closely guarded on both sides. (On the Avignon side, the bridge passed through a large gatehouse.) Eventually, after much of it collapsed beyond repair during floods in 1660 (several arches were already missing by this time and spanned by wooden sections instead), it was left to ruin. Today, only a few of the bridge's original 22 arches remain.

After his death, Saint-Bénézet's body was interred in a small chapel standing on one of the bridge's surviving piers on the Avignon side, as a tribute to the boy who started it all.

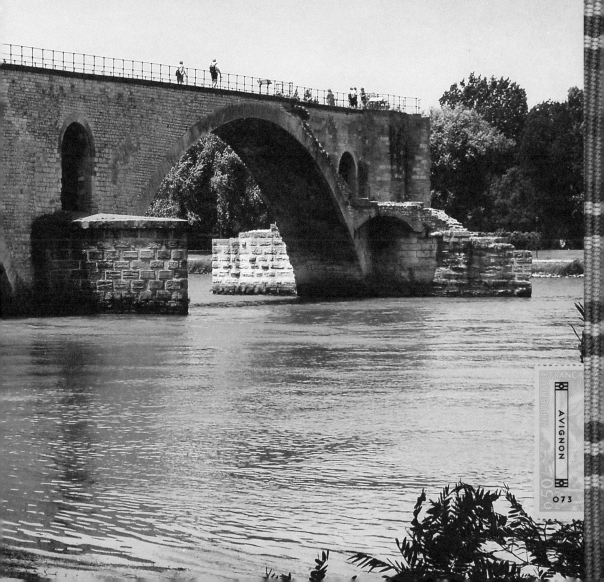

When you're finished taking in the lay of the land from the park, walk back down and head for the **Palais des Papes**. The Popes' Palace is the largest Gothic palace in the world, and was the seat of Western Christianity during the 14th century. It features incredible architecture and exquisite interior tile work. But be warned: It's huge, and can be rather imposing, so you may be exhausted before the hour is up.

After a tour through here you'll probably need a strong coffee, so head to nearby **Place de l'Horloge,** the town's main square. Conceived and designed in the 15th century, and named after the clock tower above the Town Hall, it has been modernized over subsequent centuries but has lost none of its charm. Pick one of the many outdoor restaurants and cafés on the square and treat yourself to a long Provençal lunch. Some travelers consider this square rather touristy; others sit back and enjoy its atmosphere, especially on a sunny day. It's also particularly lovely in the evenings.

The square is also notable as the venue for annual events. The town has always been aware of its artistic heritage—and its creativity—and embraces this through its festivals, theater companies, galleries, art studios, and even its own opera house. The **Avignon Festival** in July (festival-avignon.com) is so popular, it is now an international event, and is a great time to see this city come alive.

If you love markets, Avignon's **Flower Market** (Marché aux Fleurs) is especially charming. It's held in the Place des Carmes on Saturday mornings. If you prefer bric-a-brac, there's a flea market in this same area on Sunday mornings, plus a **Petite Brocante d'Avignon** in the Place des Corps Saints on Tuesdays, and the **Puces de Bonpas** outside Avignon in Montfavet (about three miles/five kilometers from the Old Town) on Saturday mornings. If it's a food market you're after, there's the weekend **Marché Forain** on the Remparts Saint-Michel.

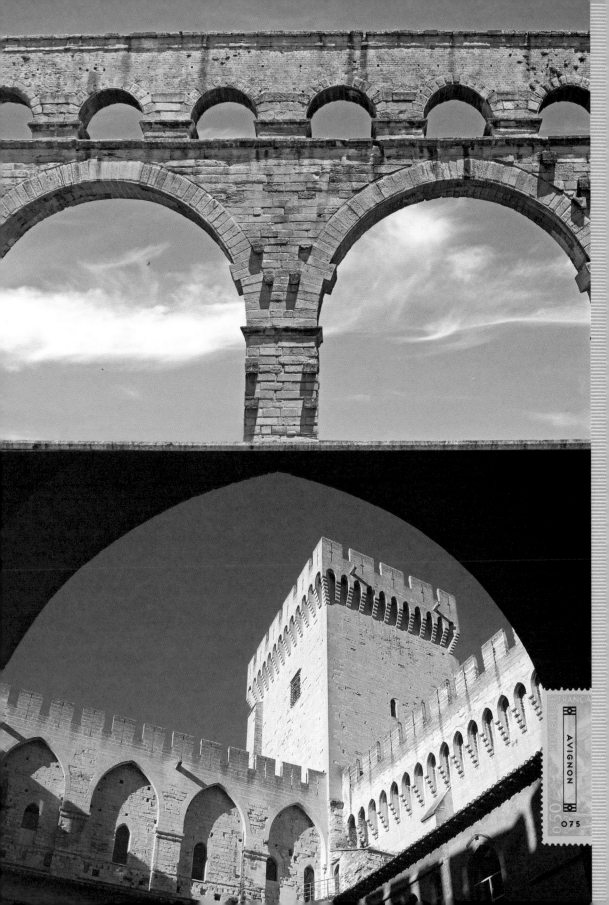

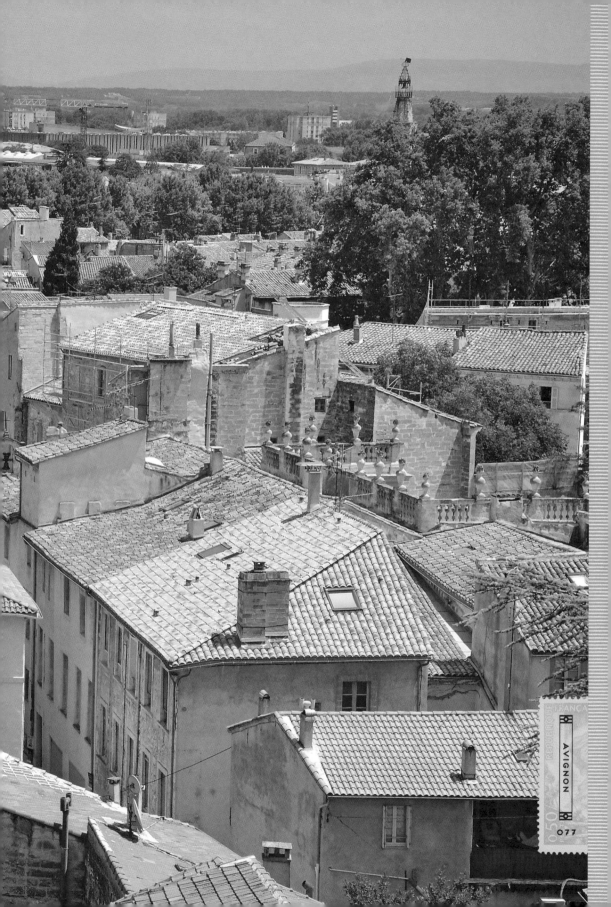

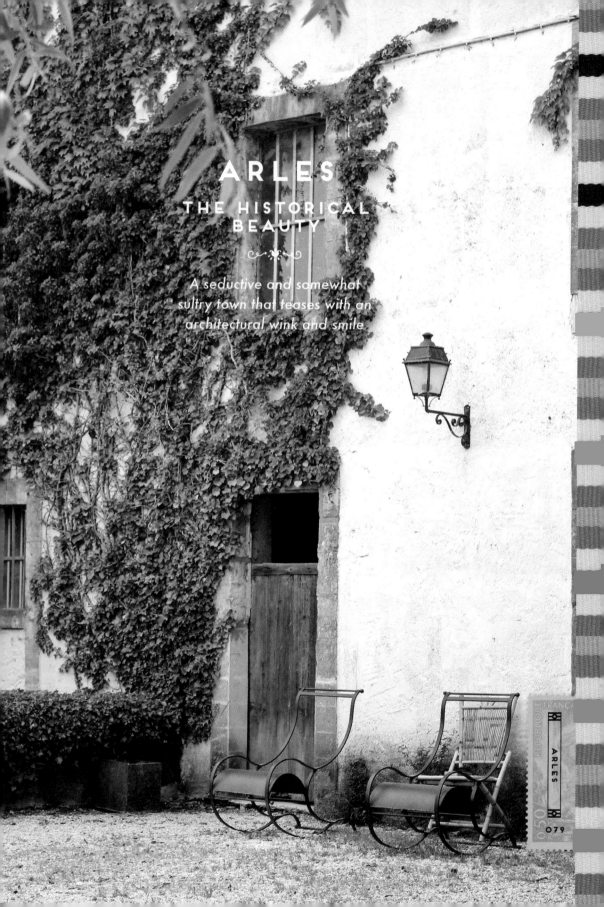

ARLES
THE HISTORICAL BEAUTY

A seductive and somewhat sultry town that teases with an architectural wink and smile

ARLES

0.50

079

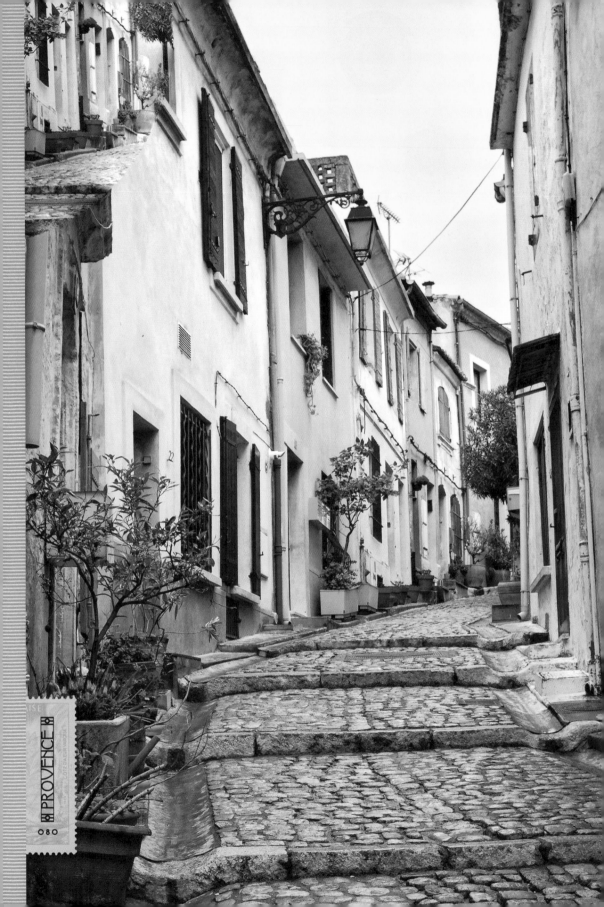

Unlike Avignon, which can become congested in summer (particularly with frightened tourists in tiny rental cars who drive into the labyrinthine center and can't find their way out again), Arles is rather laid-back. This is perhaps because it isn't as busy as its popular neighbors. And the reason for this is that it's often overlooked by tourists making the dash from the Côte d'Azur to Provence. "Arles?" they say, lifting their foot off the pedal as they see the signs flashing past on the highway. "What's there?" And then they accelerate again. This is both a good and a bad thing. It means Arles isn't overrun with people. Even during high season and festivals, it's always an easy place to navigate. The downside, of course, is that without the demand driven by the tourist dollar, there isn't a huge amount to do in terms of sightseeing.

Like Avignon, Arles is a UNESCO World Heritage Site. Located on a low hill where the Rhône branches into two tributaries on its way to the sea, it's blessed with both scenery and a wonderful spirit. The bullfights are a controversial part of this spirit, but the festive atmosphere that takes over the streets is still infectious. No wonder van Gogh loved it here. Arles' sense of joy and love of life is palpable. (Unfortunately there are no van Gogh artworks to be found in the city, despite the fact that his time in Arles was his most productive.)

The center of the city is still medieval in character, with narrow and winding streets weaving between ancient buildings. Every now and then a square breaks the grid, offering a splendid pause in the architectural narrative.

A seductive and somewhat sultry town, Arles teases with an architectural wink and smile. Its colorful houses flirt with the light that drifts over the landscape (van Gogh loved painting those too), and its locals love a drink, a laugh, a dance, a bullfight, and a good time. I don't advocate the killing of animals, so I won't comment on that tradition, but it's up to you to find out more about it and make up your own mind. What I will say is that it's hard to judge Arles, especially when it's so welcoming and convivial.

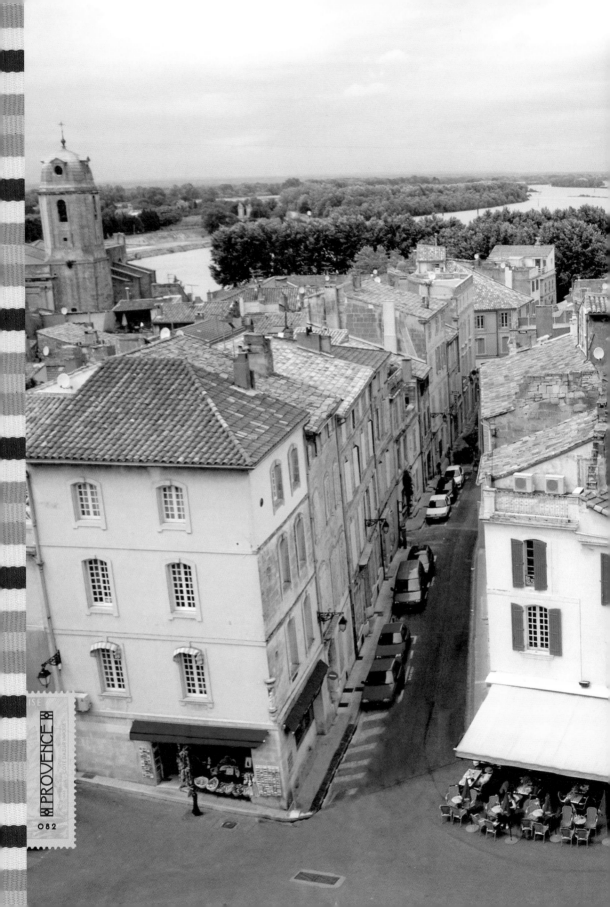

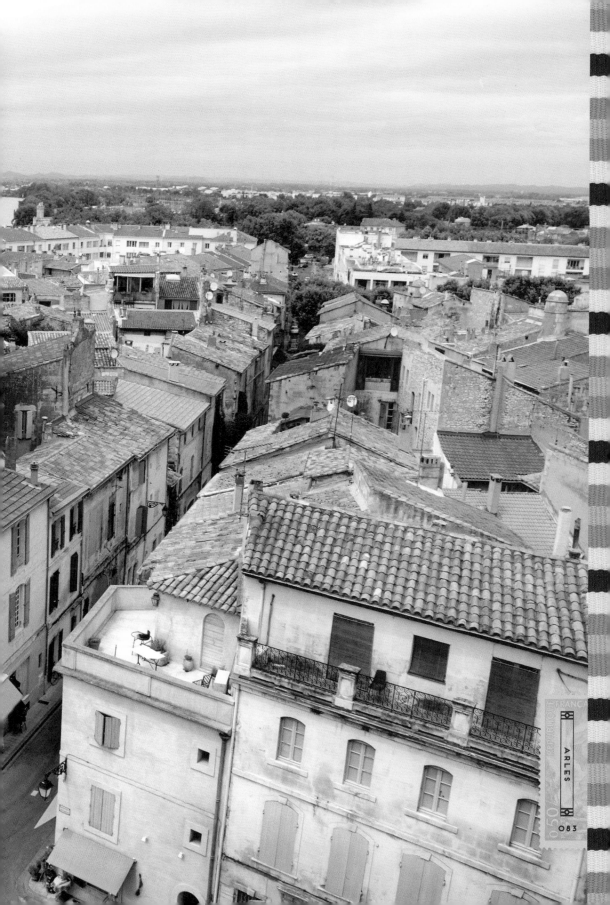

To discover the sweet life of this happy town, start at the **Place du Forum**, which has been the hub of Arles since Roman times. Find a café, order a glass of Rhône red, and watch the Arlesian parade. Fortified, begin your tour with a stroll through the old lanes, where the houses are tinted with colors from an artist's palette: pink, pale blue, green, yellow, and lavender. If it's a Wednesday or a Saturday, head for the **market,** which stretches along the shaded Boulevard des Lices. It can be hit-and-miss here, but the food section is worth a pause, if only for the aromas of pungent cheeses, honey, lavender, mint, and spices.

Grab some picnic fare (a goat-cheese salad and dessert of crème brûlée laced with lavender is fabulous) and head for the lovely park along the **Boulevard des Lices**. Find a bench in the sun or, if it's warm, under the shade of one of the great old trees (look for the gigantic cedar).

If you fancy some history with your luncheon, skip the park and head for **Les Arènes,** the enormous, two-tiered amphitheater that dominates the town. Sitting in a sunny spot, you can picnic while taking in the history of this grand place, which once seated as many as 20,000 spectators.

There's not a lot to do in Arles in terms of tourist sights. The thing to do here is immerse yourself in the lifestyle while admiring the history and beauty of the architecture, and the passion of the people.

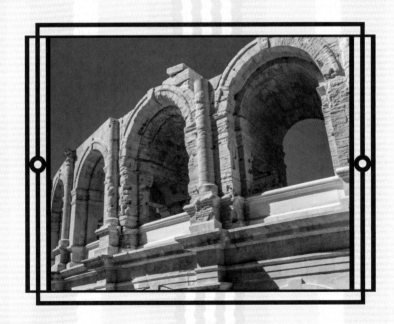

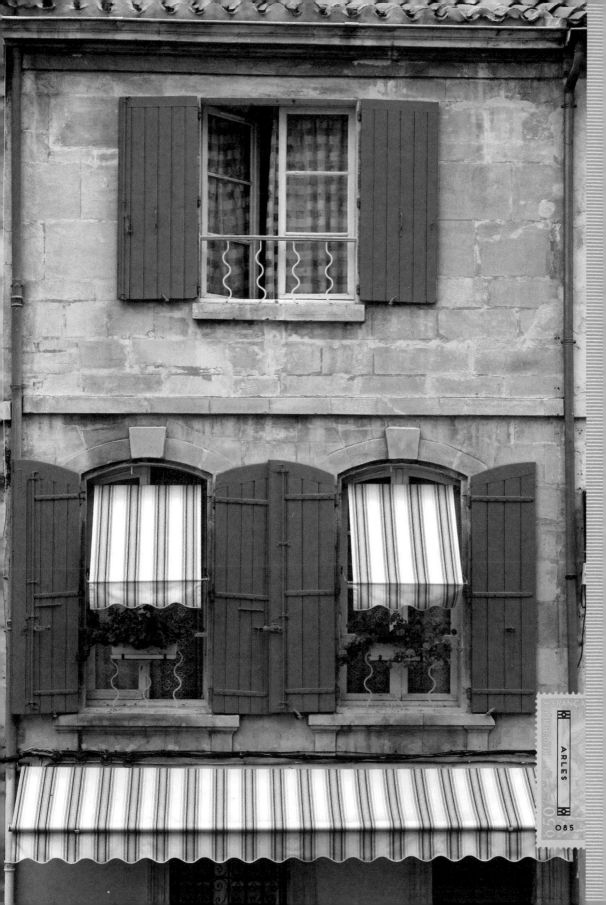

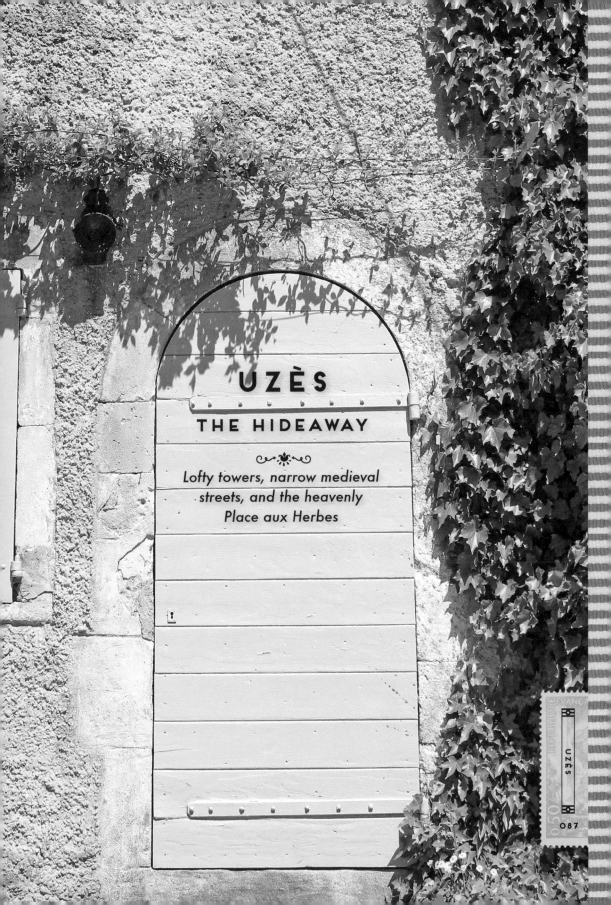

UZÈS

THE HIDEAWAY

Lofty towers, narrow medieval
streets, and the heavenly
Place aux Herbes

UZÈS

0.50

087

Uzès, with its high towers and narrow medieval streets, is a place lost in time. It's almost as if it were built on the back lot of a Hollywood studio to resemble a fairytale French village. But I assure you, it's not. It's authentic Provence.

Uzès may be small (population 8,300), but makes up for its size with architecture that is pure theater. You can see the skyline long before you reach it. The town's lofty towers strike a dramatic note, while soaring buildings such as La Tour Fenestrelle offer an architectural exclamation mark.

But all tours of Uzès must begin at the heart of this heavenly destination: the arcade-lined **Place aux Herbes**. (Have you ever heard of a more evocative name for a town square?) This is where most things happen in Uzès. One of the most colorful **Saturday markets** in the South of France is held here every week. It's frenetic, so if you can't abide crowds go to the smaller Wednesday version instead. This is the place to stock up on fabulous food, including olives, cheese, olive oil, vegetables, and fragrant herbs—some of the best ingredients for a great French meal.

There are also some wonderful cafés here for a leisurely brunch in the sun, such as **Café de l'Oustal**. Once you're caffeinated, and have checked out the comestibles, make for the streets. The pretty, pedestrian-only streets of Uzès' center offer beautiful boutiques selling gorgeous women's wear and luxury goods—much more upscale than you'd imagine from a country town miles from Paris. The side streets leading off from Place aux Herbes hide many of the more interesting and sophisticated shops. Their stylish cream-and-gray façades add to the experience.

When you're shopped-out and feel like grabbing a late lunch, there's **Les Terroirs** (5 Place aux Herbes)—one of Uzès' best dining spots. Check out its fine food shop for a foodie souvenir to take home. Two other excellent dining establishments are **Le Comptoir du 7** (5 Boulevard Charles Gide) and **Au Petit Jardin** (66 Boulevard Gambetta).

After you've wandered the village, you can climb one of the famous towers, or grab a photo of Uzès' own leaning tower of Pisa, **La Tour Fenestrelle**. Then, if the weather is sunny, hop back in the car and head out into the surrounding countryside for more scenery.

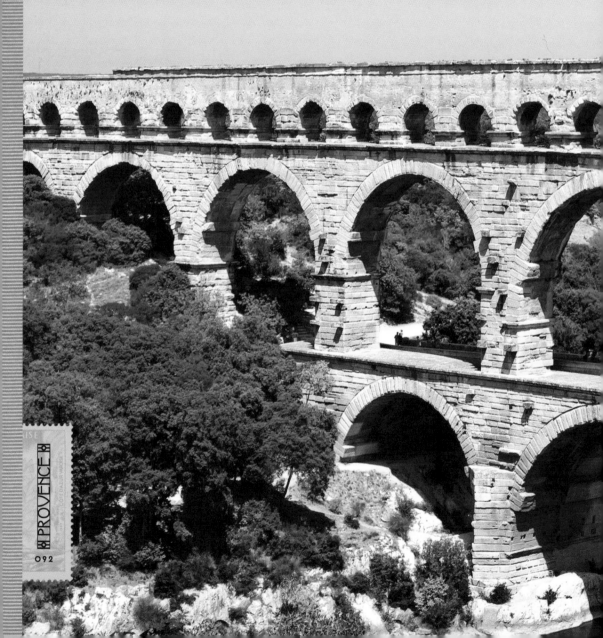

One of the landmarks of this area is the incredible form of the **Pont du Gard**, the ancient Roman aqueduct bridge that crosses the Gardon river in Vers-Pont-du-Gard near Remoulins. It is part of the Nîmes aqueduct, a structure 30 miles/ 50 kilometers long that was built by the Romans to carry water from a spring at Uzès to the Roman colony of Nîmes. No visitor to this part of the region should miss it.

If you want to finish off your visit with a small thrill (okay, a spill and a thrill), try canoeing down the Gardon river. It's one of the loveliest ways to see the landscape.

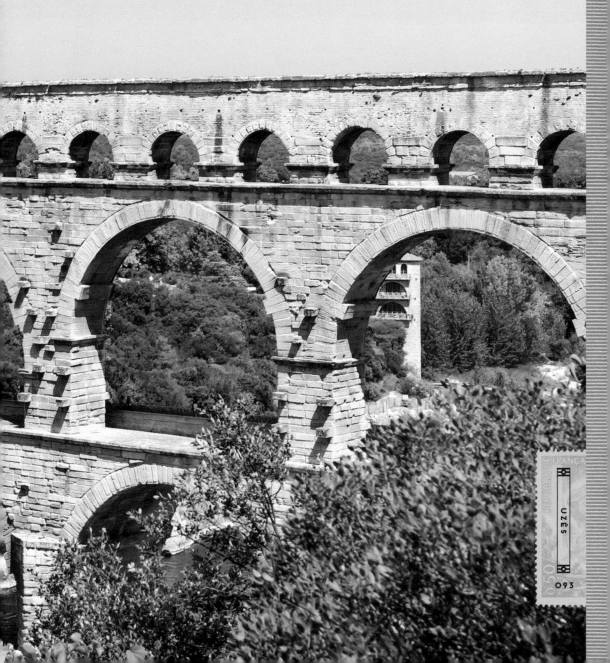

PART TWO
THE CÔTE D'AZUR

CARTE POSTALE

Ah, the French Riviera. For more than a century the southern coast of France has been the summer playground of artists, writers, celebrities, and anyone else with a yearning for its pleasures. The striped deck chairs stretched out on the beaches, their bright canvas slings sending an inviting wink to all those who pass. The slender pencil pines standing like exclamation marks along the stunning coastline. The glamour of Cannes during the film festival, when you're nobody without a camera lens aimed at you.

Correspondance

The lazy tides of the beaches and coves, where the waves lap the bows of weathered fishing boats or form elegant curls against the enormous white hulls of the motor cruisers moored in the harbor. And the over-the-top offerings of Saint-Tropez; a place where sybarites and gazillionaires strut their stuff in the sun while the rest of us gaze in amazement. The Côte d'Azur is all this and more. It's a seductive mix of beautiful landscapes and battered ones, of fast money and idle lives, of endless sun and dark temptations—all played out beside the deep blue of the legendary Mediterranean.

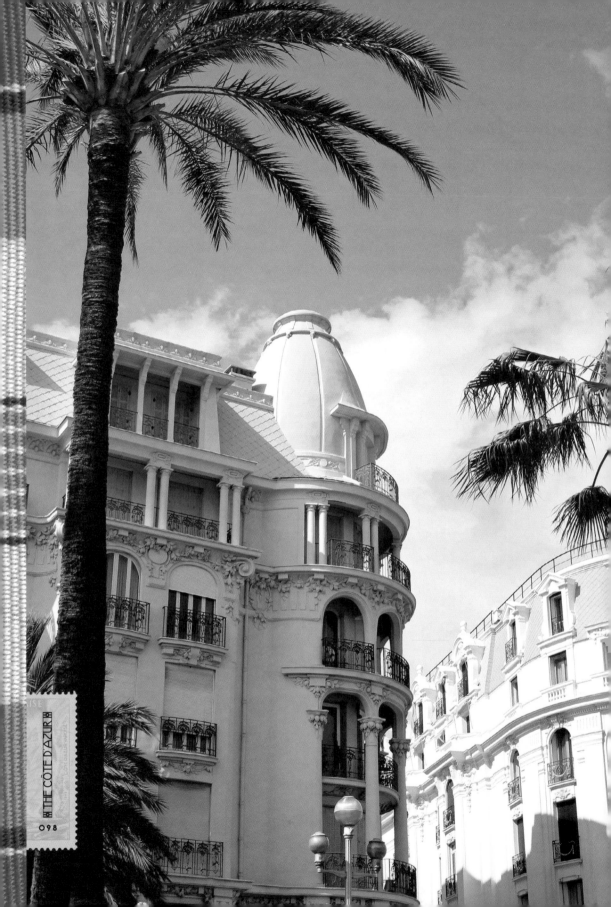

THE CÔTE D'AZUR

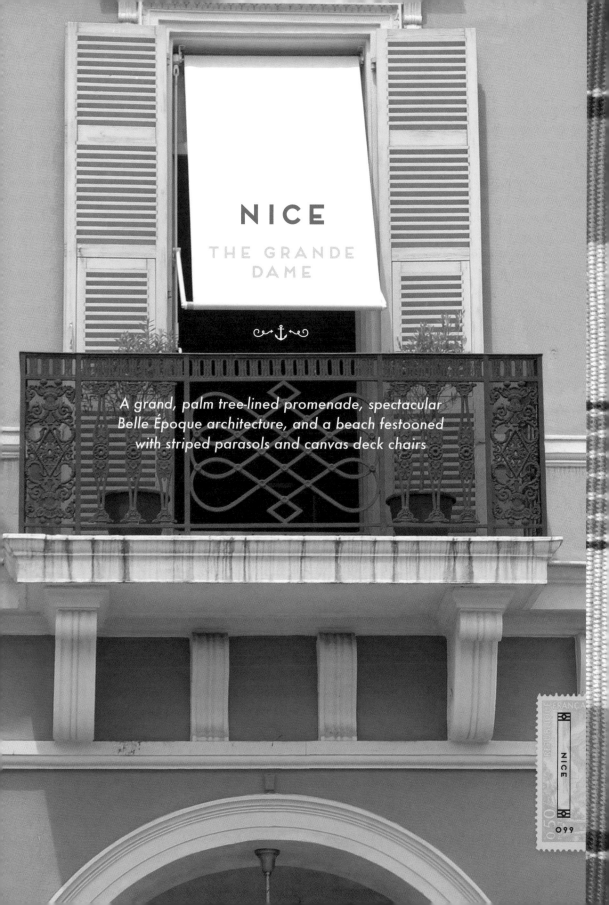

NICE

THE GRANDE DAME

A grand, palm tree-lined promenade, spectacular
Belle Époque architecture, and a beach festooned
with striped parasols and canvas deck chairs

Although this grand old town is often criticized by those who prefer the posher places down the way, Nice is actually very, very nice. For a start, it's brimming with superb Belle Époque buildings, each more beautiful than the last. Indeed, you could walk here all day and never grow tired of looking up at the ornate balconies and elegant roof-lines. It's also a town of great stories that you will soon discover as you explore its excellent museums, beautiful parks, and truly lovely promenade. All in all, the city is a thoroughly entertaining place.

Nice's history is long and rather convoluted. The town was founded by the Greeks around 350 BC, although early humans had lived in the area starting some 400,000 years before. Over the centuries, various empires (Roman, Saracen, Ottoman) attempted to take control of the city until, in 1860, it finally came to rest in French hands for good.

Its modern popularity really began in the 18th century, when aristocratic English families journeying to Italy for the winter began stopping here en route. Its location—with the sea on one side and the protective hills on the other—meant it enjoyed a perfect microclimate—something the winter-weary northerners were searching for. Many were so impressed that they didn't go any further.

Soon, so many English, including Queen Victoria, had begun trickling down that the town renamed the main seaside promenade Camin deis Anglés (the English Way) and then later the Promenade des Anglais. Soon, the town was a huge hit. Artists such as Marc Chagall and Henri Matisse arrived and set up their easels to try to capture the soft, gentle scenery. By the 1920s, Nice was romanticized as the perfect place to seek a more idyllic existence.

Then, during the middle of the 20th century, Nice's sheen began to rub off, and the town was overlooked in favor of ritzier resorts such as Saint-Tropez and Monte Carlo, which became *the* places to be.

In the last decade or so, though, people have begun to appreciate this old Belle Époque beauty once more. The Scandinavians and northern Europeans particularly adore it, with many purchasing second homes here. The Russians have become a significant community, buying up a great deal of property with their new wealth. As well as the foreign investors, a new generation of entrepreneurial French people is changing the nature of the city, creating everything from offbeat exhibition spaces to unique culinary hideaways.

To explore this grande dame of a town, you really need to begin on the spectacular palm tree-lined **Promenade des Anglais**, which winds along the Baie des Anges (Bay of Angels). Curiously, for many years the seaside part of Nice was considered inferior, and the rich preferred the higher ground. (This was long before people such as Coco Chanel made sunbathing and tans popular.) Then, in the early 1800s, a clever (and rich) English businessman proposed a new waterfront walkway to replace the six-foot-/two-meter-wide track. The result transformed the town. The beauty of the Prom was finally recognized when it was inaugurated in 1931 by the Duke of Connaught (son of Queen Victoria). Today, with more than five miles/eight kilometers of flat walkways embroidered with flowerbeds, palm trees, and seats all set against a magnificent view of blue, it is still one of the most beautiful places to walk on the entire Riviera. You can also rent one of the famous *chaises bleues* ("blue chairs"), but the beach is pebbly so doesn't quite have the same feeling as a sandy shore. Still, the promenade is a wonderful place for a stroll in the late afternoon, with the yachts and lines of striped umbrellas spread out before you.

As you walk along the Prom, you can picture Nice at the peak of its popularity just before the turn of the 20th century: the well-heeled Edwardians strolling along, their parasols in full bloom; the beach festooned with striped umbrellas and canvas deck chairs. Look out for the landmark **Hôtel Negresco** (page 188;

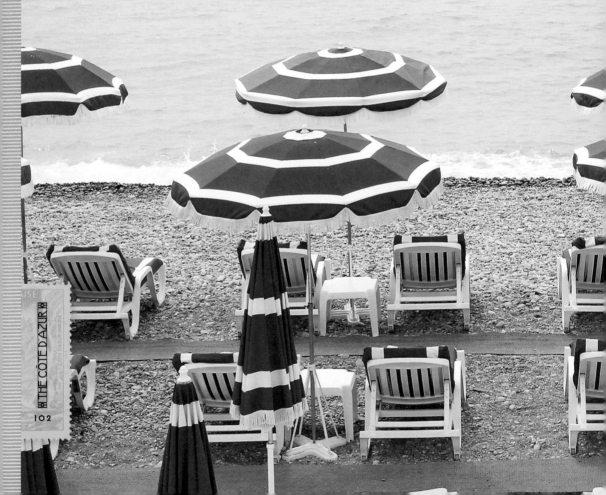

37 Promenade des Anglais, hotel-negresco-nice.com)—you'll recognize it from the pale pink dome and the quirky doormen in knee breeches and plumed hats. This is one of the most extraordinary hotels in France, which is why it often plays host to visiting prime ministers, presidents, and movie stars. A century old in 2013, the Negresco was built by one-time gypsy and innkeeper's son Henri Negresco in 1913 after he made his money running a casino on the Riviera. He wanted the best hotel imaginable, so hired the architect Édouard-Jean Niermans (considered the favorite of café society) to design the hotel and its now-famous pink dome. Negresco also picked up a discounted 16,000-crystal Baccarat chandelier after Czar Nicholas II was unable to take delivery due to the Revolution. (The chandelier's twin is found in the Kremlin.) The rest of the hotel was fitted out with a staggering glass-ceilinged rotunda and furniture that would befit a palace. Henri's hotel went into decline after the outbreak of World War I, and, by the time of his death (age 52 and bankrupt), had been converted to a hospital and then sold.

Today, however, the Negresco has returned to its former glory and, if you can afford the rates, is one of the most opulent establishments to stay on the Riviera. Think mink bedspreads, an astonishing art collection, and staff who are the epitome of graciousness. The dancer Isadora Duncan loved the hotel, and spent the last few months of her life there. She died tragically while driving along the coast when her silk scarf caught in the Bugatti's open-spoked wheels and broke her neck.

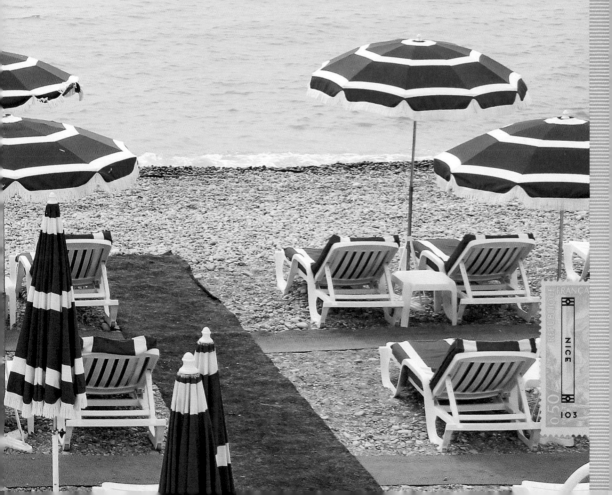

While you're wandering along the promenade, make time to see the beautiful **Masséna Museum of Art and History** (65 Rue de France; musee-massena-nice .org). The 19th-century Italianate villa features a sublime Empire-style hall and a beautiful garden that was the work of landscape architect Édouard André who also designed the gardens of the Monte-Carlo Casino. Inside, 20 exhibition rooms featuring more than 15,000 exhibits retrace the history of Nice through furniture, decorations, and artworks. It's a beautiful building, inside and out, and well worth a visit.

Running parallel to the Promenade des Anglais is an equally lovely walking street, the pedestrian-only **Rue de France.** It's lined with cafés and restaurants, many of them with protected terraces for people-watching. Head east along here and you'll soon hit **Place Masséna,** a grand square surrounded by magnificent Italian-style yellow and chile-red buildings reminiscent of Venice's Piazzo San Marco. (Nice was once owned by the Italians; hence the Italianate feel.) This pleasing Mediterranean plaza is considered the heart of Nice, as it's where many of the annual activities take place, including the Carnaval de Nice in February, the Bastille Day procession and Jazz Festival in July, the Christmas markets, and the general fun in the summer months. Galeries Lafayette, a branch of the famous French department store, is also situated on the north side of the plaza. And a new tramway connects Place Masséna to Nice's central train station (Gare de Nice-Ville).

Farther along from the piazza is **Le Vieux-Nice** (Old Town), which is heralded by the colorful **Cours Saleya;** a wonderfully vibrant square that hosts the daily Marché aux Fleurs (Flower Market). It's one of the most charming surroundings for a flower and vegetable market, and the produce ranges from peonies to unusual fruits.

At the eastern end of the Cours Saleya is **Place Charles Félix,** another grand square that vies with the Place Masséna for architectural drama.

From here, you can either head a block south back to the beach and **Les Ponchettes,** a fabulous architectural folly of low white buildings tucked under the promenade that were once used by fishermen and are now galleries and eateries; or you can go north, deep into the Old Town and its labyrinthine lanes.

If you fancy a hike to burn off the gelato, head up the steep steps to Le Château, the shaded hill and park at the eastern end of Quai des États-Unis. It isn't really a château; it was named after a 12th-century château razed by Louis XIV in a fit of anger. (It should be called Ghost of a Château.) The park itself is a pleasant mix of waterfalls, pools, and gardens—great on a hot day—and the views over Nice are spectacular.

On the other side of the park, the port is always photogenic, especially on a sunny day. If you really want some exercise you can walk all the way to Villefranche and Cap Ferrat and back—a three-hour hike that rewards with some of the best views on the entire coastline.

Another place worth seeking out in Old Nice is the **Opéra de Nice** (9 Rue Raoul Bosio; opera-nice.org), which provides a regular program of performances that are as grand as the building.

Back toward Cannes, there is also plenty to explore, including the **Jardin Botanique de la Ville de Nice**, the town's botanical garden (78 Avenue de la Corniche Fleurie; bgci.org), and the **Musée des Beaux-Arts de Nice** (page 205; 33 Avenue des Baumettes; musee-beaux-arts-nice.org), which was created from a resplendent villa and features treasures from the Second Empire and the Belle Époque. Finally, don't miss the **Marc Chagall Museum** (page 208; Avenue Docteur Ménard; musees-nationaux-alpesmaritimes.fr/chagall) and the **Matisse Museum** (page 208; 164 Avenue des Arènes de Cimiez; musee-matisse-nice.org). Both are wonderful tributes to the colors, lines, and joyous pleasures of this impossibly beautiful place.

There is no best time to visit Nice, as it has a mild climate year-round; however, during February the town revels in the **Carnaval de Nice**, one of its favorite festivals. It features the Bataille de Fleurs, an exuberant parade of floats decorated with thousands of flowers and usually topped with equally beautiful women. Nice loves its flowers, as the daily flower market shows, and this festival is a flamboyant celebration of color, scent, form, and style—much like Nice itself.

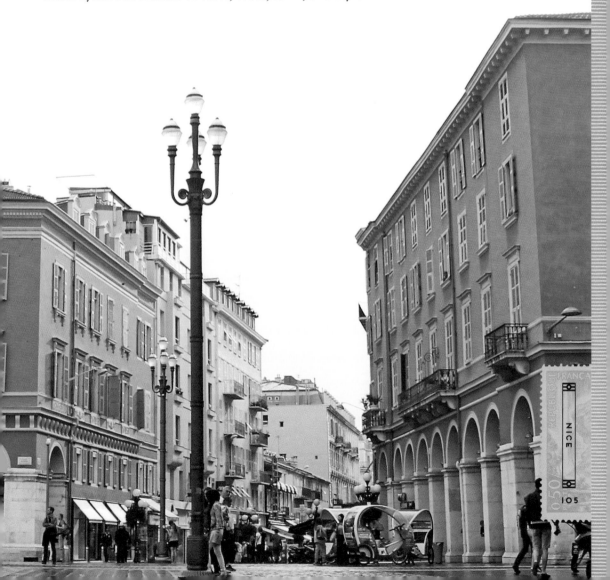

CAP FERRAT
THE ARISTOCRAT

One of the most beautiful peninsulas on the Riviera, where lush gardens hide an enclave of elite villas, and charming coves beckon with turquoise water and teal-blue motor cruisers

RÉPUBLIQUE FRANÇAISE
CAP FERRAT
0,50
109

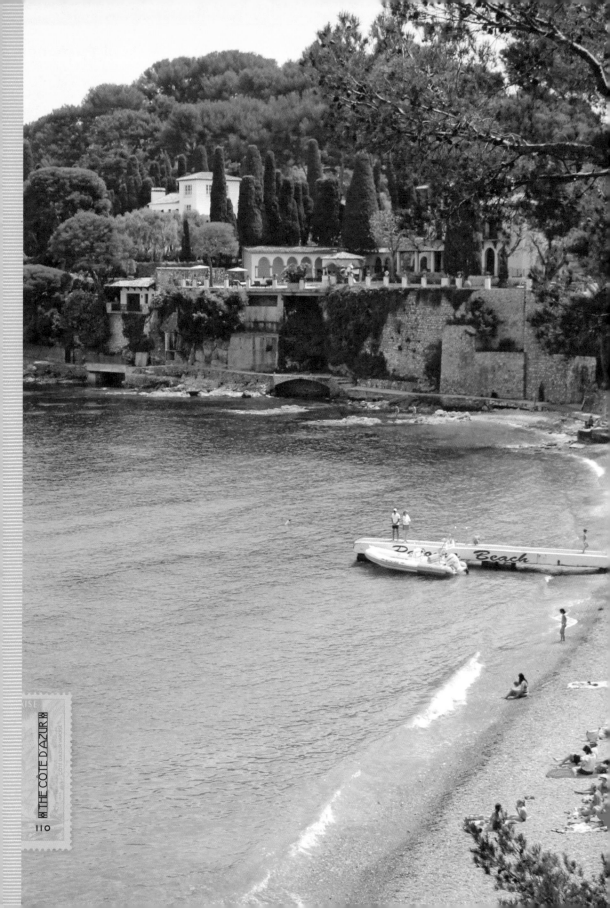

Cap Ferrat is now the second or third most expensive real estate in the world, depending on which source you read. It's always been an exclusive piece of the Riviera, thanks to its geography and beauty, but in the last half century it's become more coveted than ever.

This idyllic part of the French Riviera was first noticed by Leopold II, king of Belgium, who came to Cap Ferrat for a visit in 1895. Back then, it was a fairly understated bit of backcountry used for fox hunting. There were no roads, only a few paths and some humble dwellings. The king, an astute businessman who liked buying land for his portfolio, noted the beauty of the Plage de Passable, the gentle views of the Mediterranean, and, in the distance, a small villa. He decided to buy it, and then snapped up 15 plots of land around it. The locals thought he was mad. Who would want Cap Ferrat? But there was an ulterior motive. The cape was the perfect place to carry out illicit love affairs, far from the prying eyes of the palace; and the king had a mistress, Blanche Delacroix, whom he wanted to woo. The villa was to be the setting—framed by blue views of the sea and hidden in what would soon be a garden of luxuriant vegetation (which the king was also planning). He imagined it as a bucolic paradise. The king also bought a nearby villa called Les Cèdres, for his own use, and every evening, with a tiny lantern, he would step between the two along a path hidden by the trees. The gardens eventually became lush and lovely, thanks to the climate, and Cap Ferrat soon grew from a wild backwater to a surprisingly spectacular oasis. You can still see the profusion of exotic plants, trees, and other botanical species that the king's gardener introduced. In fact, much of Cap Ferrat is now an Eden where geraniums grow as big as hedges and hibiscus, jasmine, bougainvilleas, roses, wisteria, and citrus flowers perfume the air. No wonder the intensely private celebrities love it: You can barely see the villas through the greenery.

Despite the "Keep Out" signs on the gates, Cap Ferrat is easily explored, even without a map. In fact, one of the best walks in the world is here, the **Sentier du Littoral**, a coastal path that goes right around the cape.

The best way to do this walk is to start at the beach in front of the Hôtel Royal-Riviera (3 Avenue Jean Monnet) on the Beaulieu-sur-Mer side of Cap Ferrat. You'll see the start of the coastal path winding out to the promontory. Follow the path, known as Promenade Maurice Rouvier, as it meanders past David Niven's former home, an exquisite pink villa with its own pink harbor.

Originally called Lo Scoglietto (Little Rock), the house was built in 1880 and rented by the Duchess of Marlborough in the 1920s. It was then extended in the 1950s and bought by Charlie Chaplin, who in turn sold it to actor David Niven, who then lived here until his death. The small square in front of the villa is named Place David Niven as a tribute. (Rumor also has it that Dodi Fayed bought it as a hideaway for Diana during their courtship.)

Continue on the path, past the splendid villas and hidden gardens, and you'll shortly reach the picturesque fishing village of **Saint-Jean-Cap-Ferrat**, from which the cape takes its name. Here, you can stop for an ice cream or lunch on the terrace of the famous Voile D'Or hotel (page 192) overlooking the tiny harbor. (Service is slow, so go for the view.) It's also lovely just walking around the village, its quayside shops and cafés, and its little harbor—surely one of the prettiest on the Riviera. Look for the coconut-ice-style Mairie (Town Hall) with its trompe l'oeil flowers painted around the door.

The artist Matisse was captivated by the purity of the light here. "This is a place," he wrote, "where light plays the first part. Color comes afterward." You can see the interplay of light and color in the marina, where turquoise and teal-blue boats bob up and down in the shimmering, luminous sunlight.

Keep following Avenue Jean Mermoz, past the Hôtel Brise Marine (a great little cheapie; page 186) until you reach **Paloma Beach** (Plage de la Paloma; page 200); one of the sweetest coves on the coast and a favorite of the jet set who moor their yachts in front. Follow the steps down to the beach for lunch at the cheery café or (if you remembered your bathing suit) have a dip in the sea. Then retrace your steps back to the Brise Marine and turn down Avenue de la Puncia and then left at Chemin de la Carrière. This pretty road will eventually take you to a gate;

don't be afraid to walk around it—it's a public path. From there, you're on the track that goes around the cape, right to the base of the legendary **Grand-Hôtel du Cap-Ferrat** (page 186). There are spots for swimming at intervals, but watch the current and the waves. Eventually, near the lighthouse, you'll be able to ascend the steps back up to the residential streets. Look out for Avenue Somerset Maugham, where the writer lived at his villa, La Mauresque. Maugham, who called the French Riviera "a sunny place for shady people," spent the last 38 years of his life here (with a gap during World War II) and hosted a long list of artists, writers, politicians, and royalty.

But Maugham's villa isn't the only impressive property here. The entire cape is filled with houses of the wealthy, including Microsoft's Paul Allen. Take photos but try not to gawk.

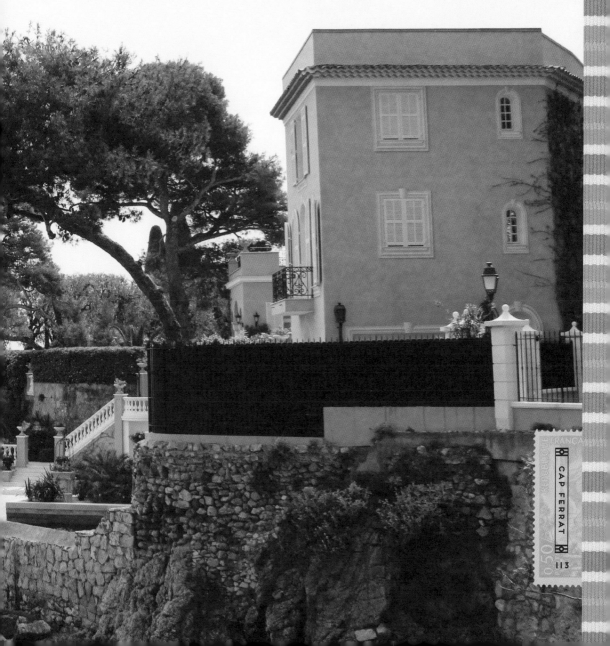

Find your way to the main road, **Boulevard du Général de Gaulle**, and follow it all the way until you reach the signs for the **Villa Ephrussi de Rothschild**— Béatrice's renowned villa and gardens (1 Avenue Ephrussi de Rothschild, page 201). This grand garden of exotic plants, glamorous fountains, and beautiful pink roses offers lovely sea views over sparkling coves and is the perfect finale to a day on the Cape. The villa is decorated almost entirely in blush pink, which is more enchanting than you might think. You can also wander down to the beach, **Plage de Passable**, an idyllic cove that offers stunning views of Villefranche across the deep blue waters of the harbour. Look for King Leopold's villa, which dominates the beach's northern end.

Then, as dusk falls in the same shade of Rothschild pink, you can head for the train station at Beaulieu-sur-Mer and travel back to Nice, tired but happy. Or, if you're lucky, wander back to your hotel on Cap Ferrat to enjoy a drink as the sun sets over this truly spectacular part of the French Riviera. Oh yes, the king of Belgium certainly knew what he was doing when he invested here.

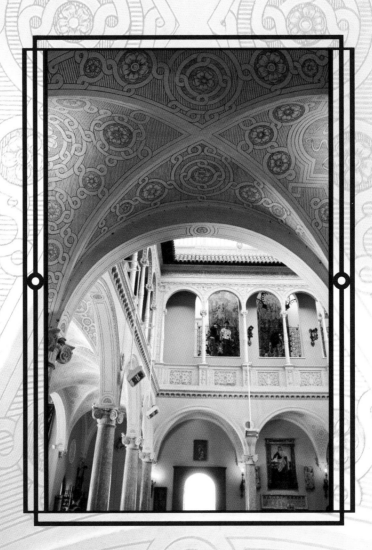

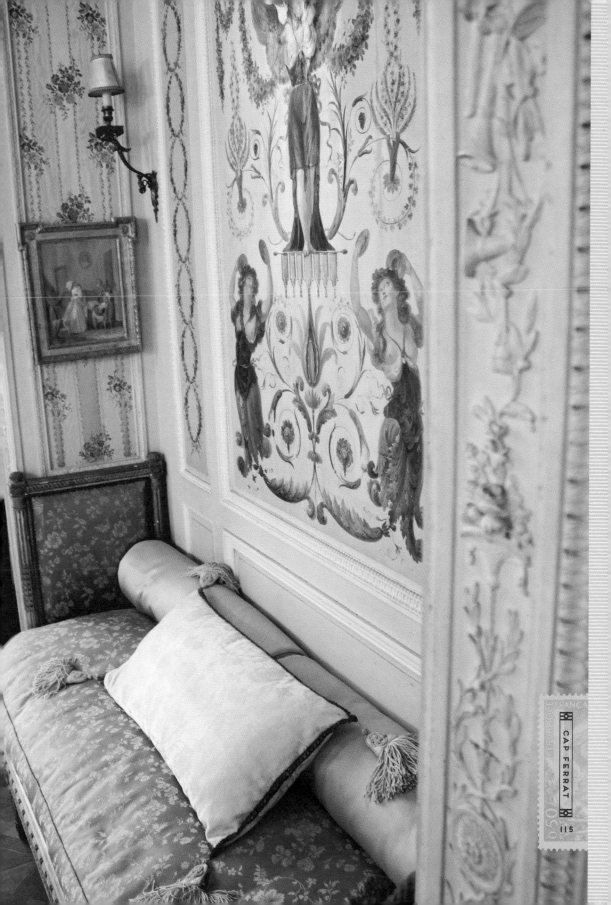

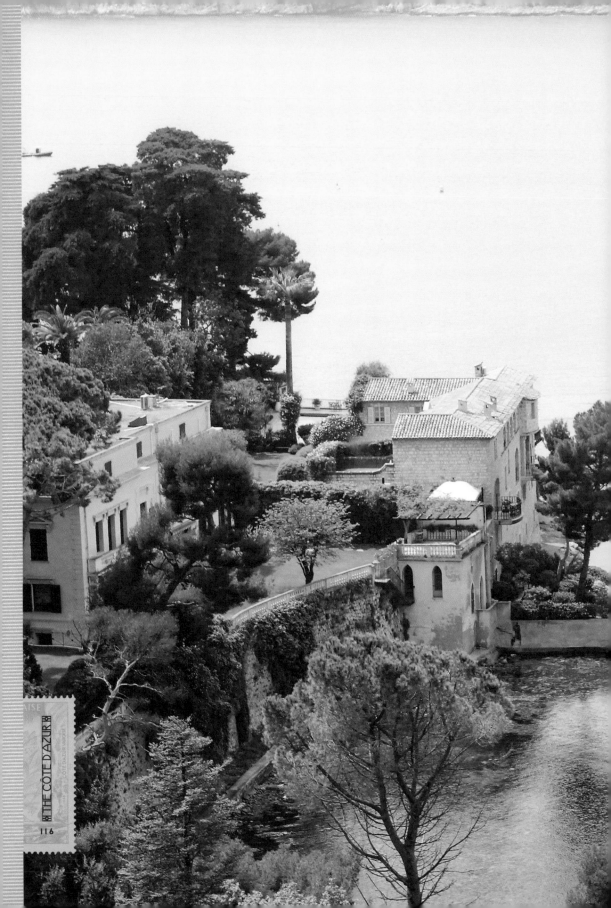

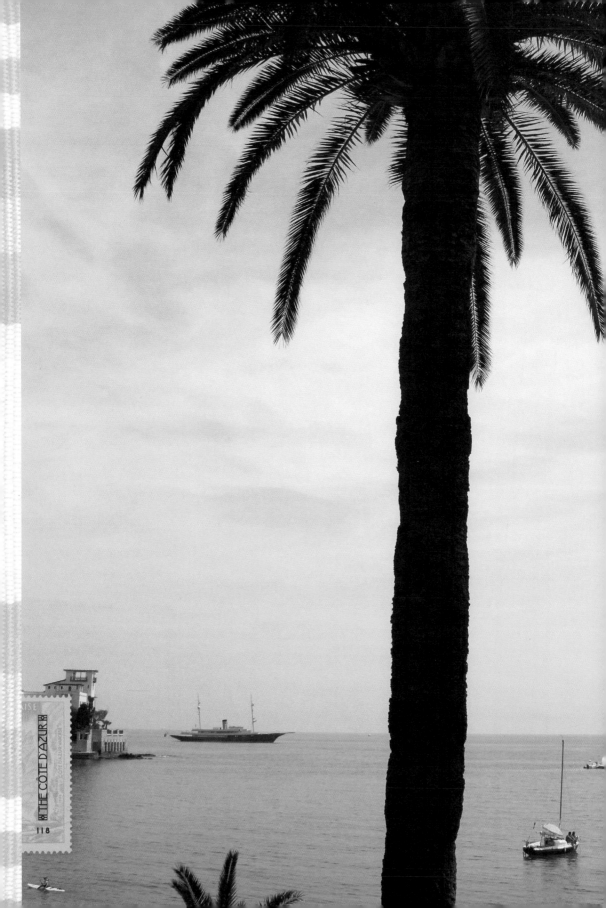

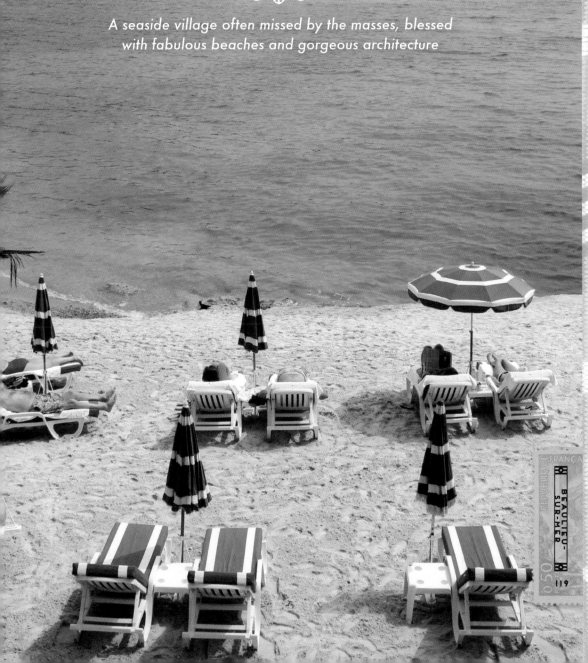

BEAULIEU-SUR-MER

THE SECRET DELIGHT

*A seaside village often missed by the masses, blessed
with fabulous beaches and gorgeous architecture*

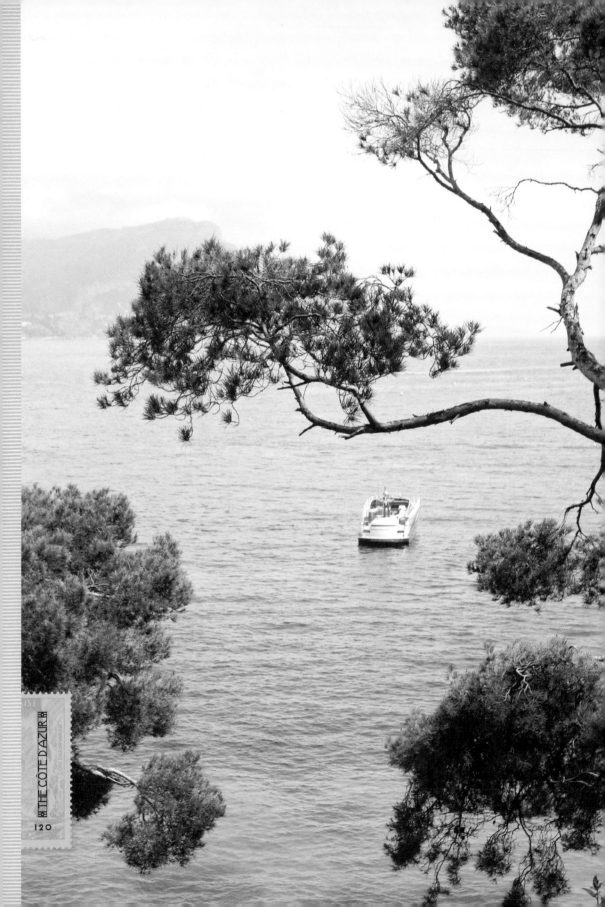

It may seem strange to some to devote an entire section to this tiny part of the French Riviera, but Beaulieu-sur-Mer has a history, a reputation, and a landscape as impressive as any of its swankier cousins down the coast. It's just that few people are aware of its allure.

You see, Beaulieu's quaint charms have for years been eclipsed somewhat by its more dazzling neighbors: Nice, Cap Ferrat, and Monaco, whom the media regard as destinations with more drama. This, however, is a good thing, because it means that Beaulieu remains a little under the radar. The last thing we want is for it to become another Saint-Tropez.

This seaside idyll has had a surprising and curious past. Having passed between Greek and Roman hands, the village was left in ruins in the third century. It was eventually resettled and became the site of a monastery, which then fell to the Lombards in the sixth century, who proceeded to destroy it again. Its residents fled to the safety of surrounding hills at Montolivo, returning to live there in the 13th century. Eventually it was established as a self-standing commune in 1891, but curiously remains the smallest in the Alpes-Maritimes department (230 acres; population 4,000).

It began attracting aristocratic travelers around the same time that Nice was being noticed. By the end of the 19th century the place was being touted as a potential resort. The queen of Portugal, Kaiser Wilhelm II, and Tolstoy all passed through. The village, just as the rest of the Côte d'Azur was doing, rapidly developed into a world destination for the wealthy elite.

The difference between Beaulieu and the rest of the coastline is that the former never became as built-up as some of its neighbors. Today, apart from the huge yacht harbor that takes up most of the seafront, the rest of the village remains very much as it was a century ago. It's such a quiet and seemingly understated place (apart from the luxury villas tucked among the vegetation) that the village's most distinctive landmark, **Villa Kérylos**, stands out like a beacon (Rue Gustave-Eiffel; villa-kerylos.com). Built in the early 1900s by French archaeologist Théodore Reinach and his wife, Fanny Kann (a daughter of Maximilien Kann and Betty Ephrussi), the building is designed in the style of an ancient Greek villa. Perched right on the end of a rocky promontory, it took six years to complete, and no wonder: The interior combines design styles from Rome, Pompeii, and Egypt, even down to the exact replicas of ancient Grecian chairs. It was bequeathed to the Institute of France in 1928 and is now a lovely museum.

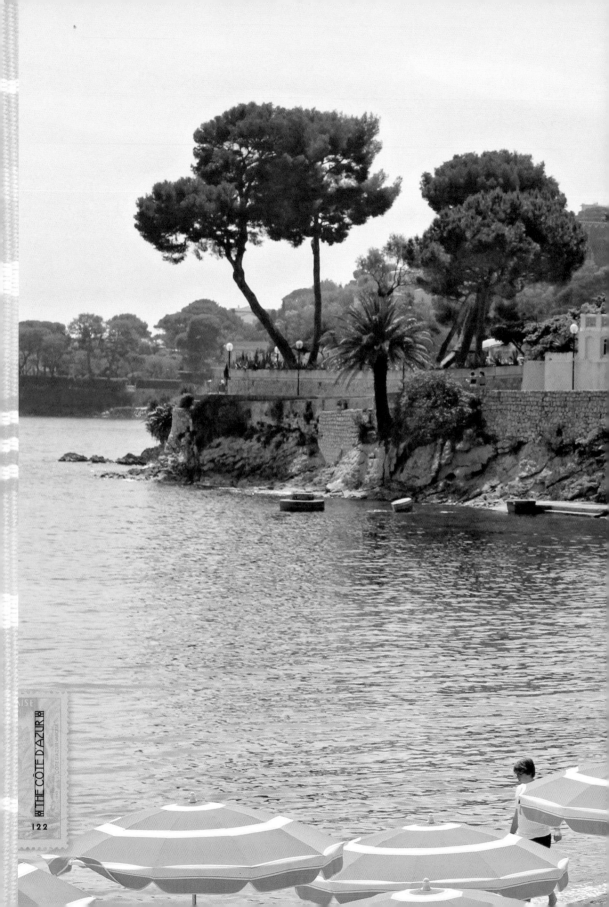

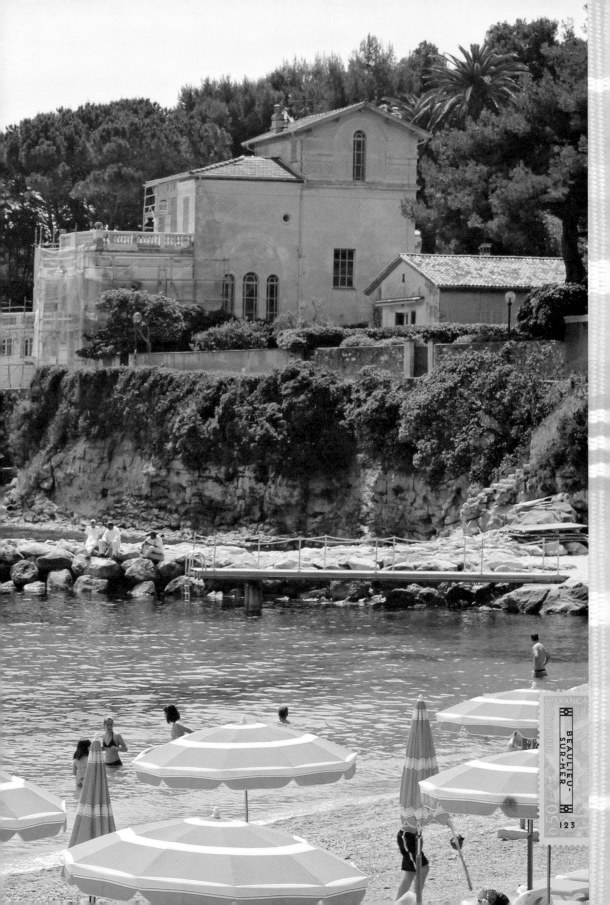

Perhaps the best things to do in Beaulieu are walking and swimming. Beaulieu has some of the prettiest beaches and promenades outside Nice, shaded by low-hanging trees that are cool in summer; and the beaches themselves are sheltered and mostly sandy (unlike many others). Kids love it here. The sea also feels warmer here, perhaps because it's sandy and shallow, rather than wide and deep (as it is at Nice). Walk along the promenade and take one of the many trails that meander through the area, from which you can look back and see the wonderful views of the mountains. Try strolling from Beaulieu to Èze (about a two-hour walk; see the next section, page 127) for a view of all the walled gardens and stately Belle Époque villas peeking out from behind the pine trees. It's possible to see Bono's villa at Èze-sur-Mer; a terra-cotta mansion with blue shutters right on the beach.

If you go for a swim or head out on a boat, keep an eye out for a spectacular property set on a cliff with a sheer drop to the beach. This is the celebrated **Villa Leonina,** the former home of Etti and Dr. Árpád Plesch (1889–1974), a Hungarian lawyer, international financier, and collector of rare botanical books and pornographic esoterica. Etti met Árpád (her sixth and last husband) through her friend Gloria Guinness, and settled down with him in their homes on the Avenue Foch in Paris and here in Beaulieu. It was at Villa Leonina that Dr. Plesch indulged in his love for flora, and his botanical garden soon became world renowned. Less known is his obsession with erotica.

Beaulieu's residents can be a little whimsical if not quirky. There's **Villa Namouna,** which once belonged to Gordon Bennett, the owner of the *New York Herald*, who sent Stanley to Africa to find Livingstone. There's also the restaurant **The African Queen** (Port de Plaisance; africanqueen.fr), which offers a jungle-inspired decor (it's actually based on the famous film) and some of the best water views on the coast. The check is presented in a videocassette case with the movie poster cover—very Hollywood. And if that's not enough Africa for you, there is a residential area called Little Africa, which is actually where Etti Plesch's Villa Leonina is set, while the longer of the town's two free public beaches is called, ironically, Petite Afrique. If you want to rent a sun lounger, try Africa Plage, which also sells snacks and drinks.

In fact, some people have actually dubbed Beaulieu "La Petite Afrique" (Little Africa), as much because of its mild climate as its African-inspired gardens. Like Menton farther along the coast, Beaulieu is graced with lush vegetation, including palm trees, orange and lemon trees, and banana palms. It is indeed a curious oasis on the Côte d'Azur.

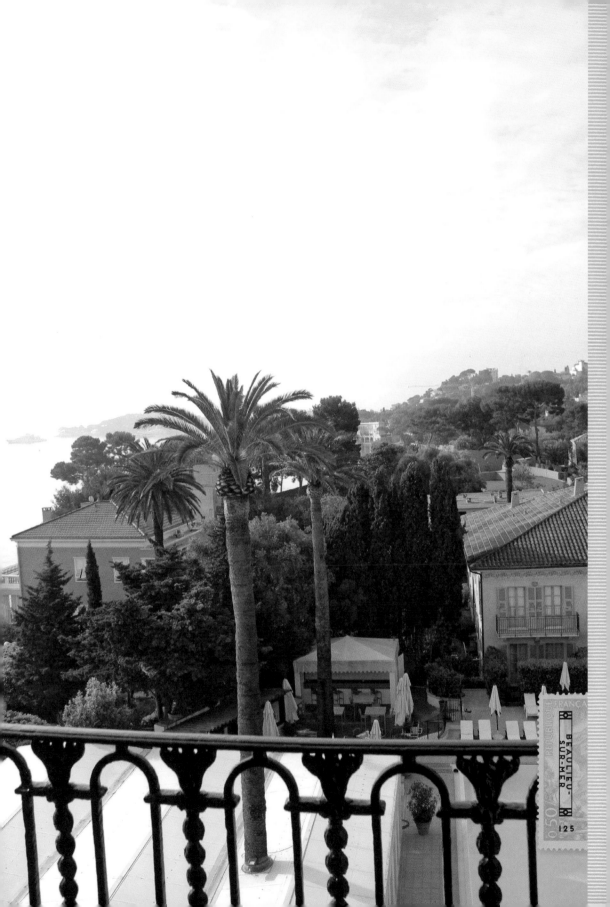

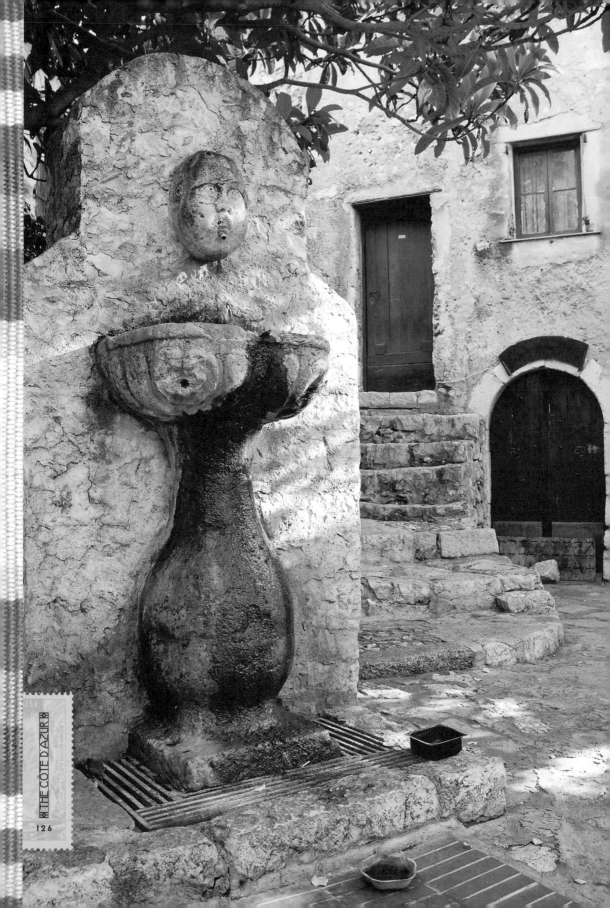

ÈZE

THE ESCAPIST

⚓

Located high above the Riviera, with views to swoon over, gardens to enthall the senses, and lovely, labyrinthine streets to enchant the cynics

One of the most incredible places on the Riviera, Èze village is perched 1,400 feet/500 meters above the sea, and appears as if it could drop into it at any time. Yet it's been there, on the mountain, since the Middle Ages and—here's the lovely part—its location has in fact saved it. The village was fortified on top of this rugged mountaintop to protect its inhabitants from constant enemy raids. By securing the village behind dense walls and clustering the houses along narrow streets, the villagers were able to defend their settlement more easily. Today, the views are what make the village so extraordinary, although the pretty stone homes and the cobbled lanes, which have been preserved so well through the centuries and recently restored, are equally beautiful. Èze is a delight for the senses, quite literally on every level.

There's a bit of irony about the name Èze. It's really not that easy to get to, you see. As a matter of fact, going to this ancient village is like ascending Jack's beanstalk to a place in the clouds. The best way to reach Èze is not by car—although if you do drive, make sure you take the Grande Corniche, as it's the quietest to drive and the most glorious to look down from. (Note: The village is for pedestrians only so you need to leave all cars in the parking lot at the base of the village.) Nor is it easy to reach by bus, although the service from Nice operated by Ligne d'Azur (route number 82) is comfortable, albeit irregular. No, the best way to reach Èze is to walk on **Le Chemin de Nietzsche**—as in the philosopher Nietzsche, who knew a thing or two about the power of landscapes on the body, mind, and soul.

First, you take the train to Èze-Bord-de-Mer (sometimes shortened to Èze-sur-Mer), which is Èze's sister village on the beach (don't confuse the two). The train from Nice's Gare SNCF station to Èze-sur-Mer takes 14 minutes (3 Euros one-way). Once at Èze-Bord-de-Mer, walk across the main road and follow the signs to the Chemin de Nietzsche. The walk will take one to two hours (uphill). Wear good shoes (no flip-flops) and bring lots of water (don't do the walk on a hot day); the views will astound. This was the path beloved by Mr. Nietzsche. Some people call it "the thinking man's hike." (The plaque at the summit reads: "Though the ground keeps me rooted, my mind is in the heavens.") Nietzsche was so inspired by this area that he wrote the third part of *Thus Spake Zarathustra* here, composing much of it while hiking this trail. "I slept well," he said, while staying in Èze, "I laughed a lot and I found a marvelous vigor and patience." The Nietzsche path is a wonderful way to find some inspiration and mental strength of your own.

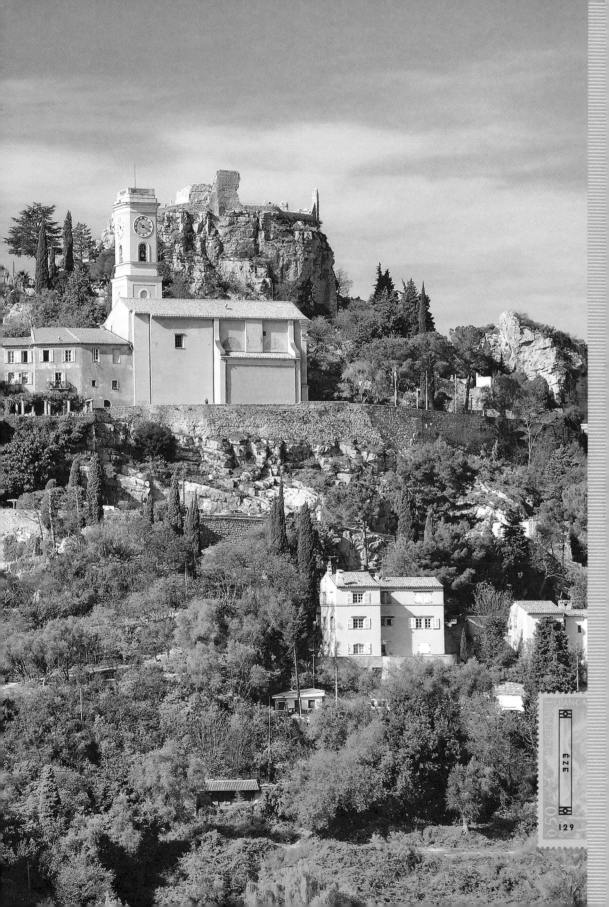

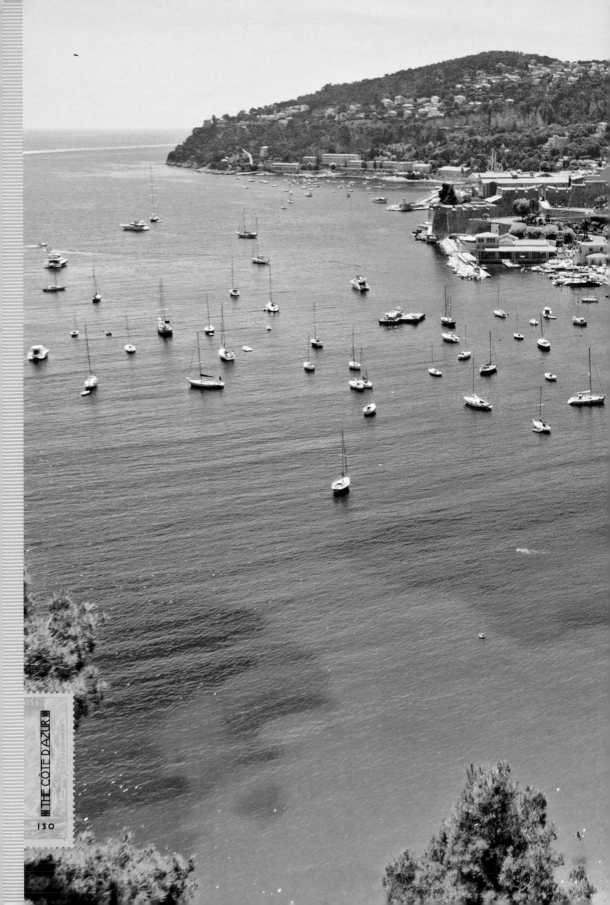

If you are unable to hike uphill, take the bus up to Èze village and walk back down to the beach to connect with the bus to Nice; the view will be in front of you all the way.

Once you've reached the top of the village, there are some fine things to see, including a panorama of the French Riviera, which on a clear day stretches in a magnificent arc over Cap Ferrat and on to Nice and Cap d'Antibes. You can also explore the village's ancient cobbled lanes, which are less touristy than Saint-Paul-de-Vence. (If you go early enough in the morning you may even have it all to yourself.) The town is a tasteful and scenic treat, with stylish shops, art galleries, restaurants, and hotels. It's not a residential place as such, so some may find it slightly commercial, but it's still a charming place to wander around. Find an ice cream, have some lunch, and shop in the myriad stores that line each alley. If you want to dine somewhere special, make for **Château Eza** at the top of Rue de la Pise. The hotel is beautiful but it's the Michelin-starred restaurant that receives all the fuss. Some claim it's not as good as it once was; others say it's still superb. The food is great but expensive—you're really paying for the memorable views. Or go to **Le Nid d'Aigle** (The Eagle's Nest, 1 Rue du Château): It also has a great view out over the Riviera.

Just below the town is a Fragonard perfume outlet, which scent lovers may like. But one of the best destinations is the well sign-posted **Jardin Botanique d'Èze** (Place du Général de Gaulle). The garden was created after World War II on the ruins of a château and is set on a steep slope with spectacular views of the coast. The plantings of cactus and succulents are wonderful but the panoramic views over the coast are unparalleled. Consider skipping Château Eza, buying a baguette, and having a picnic here instead.

MENTON

THE GARDEN LOVER

⚓

A picture of civilized gentility and understated grace; a place devoid of nightlife and noisy partygoers but blessed with blooming gardens, half a dozen gorgeous beaches, and a beautiful sweep of an Old Town.

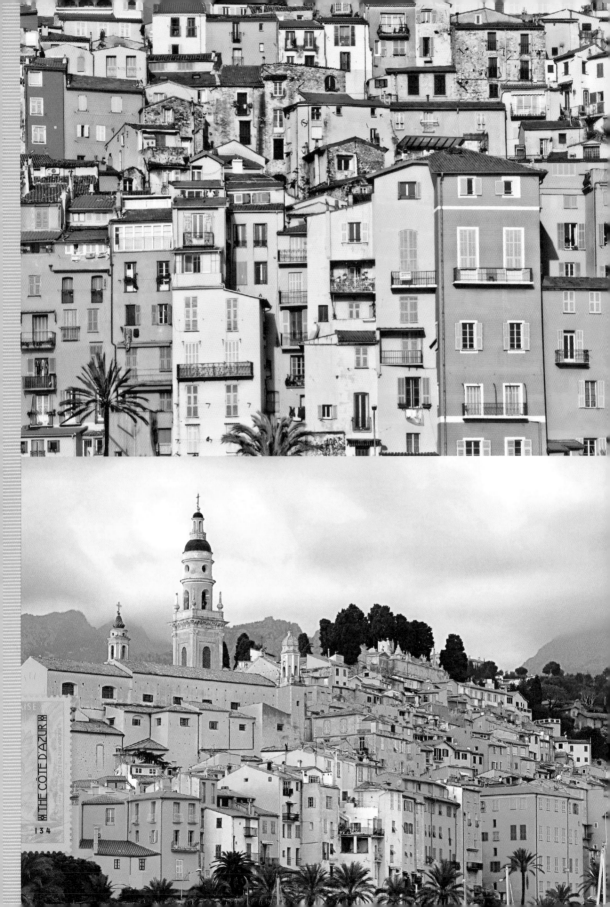

Menton is often missed by the tourist hordes, situated as it is at the far end of the Riviera near the Italian border. Some visitors to the South of France don't even realize it's there. They go as far as Monte Carlo on their daily expeditions and think they've seen it all. This is a shame, as Menton is glorious. Garden lovers will particularly adore it. It's a little piece of horticultural heaven.

Menton is known by several names: *perle de la France* ("pearl of France"), "the garden of France," "the lemon festival capital of the world"(!), and even Mentone (its Italian name). The town has actually changed hands several times between France and Italy, and the different names reflect the fondness people feel for it.

Much of modern Menton was, in fact, invented by the English. Queen Victoria loved it here, as did her son Bertie (later to become Edward VII). There is still a statue of Queen Victoria in the town. (She used to stay in a grand villa tucked among the hills.) They loved it because of its climate, which was so good that in the 1870s Dr. James Bennet opened a clinic for consumption sufferers and became very rich. (Sadly, the climate did not heal tuberculosis, and survival rates were the same as anywhere else—more than 50 percent of sufferers would die within five years. The antibiotic cure would not be found until 1944.)

News of Menton's mild seasons spread, and soon the British, Germans, Swedes, Russians, and others flocked here and the entrepreneurs started building grand Belle Époque buildings to cater to them. Menton had become a home away from home for the British aristocracy and bourgeoisie. Katherine Mansfield, in search of a solution for her ailments, spent months in Menton before moving on and dying elsewhere. The Duke of Westminster bought a villa for his mistress Coco Chanel near here. Many of the hotels still have Anglicized names.

To understand the appeal of Menton, you need to understand the geography as much as the climate. Picture the Golfe de la Paix (Gulf of Peace) with the Alpes-Maritimes behind it—a location that allows people to ski in the mountains in the morning and swim in the Mediterranean in the evening. In between there is nothing but clean air, bright light, picture-perfect palm trees, lovely Italian architecture, and delicious French cuisine. The Old Town, the former fishing village with its narrow streets, is in the east; the tourist zone and residential neighborhood are to the west.

To begin a tour of Menton, start at **Place des Victoires**, with the grand Edwardian Winter Palace behind you. Head south down Avenue Édouard VII and continue until you reach the beach and the Promenade du Soleil, then turn left along the esplanade. Head toward Avenue Félix Faure and turn left onto this street, then go right at the traffic circle and you'll hit Rue Barel on the left. Turn right into Rue de la République and continue past the **Town Hall**. You are now in the heart of the Old Town. This is where Menton's history really reveals itself in the glamorous architecture and gracious spirit.

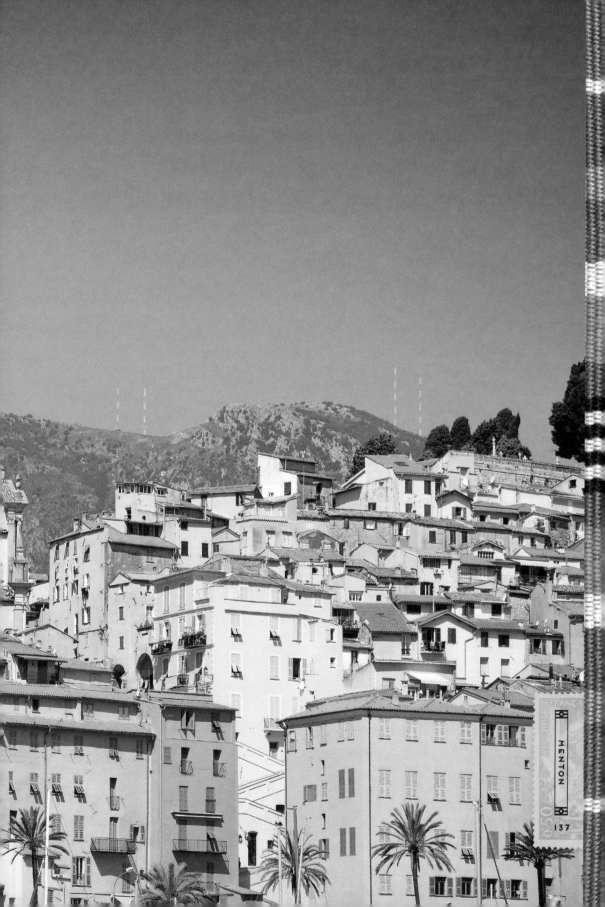

But Menton isn't just about grand buildings and impressive villas. The gardens here are among the most famous in France, thanks to the ideal microclimate and wealthy expats. This is where American Lawrence Johnston (who created the renowned Hidcote in England) established the **Serre de la Madone,** which has recently been restored. It's where Sir Percy Radcliffe created Val Rahmeh (named after his wife), a seriously impressive spot of horticulture that is now the **Jardin Botanique Exotique du Val Rahmeh.** And it's where the artist Ferdinand Bac conceived **Les Colombières,** a series of whimsical but pretty gardens along a picturesque promontory. There's also **Jardin Fontana Rosa,** which belonged to the Spanish writer Vicente Blasco Ibáñez and paid homage to his favorite writers: Cervantes, Dickens, and Shakespeare.

A visit to any of these gardens will delight, or you can simply walk along the elegant **Boulevard de Garavan,** which overlooks many splendid pink, cream, lemon, and ocher villas, with their olive and lemon groves and their terrace walls overflowing with jasmine. The boulevard has recently been redone in mosaics by Portuguese artisans, and offers superb views of the sea and villas. If you can ignore the apartment buildings (many grand old homes sadly were razed to make way for them) and focus on the views and surviving villas, you'll understand what the Riviera looked like before developers moved in.

To the west of Menton is **Roquebrune-Cap-Martin,** which is also worth a stroll, and not just for the sea views and the glimpses of villas.

My favorite place in Menton is the **Musée Jean Cocteau** (Bastion du Port, Quai de Monleon; jeancocteau.net), which celebrates the life and work of the film-maker, poet, and artist. It's full of wonderful charcoals and watercolors and brightly colored pastels and ceramics. If you don't want to pay an entry free, Cocteau's paintings can also be seen in the Town Hall's wedding room.

Menton is a picture of civilized gentility and understated grace—a place devoid of nightlife and noisy partygoers but blessed with blooming gardens, half a dozen gorgeous beaches, and a beautiful sweep of an Old Town topped by the Baroque Basilique Saint-Michel. It's not for everyone; but for many, Menton is where their Riviera dreams come to fruition (if you'll forgive the horticultural pun).

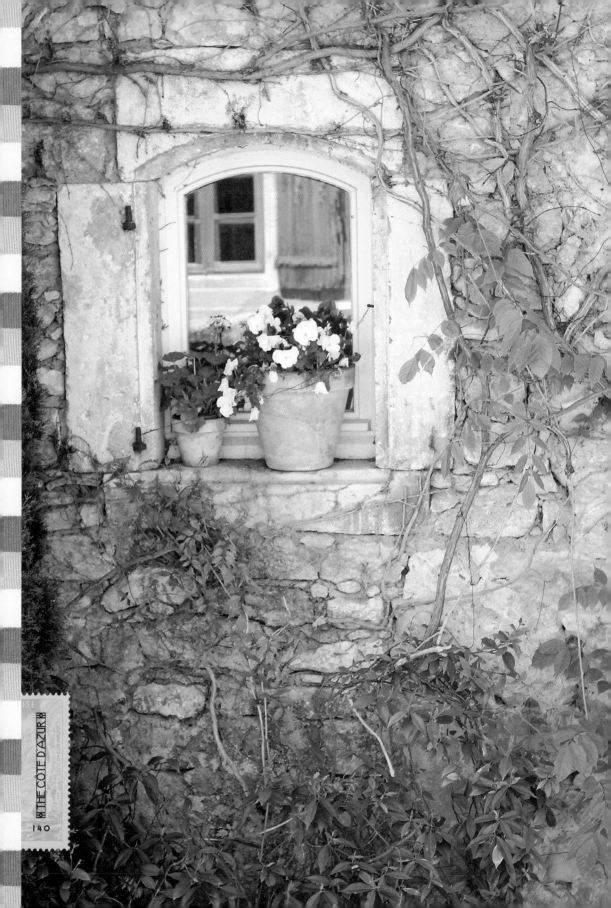

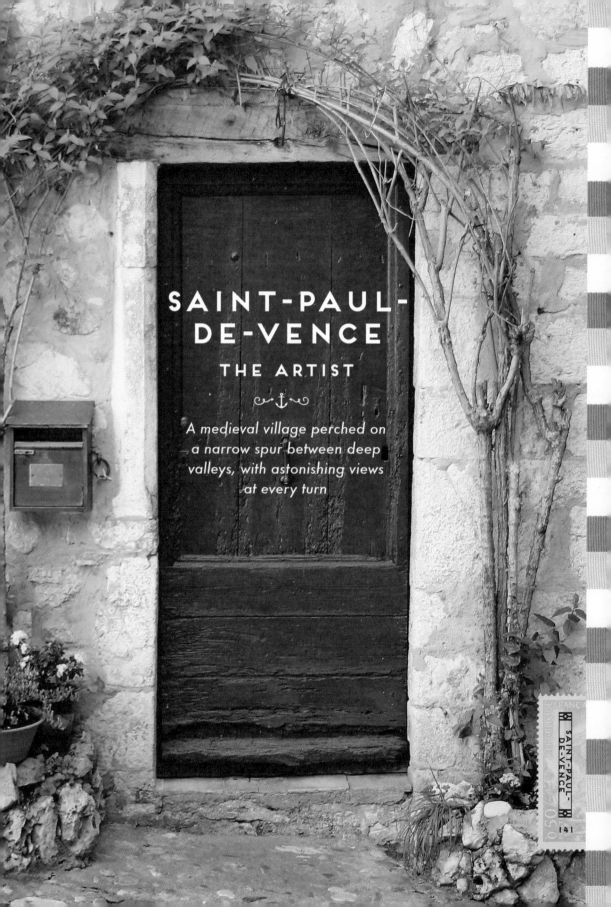

SAINT-PAUL-DE-VENCE

THE ARTIST

A medieval village perched on a narrow spur between deep valleys, with astonishing views at every turn

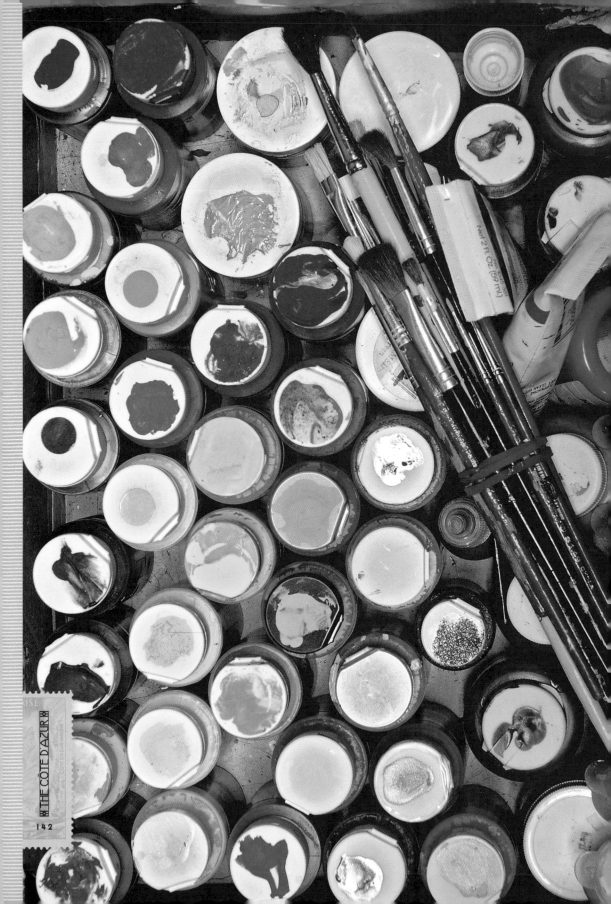

There's no way to avoid saying this: Saint-Paul-de-Vence is over-flowing with tourists. The problem is, unlike Nice or Cannes, this tiny town perched above the Côte d'Azur isn't really designed for them, so everyone just sort of squeezes in and then squeezes out again.

Despite this, the place is very charming—it's the archetypal idyllic medieval hilltop village. If you like art you'll love it here. Saint-Paul, you see, is a celebration of the brush stroke.

There are scores of art galleries and artisanal stores selling original, authentic, and sometimes not-so-authentic artwork. There is a world-famous restaurant and hotel, **La Colombe d'Or** (page 189), which displays priceless artwork from the likes of Picasso, Dufy, and Modigliani, often given as gifts by the once-penniless artists in return for a meal. And there are many artists still living and working here, so you're liable to see that classic French scene of a bereted bohemian squinting before his canvas as he calculates the perspective on a landscape of dappled light.

Art seems to be the dominant commercial activity here, and when you wander around you'll soon understand why. The light is clear, and even when it's beautifully diffused in the mornings and evenings there's still a delightful quality to it. And the views are astonishing: The village's location on a narrow spur between two deep valleys guarantees that there will always be a vista to sketch. The town itself is endearing, with its old stone houses and honey-colored stone walls—so cool on a hot Provençal afternoon. And the streets (when clear) are lovely to linger in, watching the locals play *pétanque* (boules) under the shade of the plane trees.

Saint-Paul has a timeless beauty: It could be 2013, or it could be 1913. Remove the tour buses, and the place is as it was a century ago. No wonder artists such as Renoir, Chagall, Modigliani, and Matisse were seduced by the classic beauty. It's just a pity that Saint-Paul has become a victim of its own artistic success. Never mind; there are still corners you can explore without fear of being elbowed out of the way by a day pack or a digital SLR.

Not surprisingly, some of the nicest things to do here involve embracing the artistic spirit. Make a reservation for a truly memorable lunch at **La Colombe d'Or** (1 Place du Général de Gaulle) and take in the incredible artwork lining the walls while you sip your wine. (Tip: The terrace is the best place to sit, as the views are amazing. But you'll miss out on the paintings.)

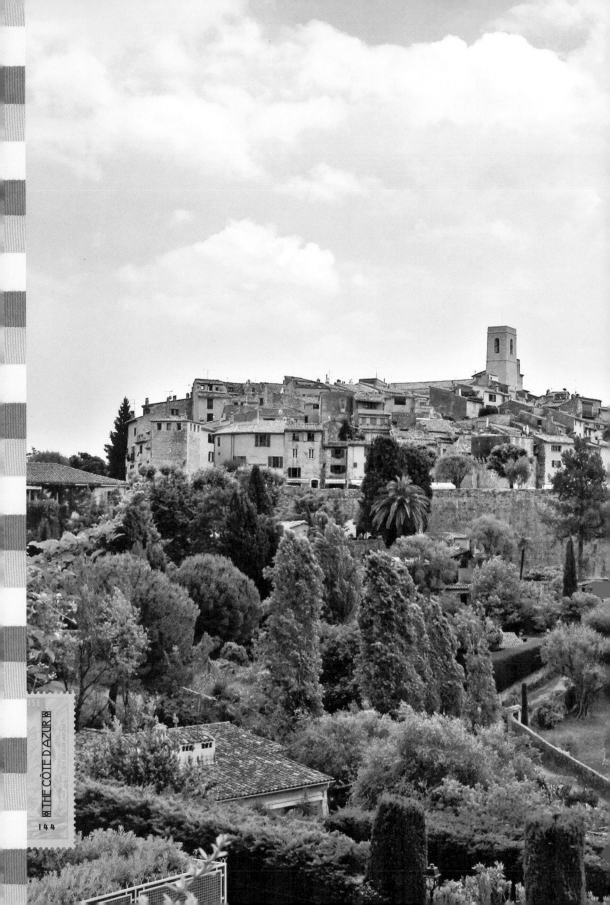

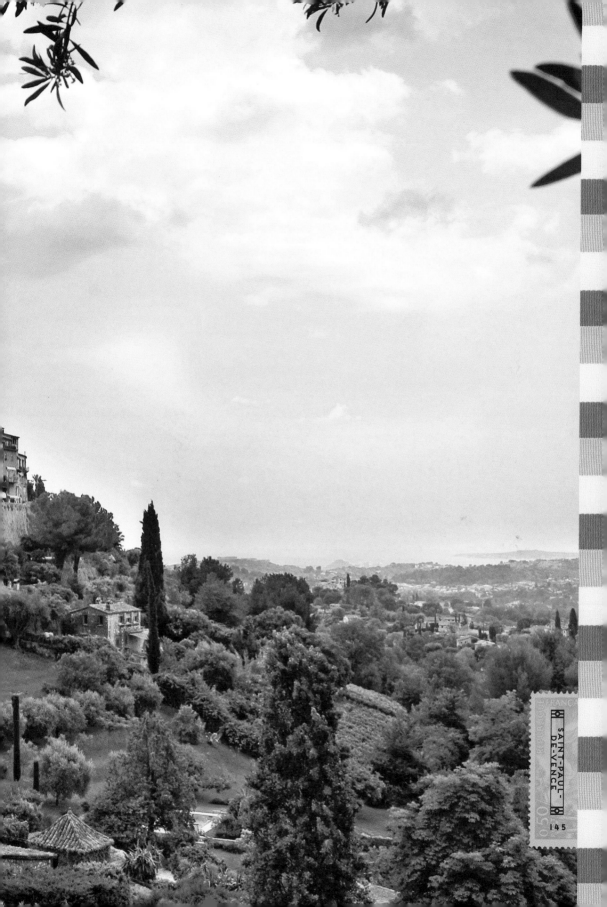

SAINT-PAUL-
DE-VENCE

FRANCE

0,50

145

Or you can visit the grave of Russian-born painter Marc Chagall in the town's pretty cemetery (Chemin de Saint-Paul), and add a small white stone as a tribute to his work. Or you can drop into some of the artists' workshops and talk aesthetics. Or you can pay a visit to the world-renowned **Fondation Maeght** (623 Chemin des Gardettes, page 205), and be rewarded with an extraordinary collection of 20th-century paintings, sculptures, and ceramics, along with a museum setting that combines water, trees, shade, nature, and utter tranquillity.

If you love the lively spirit of Saint-Paul, consider visiting on Saturday, which is market day. The weekly fair creates a boisterous, festival atmosphere throughout the village, filled with color, stalls, and irresistible produce.

The thing is, the tourists here may make your viewing opportunities difficult, so if you find the crowds too much, get back in the car and go farther up the road to **Vence**, Saint-Paul's quieter neighbor. It's just as beautiful but has fewer people, better shops (in my opinion), more interesting art galleries, and gorgeous cafés with terraces that are less cramped. There are also delicious pâtisseries, where you can buy a baguette or freshly made pastry and then find a quiet spot for a picnic.

Another village worth seeing is **Tourrettes-sur-Loup**, which is just under two miles (about three kilometers) west of Vence, and also has lots of great art stores run by artists.

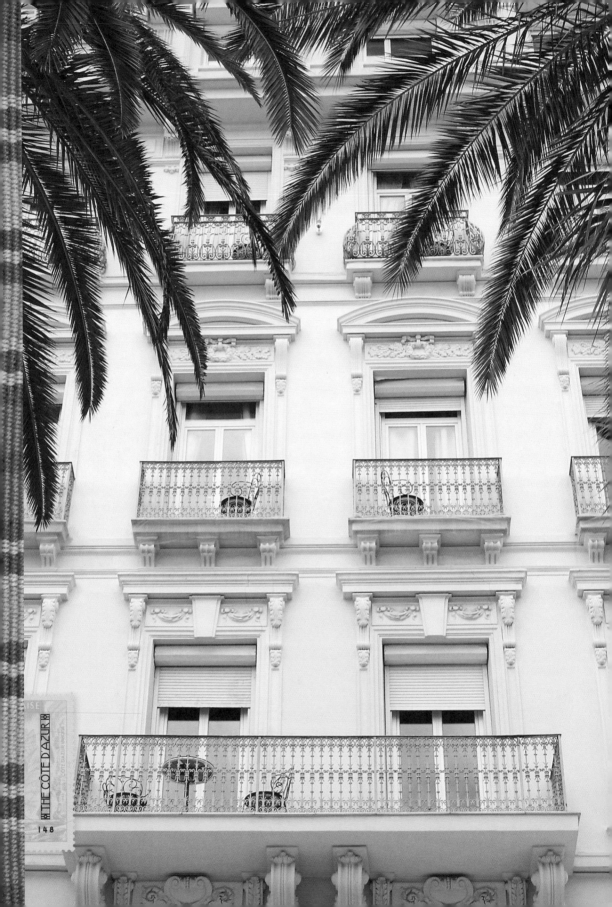

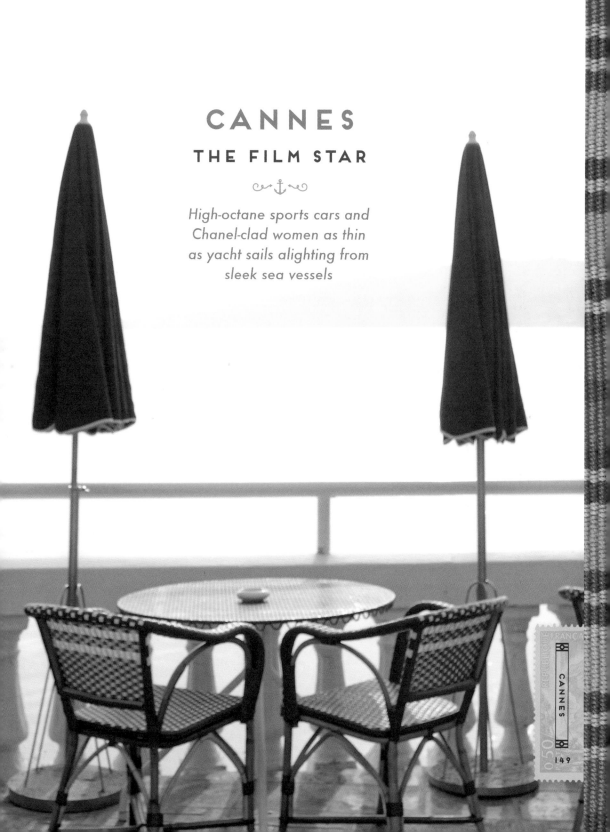

CANNES

THE FILM STAR

High-octane sports cars and Chanel-clad women as thin as yacht sails alighting from sleek sea vessels

Cannes has virtually become a star in its own right, thanks to the Cannes International Film Festival (festival-cannes.fr) held here in May each year. The festival was established in 1939 to rival Mussolini's Venice Film Festival but has long since eclipsed it to become one of the world's best. Every year it attracts a significant number of Hollywood's glamorous set, who come as much for the worldwide publicity as for the chance to get some downtime in the South of France.

But Cannes is far more than just a backdrop for a few film screenings or a place for celebs to crash afterward. It's a lively seaside resort town with a dazzling port, an elegant seafront boulevard, and some astonishing shopping. Take away the film festival and it is still a head-turning town.

From the point of view of exploring, the best thing about Cannes is its compactness—the town is more manageable than a 10-minute art-house flick. So let's begin our tour at the dramatic **La Croisette**, the city's picture-perfect promenade. This gleaming beachfront scene features a glorious bay, soft sandy beaches, high-octane sports cars purring down the road, and Chanel-clad women as thin as yacht sails alighting from sleek sea vessels.

As you walk along the western part of La Croisette, look out for the celebrity handprints and signatures in the pavement. It's cheesy to compare your own hands against them, but everyone still does. There are also wall frescoes of movie stars dotted all around Cannes. The best one is on the western side of the port and covers the whole side of a building.

Like Nice, Cannes is embroidered with the palm trees and Belle Époque architecture that gives it the essential "Riviera look." The town's landmark hotels are especially grandiose and proud of it. Peek inside the Intercontinental Carlton Cannes and the **Hôtel Martinez** (page 187), both favorites of Hollywood types, and you'll see why some stars need to wear sunglasses: The furniture is almost as shiny as the bling that adorns many of the fingers around here.

While you're here, make sure you explore the **Vieux Port** (Old Port). There's always a lot to look at here and not just the shiny white yachts and enormous motor cruisers juxtaposed against the humble fishing boats. Indeed, those who come and go from the yachts' gangplanks are often just as intriguing as the boats themselves, especially during festival week when, as many insiders suggest, the dozen or so young women on each craft are often C-grade actresses in various stages of dress (or undress).

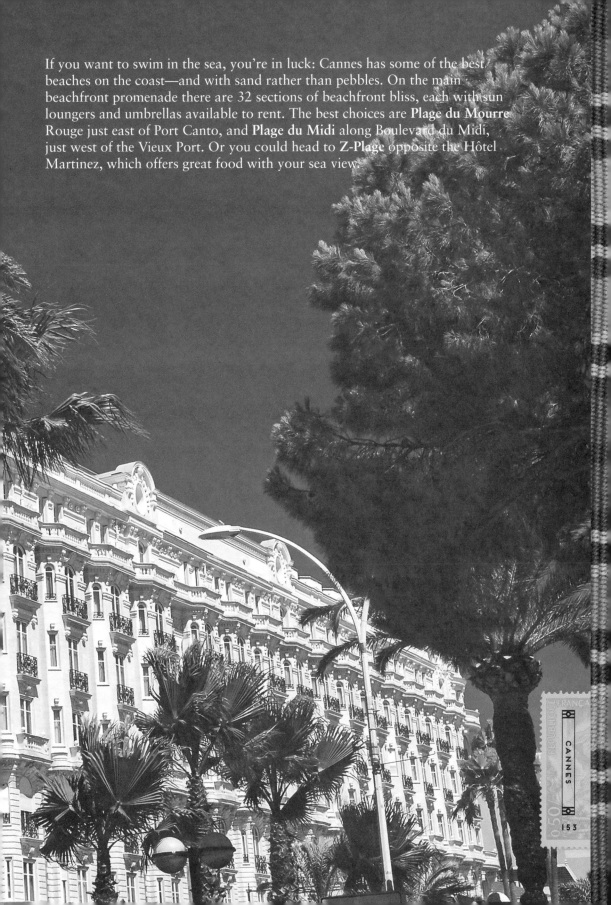

If you want to swim in the sea, you're in luck: Cannes has some of the best beaches on the coast—and with sand rather than pebbles. On the main beachfront promenade there are 32 sections of beachfront bliss, each with sun loungers and umbrellas available to rent. The best choices are **Plage du Mourre Rouge** just east of Port Canto, and **Plage du Midi** along Boulevard du Midi, just west of the Vieux Port. Or you could head to **Z-Plage** opposite the Hôtel Martinez, which offers great food with your sea view.

Running parallel to Boulevard de la Croissette is **Rue d'Antibes**. This long, narrow thoroughfare and several streets adjacent to it constitute the main shopping area in Cannes and in the height of summer crowds fill every corner. The shops are on the pricy, designer side, but window shopping and people-watching are just as enjoyable. A stroll here is what the French call *"un must."* The town's movie theaters are also situated along the Rue d'Antibes.

The pedestrian **Rue Meynadier**, near the Rue d'Antibes, is also a stylish strip of stores and fashion boutiques. Roughly six blocks long, this street has markets and shops offering produce, clothes, and gifts.

If food markets are more your thing, the covered **Marché Forville** (12 Rue Louis Blanc) offers a lively, colorful, and sometimes noisy market experience. Treat yourself to some fresh produce—perhaps some fruit, oysters, pâté, and olives. On Mondays, Forville becomes a flea market (*marché brocante*).

If you fancy some respite from all the glamour and glitz, there is a lovely grassy park at the western end of La Croisette, between the Palais des Festivals and the beach, which features a wonderful carousel—ideal entertainment for children. There's also a park and carousel (the French love their merry-go-rounds) at the eastern end of La Croisette, just before the new Port Canto yacht harbor. And don't miss the beautiful **Jardin Alexandre III**, a lovely large park full of flowers in the spring and summer.

Once you've seen the razzle-dazzle face of Cannes, take a walk to its quieter side by wandering the winding 400-year-old streets of the old quarter. **Le Suquet** (the name means "summit" in Provençal) is beloved by locals and is distinguished by the steep, zigzagging cobbled lanes lined with atmospheric restaurants, and topped with a magnificent clock tower and church that faces the Bay of Cannes. This neighborhood was originally the home of fishermen and consequently the dwellings—many with quirky tangerine and faded lime façades—are distinctly old, but the area has been beautifully preserved. Much of the old quarter is for pedestrians only, so it's easy to find a great little restaurant, then sit back and enjoy a glass of red as the sun sets.

And if you want to dance, head for **Charly's Bar** (5 Rue Suquet; pubcharlysbar .com), where everyone from tanned beauties to hip young things dances like there's no tomorrow. Then, if you want to stretch the night (or day) out, there's **B. Pub** (22 Rue Macé), a flashy, Neoclassical-style bar featuring gilt columns and sparkler-adorned Champagne ice buckets.

Afterward, take the posse to **Le Bâoli** nightclub, where six bottles of Dom Pérignon can go for 25,000 Euros, but whose clientele (including the likes of Jude Law, Beyoncé, Snoop Dogg, and Prince Albert of Monaco) isn't the type to care. This is Cannes, after all.

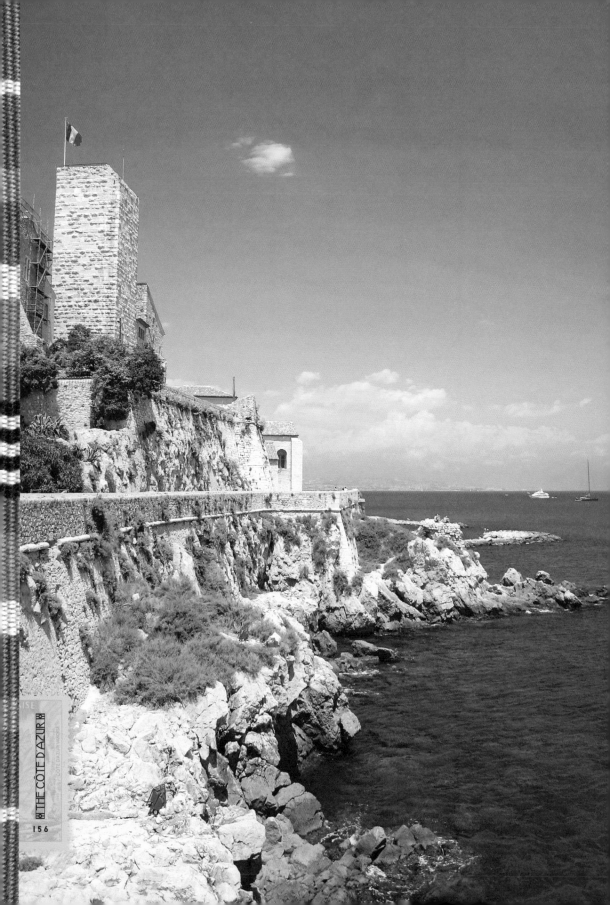

ANTIBES AND CAP D'ANTIBES

THE LIT WIT

*Magnificent villas and a movie-star lifestyle
on one side; an ancient walled city with a
traditional way of life on the other*

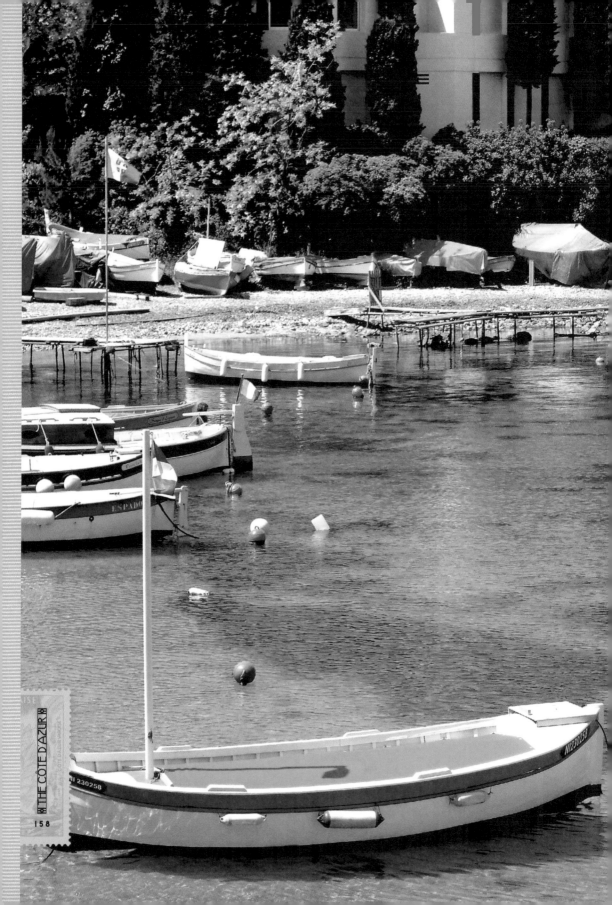

THE CÔTE D'AZUR

Before I visited Antibes, a friend told me it was an endearing place, "a place that never fails to give you fond memories of the time you spend there." I wondered how it could be any prettier or more memorable than the rest of the Riviera. Well, I hadn't counted on Antibes' gentle pace and easygoing nature; her architectural marvels and magnificent villas; her secret coves (especially those tucked away at Cap d'Antibes); her slinky ports (of which there are many); her fabulous festivals (antiques, jazz, teak boats); and her quiet Old Town, with its long protective port wall and exquisitely small streets.

Antibes will charm you, especially if you've just come from the manic pace of Nice and Cannes. It's the flip side of the Riviera: a promontory that seems to eschew the madness of the rest of the coast and go by its own moderate beat.

Some people call this part of the Riviera Antibes–Juan-les-Pins. That's because Antibes and its neighbor Juan-les-Pins are so close as to be almost indistinguishable. Old Antibes and the port of Antibes are on the mainland, on the east side facing the Baie des Anges, while Juan-les-Pins is on the west side. There's also Cap d'Antibes, which is the promontory between both. Juan-les-Pins is the livelier part, with its rocking nightlife, bikini-peppered beaches, and animated casino. Antibes is considered the quieter side, with its subdued ports and Old Town. And Cap d'Antibes is mostly residential—but, what residences they are! The entire area can be walked in a day or two—and walking is the best way to take it all in, as many of the best parts are tucked into side streets, at the end of narrow lanes, or set around coves where it's almost impossible to park when you want to take a photo. I'll focus on Antibes and Cap d'Antibes in this chapter, and Juan in the next.

A writer friend of mine calls Antibes one of the world's literary meccas (a position it shares with Manhattan, the Left Bank of Paris, and a sprinkling of other notable places). Antibes has always been loved by writers and literary types, yet no one seems to quite know why. Perhaps the slow pace helps the words flow? Perhaps the landscapes and endless blue skies offer inspiration for those with writer's block? Perhaps the locals are suitably eccentric fodder for novels? Or perhaps the wine is simply better here? Whatever the reason, Antibes has been, at various times, the home of Graham Greene, Guy de Maupassant, Victor Hugo, Dorothy Parker, Nikos Kazantzakis (author of *Zorba the Greek*), Jules Verne, and Gerald and Sara Murphy—patrons of people like Hemingway and F. Scott Fitzgerald, who were also fans of this part of the Riviera.

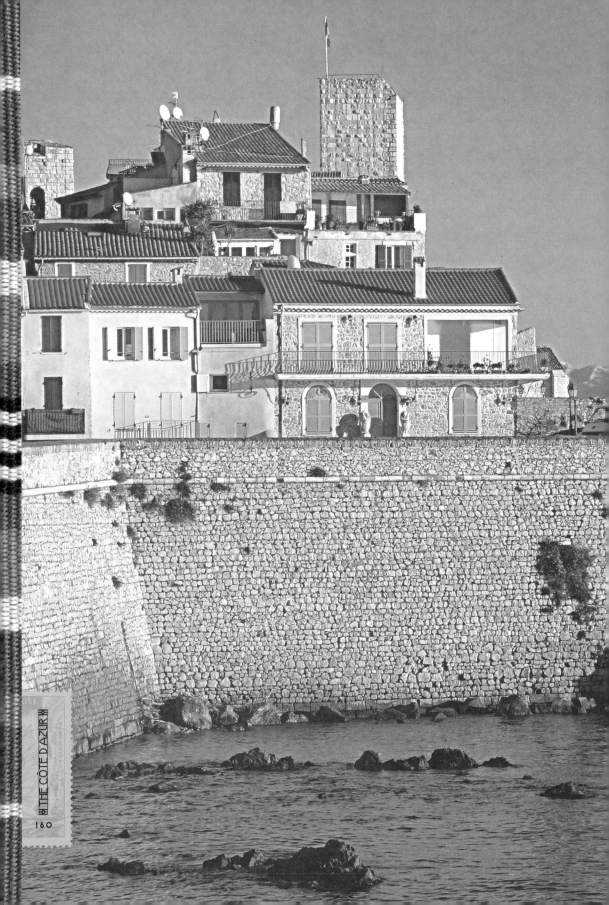

You can't walk far without stumbling over a bay, villa, hotel, street, or bar that's been featured in a book or article. Artists, too, have loved painting this region, most notably Picasso, who has a museum devoted to him here.

To begin exploring this place, so full of character and inspiration, start at the main harbor, which is divided into the old port and the newer harbor. Actually, this area has myriad ports—you'll see them scattered all around the cape—but the newest, Port Vauban, with more than 2,000 moorings, is the largest yachting harbor in Europe. It was designed to accommodate craft of more than 300 feet/ 100 meters (hence the nickname "Millionaire's Quay"). If you prefer a more traditional scene, go to **Port de l'Olivette**, a sheltered cove for sailors who enjoy the old Provençal spirit and moor their wooden fishing boats as in times past.

From Antibes' main harbor, it's a short walk south to the **Vieille Ville (Old Town)**. This is where the Antibes atmosphere really begins. And you'll see it in the locals, who are strikingly individual, even eccentric. The mix of narrow streets, old buildings, and interesting shops makes for a wonderful place to explore, especially on a sunny day when you can stop in one of the cafés for lunch and listen to the jazz that is often played. Try for a table at the **Place Nationale** or along the **Avenue Georges Clemenceau** for the best scenes.

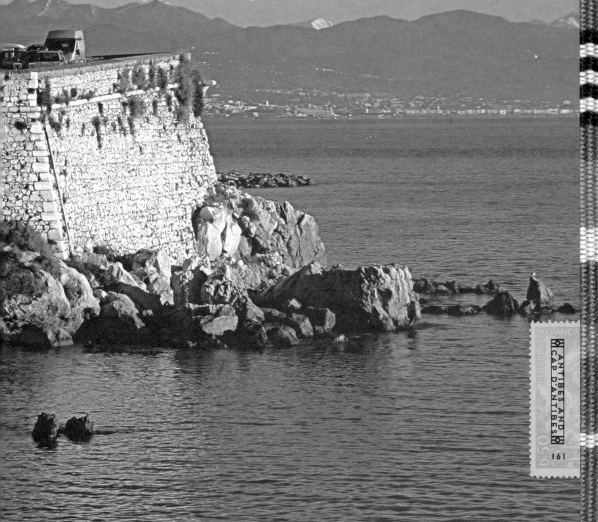

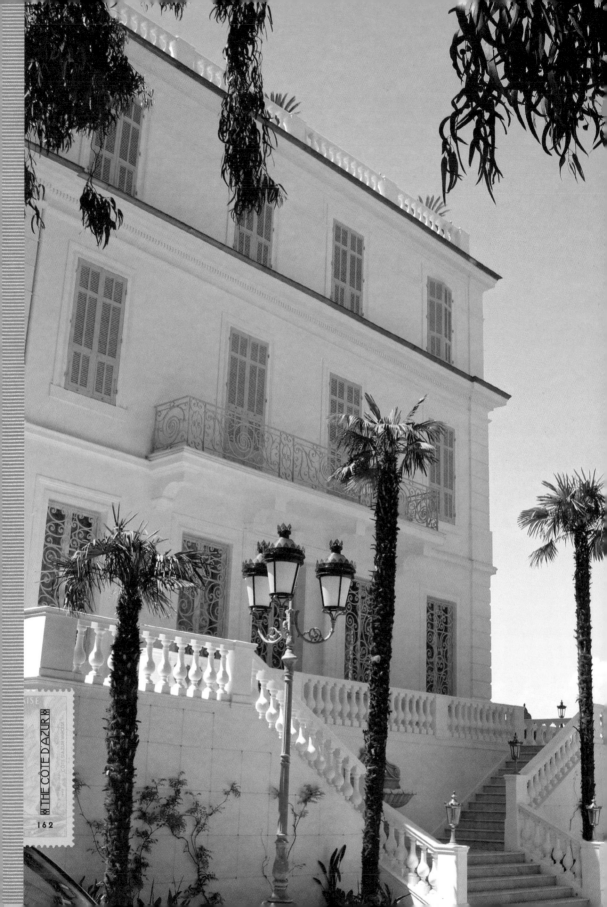

In spring, the town is garlanded with jasmine, oleander, and bougainvillea, and floral notes scent the lanes. Any of the streets around the covered market in **Cours Masséna** or **Rue du Safranier** are delightful, while the walk along the ramparts on the **Promenade Amiral de Grasse** offers magnificent sea views.

A lovely thing to do here is to buy some fresh produce at the markets and take it with you on your walk to Cap d'Antibes: There are many spots by the water to stop for a picnic. Or you can have lunch in Antibes. When the market's vendors pack up, the area and surrounding streets fill with restaurant tables. One of the best, although perhaps better visited at night, is **Bar Absinthe** in the basement of an olive-oil shop just off the market. Reminiscent of an early 20th-century drinking den, it features a vaulted ceiling, wonderful vintage posters, and rows of glasses backlit with the distinctive green color.

If you don't drink too much absinthe at lunch, you may be able to find Commune Libre de Safranier (the Free Commune of Safranier), an autonomous "village within a village" that's well hidden but worth the hunt. It has its own small Town Hall and a tiny street named after *Zorba the Greek* author Nikos Kazantzakis, who lived here.

Once you've strolled around this historic quarter, make for the waterfront esplanade and keep heading south. If you keep following the path around the coast, you'll eventually reach **Plage de la Garoupe**. This quiet and secluded beach was the favorite hangout for F. Scott Fitzgerald and his wealthy patrons Sara and Gerald Murphy. The Murphys visited one summer in the 1920s and noted the picturesque beaches and the idyllic weather. They persuaded the Hôtel du Cap-Eden-Roc to rent them a part of the hotel, which they then used for lavish parties for all their friends. Later, they bought a villa, which they called "Villa America." Celebrities such as Rudolph Valentino and Coco Chanel shortly followed, and soon the Riviera was the place for rich East Coast Americans to spend their summers—and their money.

The Murphys' favorite swimming inlet, Garoupe, isn't much today, thanks to seaweed and age, but it is still pretty and there's a charming café with red-striped awnings that's a nice spot for lunch.

The real sight here is the luxury real estate, which continues all the way along the Cap d'Antibes coastline. (Note: If you want to take a shortcut from Antibes to Garoupe and peek into the gardens of the glamorous villas, take Boulevard du Cap and then wind your way down Chemin de la Garoupe to the beach.)

After you've had an ice cream or brunch at Garoupe Beach, head back up Boulevard de la Garoupe and then down Boulevard John F. Kennedy. This will lead you past Jules Verne's former villa on the right (a stunning white home with imposing black gates: Look for the gold plaque), and eventually take you to the front entrance to the fabled **Hôtel du Cap-Eden-Roc** (page 187), one of the most famous hotels on the French Riviera, if not the world. This is where Karl Lagerfeld held his Resort Collection in recent years. It's where Madonna and other stars hide from the paparazzi when they've been to Cannes. And it's where some rather illustrious movie stars have stayed over the decades, as you'll see from the old black-and-white photos lining the restaurant's walls.

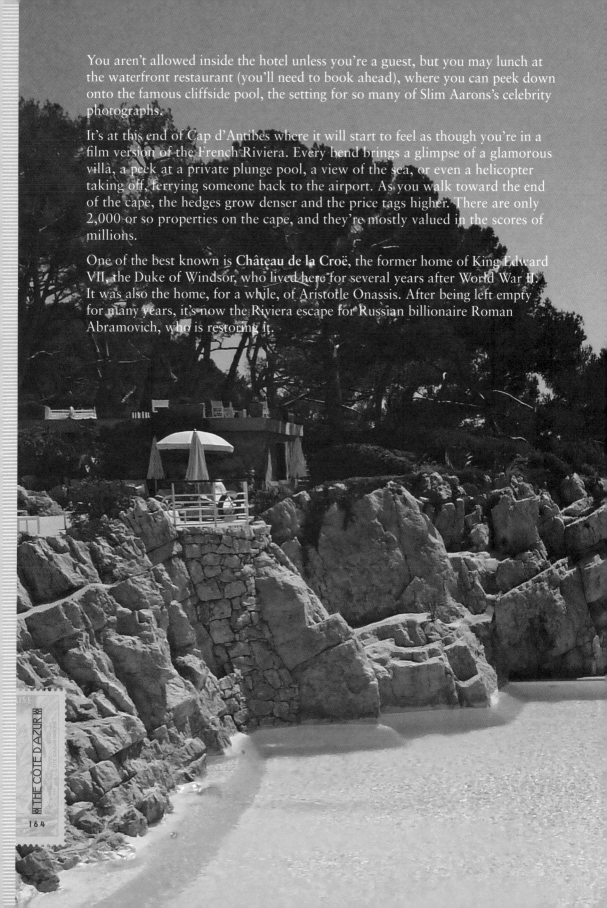

You aren't allowed inside the hotel unless you're a guest, but you may lunch at the waterfront restaurant (you'll need to book ahead), where you can peek down onto the famous cliffside pool, the setting for so many of Slim Aarons's celebrity photographs.

It's at this end of Cap d'Antibes where it will start to feel as though you're in a film version of the French Riviera. Every bend brings a glimpse of a glamorous villa, a peek at a private plunge pool, a view of the sea, or even a helicopter taking off, ferrying someone back to the airport. As you walk toward the end of the cape, the hedges grow denser and the price tags higher. There are only 2,000 or so properties on the cape, and they're mostly valued in the scores of millions.

One of the best known is **Château de la Croë**, the former home of King Edward VII, the Duke of Windsor, who lived here for several years after World War II. It was also the home, for a while, of Aristotle Onassis. After being left empty for many years, it's now the Riviera escape for Russian billionaire Roman Abramovich, who is restoring it.

And then there is its palatial neighbor, **Villa Eilenroc** (Avenue Mrs. Beaumont). Once regularly open to visitors, Eilenroc has since narrowed its hours to very irregular times, usually Wednesdays. The 10-acre garden is magnificent, thanks to the restoration efforts of the council, with views across the bay and plantings of pines, cypress, oaks, olive trees, lavender, rosemary, eucalyptus, roses, figs, and more than a mile/two kilometers of pittosporum hedges. The villa was once owned by wealthy American businessman Louis Dudley Beaumont, and still stands as one of the most valuable pieces of real estate on the entire Riviera coast. (Its nearest equivalent, La Leopolda on Cap Ferrat, was rumored to have been sold to a Russian for 300 million Euros.)

From the Hôtel du Cap-Eden-Roc, near the Villa Eilenroc, continue walking around Boulevard John F. Kennedy, which becomes Boulevard Maréchal Juin. As you round the point, look out for the pretty cove on the left, a postcard-worthy scene of weathered fishing boats and cobalt water. There are lots of beautiful villas around here too, and roaming through any of the side streets will reward you with architectural eye candy. In fact, there are tantalizing glimpses of the grand villas and gardens at almost every turn: Just make sure you don't get run over by an Aston Martin or a Lamborghini while you're taking a photo.

From here you can wander back to Antibes or, if you have the energy, continue exploring the other side of Antibes, the vastly different Juan-les-Pins.

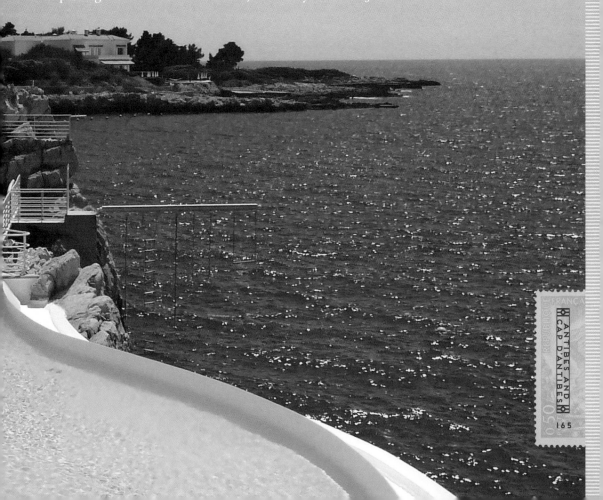

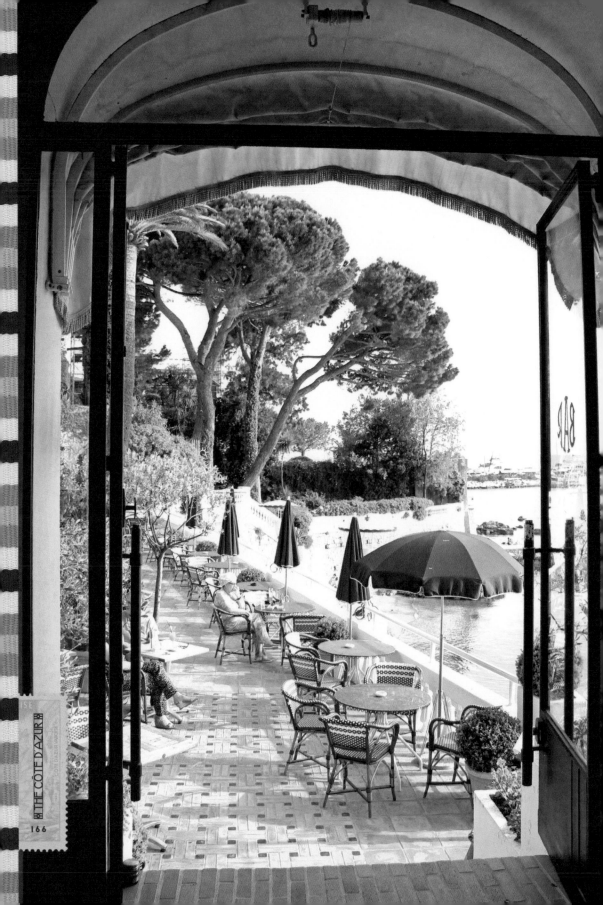

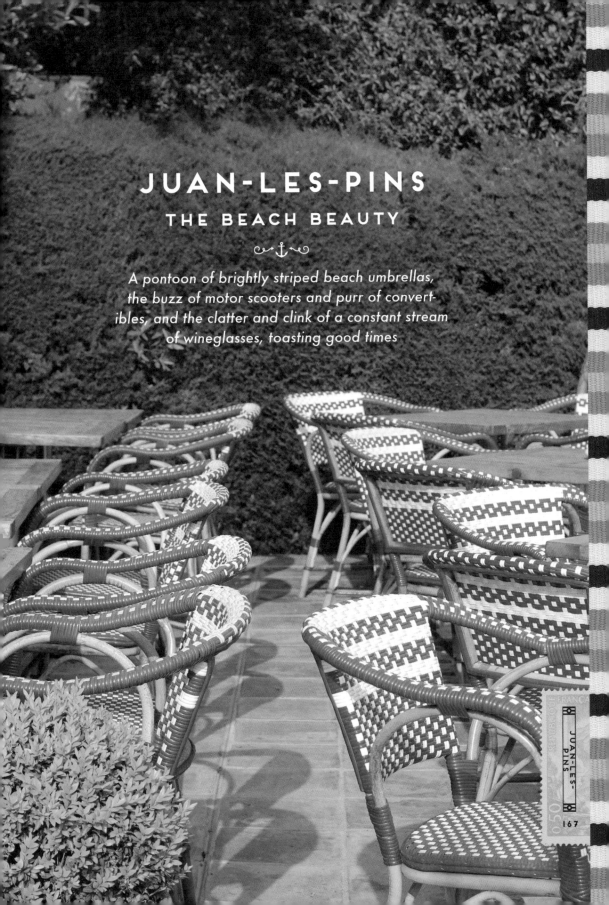

JUAN-LES-PINS
THE BEACH BEAUTY

A pontoon of brightly striped beach umbrellas, the buzz of motor scooters and purr of convertibles, and the clatter and clink of a constant stream of wineglasses, toasting good times

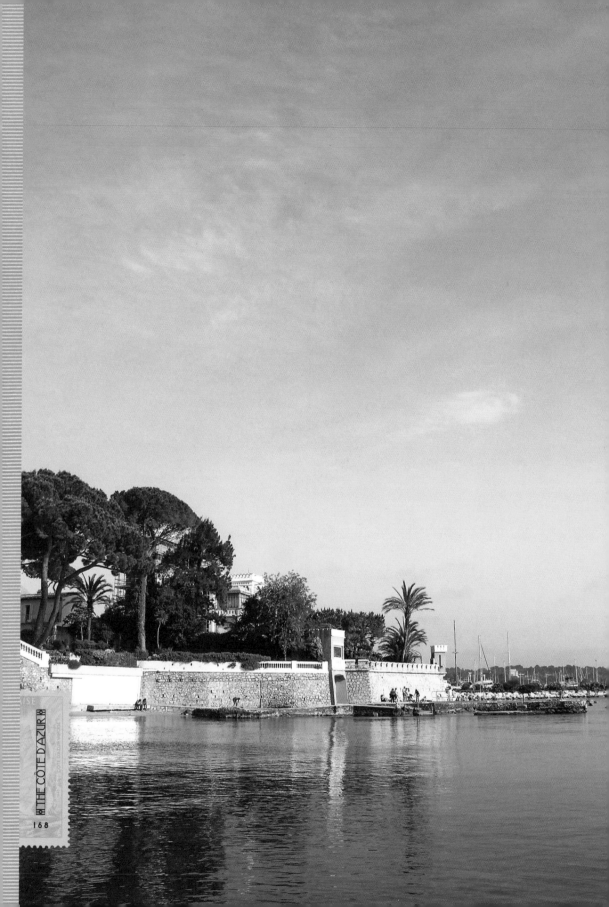

Juan-les-Pins is a bold and bustling, stay-out-late kind of place. It's where you come if you want action. Some people love it here, particularly during summer when the streets buzz with motor scooters and convertibles, and the pavements with clatter and the clink of wineglasses. Many of the globe-trotting set adore it, because there's a casino, nightclubs, and countless beaches. Other people dislike it because it's too busy and too brash. Yes, it's all that, but it's also fun. The colors are delightful (picture pontoons full of brightly striped beach umbrellas), the pine trees offer an elegant backdrop, and the palm-shaded restaurant terraces welcome guests until the early hours. And in July there's the Jazz Festival, bringing cool tunes to town. What more do you want from a summer resort?

Situated west of Antibes, Juan was originally famous for its pine trees (*pins* in French), which led to its name. It was where Antibes' locals would go for a stroll along the promenade or a picnic by a bay. As its popularity increased, visitors included American billionaire Frank Jay Gould, who immediately recognized its potential as a summer resort. He joined forces with a local businessman and built the Hôtel le Provençal, a luxury Art Déco–style retreat. They also restored the casino. Soon, the town was jumping with musicians, cabaret artists, and, of course, writers and painters. Juan-les-Pins had become a party town.

Dozens of luxury villas were soon erected to cater to the influx of wealthy expats. One of the most beautiful was the **Villa Aujourd'hui**, a striking, rather curvy, and extremely modern-looking waterfront property built in 1938 by American architect Barry Dierks. It was owned for several years by Hollywood mogul Jack Warner, who played host to Charlie Chaplin and Marilyn Monroe, among others.

Juan-les-Pins became so well known among a certain sector of the jet set that it became another word for a good time. The singer Peter Sarstedt even wrote about it in his 1969 song "Where Do You Go To (My Lovely)."

There are two popular sides to Juan. There is the street scene, which includes the casino plus a series of perpetually animated cafés, bars, restaurants, all of which offer entertainment on every level (there are dozens of boutiques, too, although most are set up for tourists and sell resort clothes and shoes at inflated prices); and then there is the beach scene, which is where people go to sleep off their hangovers in the morning under the pretense of working on their tans.

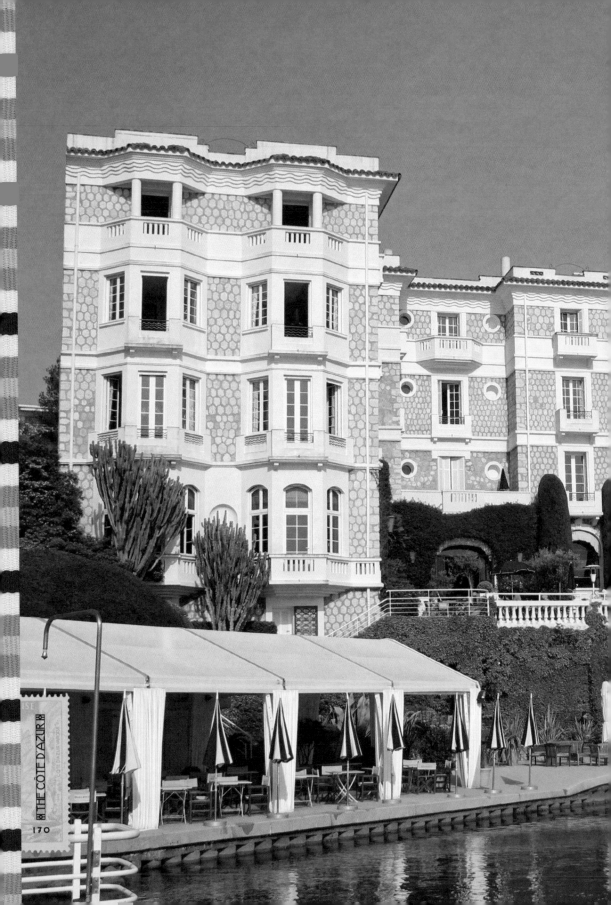

THE CÔTE D'AZUR

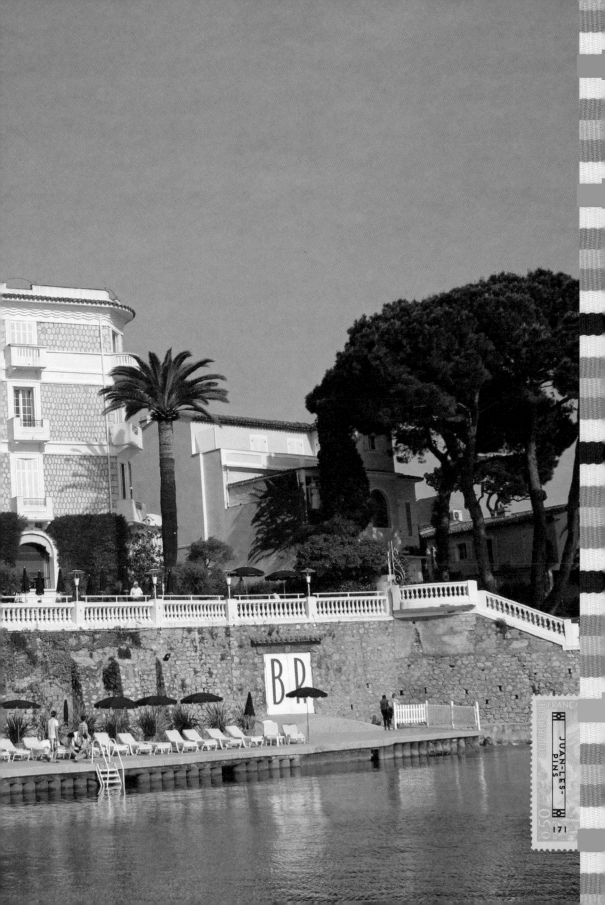

Juan has magnificent beaches—more than 30 of them. Some you'll need to pay a fee for; others will allow you to lie down free of charge. One of the best private ones, **Les Pirates**, is just in front of the pretty park of pine trees on Boulevard Édouard Baudoin (23 Boulevard Édouard Baudoin). You can rent a sun lounger and they'll bring drinks and lunch right to your chair. There are also clean shower facilities where you can wash off the sand before heading to the cafés.

If you're looking for a free beach, there's a popular sheltered beach further up, near the harbor, on the other side of the Hôtel Belles Rives. (You can't get lunch there, however, and certainly not delivered to your chair.)

In between these two beaches is the **Hôtel Belles Rives** (page 186). You can access it from either beach via the tiny coastal path in front of the hotel. The Belles Rives is one of the highlights of the Cap d'Antibes. This, you see, is where F. Scott Fitzgerald wrote part of *The Great Gatsby*. The villa next to it claims to have been Scott's home at one stage, too, so perhaps they were part of the one estate? Yet another source claims that the Fitzgeralds only spent one summer here living off the royalties of the novel. In any case, this was Scott and Zelda's stomping ground for a little while, and it's all very Great Gatsby-ish. The Art Déco hotel has kept its original furniture and has dedicated part of its library to Scott, but the truly memorable scenes are outside on the terrace. This is real old-style Riviera glamour, with a bar outfitted in red and leopard print, a spectacular private beach and pier dotted with striped umbrellas, and a splendid terrace with navy café chairs set up to allow you to sip your gin and tonic as you watch the pale Riviera light sinking over the sea. Blink, and you could almost imagine you're back in the 1920s, clinking a Champagne glass with Zelda and toasting the good times.

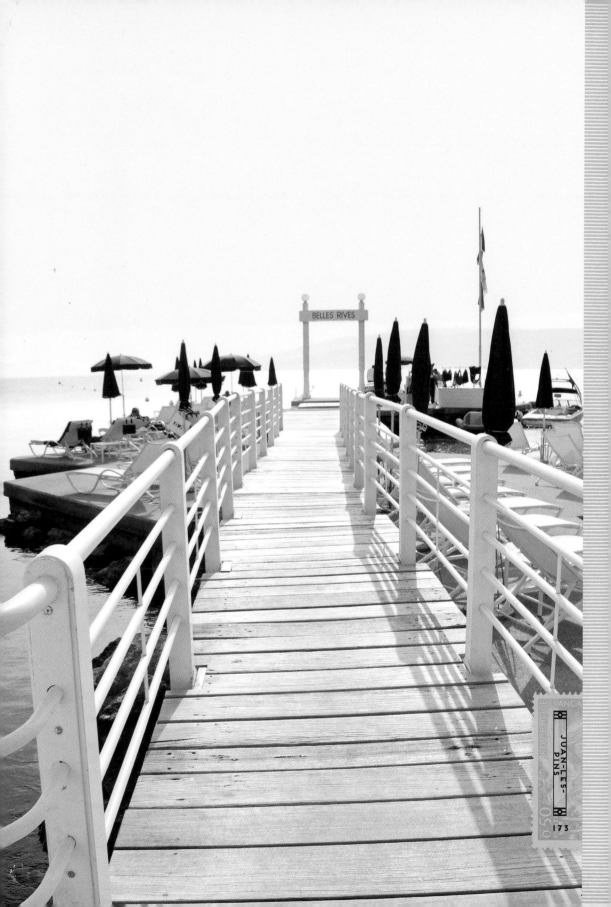

Dior

SAINT-TROPEZ
THE GLAMOUR PUSS

Tailor-made for drinking, slinking along in designer shades, sliding onto yachts, lazing on the beach, or kicking up your heels in your best Manolo Blahniks

While other resort destinations have come and gone, Saint-Tropez is still hot even after all these years. Yet its popularity is a bit of a mystery. The tiny road that leads into the one-time fishing village doesn't make for easy access; the hotels are prohibitively expensive; and, to be honest, the beaches are not the best on the Riviera.

It's a wonder Saint-Tropez has survived, let alone retained its glossy status. But it has, and it is still one of the places to visit if you're up for a good time on the Côte d'Azur.

People debate the best time to see Saint-Tropez. There are those who think the only time to experience it is during high season (July and August) when it becomes one big catwalk. Others insist it's better out of season, when you can actually see the streets, the shops, and the cute style of this celebrated village. I'm afraid I can't tell you which is better: I came in early May and although it was relatively easy to get into town, the place seemed to be devoid of character. Friends say the best time to visit is early September, when it's warm enough to swim and wear shorts or sundresses but the streets aren't choked with tourists. (The town sees up to 100,000 a day in high season.)

I guess it's a personal choice, and personally I think Saint-Tropez needs the flamboyant A-list figures (and the B and C ones) to bring it alive. It is, after all, a show-offy place. But if you do go on weekends or in the height of summer, try and get there by early morning, before 8 a.m. if possible, to avoid the snarls on the highway.

To really experience the drama of this theatrical little town, start at the harbor. You can't miss it. It's on the left as you drive in—you'll see the massive super-yachts lined up. This is the first thing that will tell you Saint-Tropez is more than a fishing village with a few fancy stores. It's a mooring spot for millionaires with more money than they know what to do with. (Although having said that, the best way is to arrive by yacht.) Wander along the promenade and count the vessels—or the money it would have taken to buy them. Everybody does. There's no shame in displaying envy here.

Running parallel to the harbor are streets lined with designer boutiques: Dior, Chanel, Louis Vuitton, Hermès, et al. Ironically, the one thing you can't buy in the fishing village is bait and tackle. However, before you judge the moneyed class too harshly, take a look at the buildings.

⚓

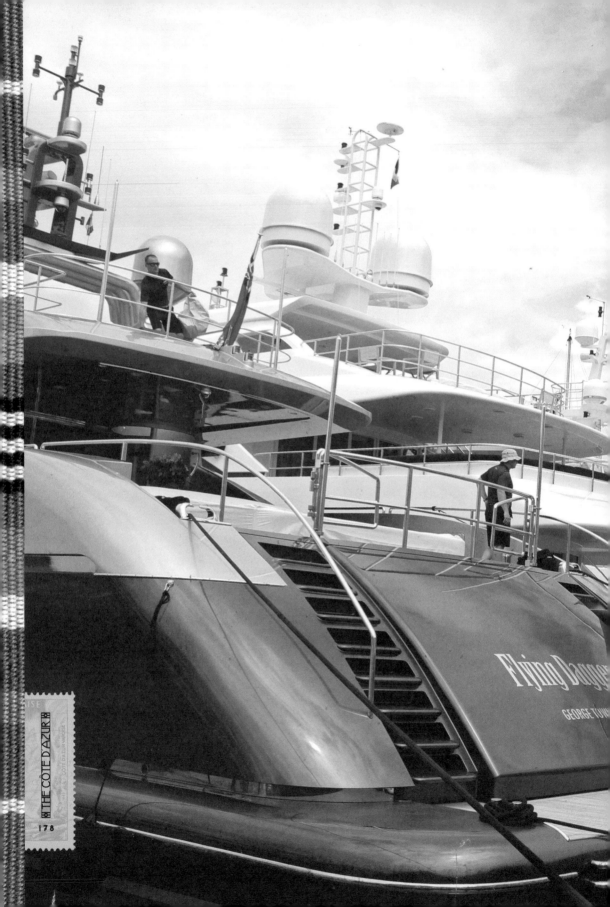

These French fashion companies have not only used beautiful old Saint-Tropez villas for their sophisticated stores, but in many cases restored them to a beautiful finish that's as striking as the clothes inside. The Hermès boutique is particularly lovely, while the Dior store is perhaps the most beautiful one in the world (it even has its own Dior café, complete with Dior-gray chairs.) Window shopping here is part of the culture, as is ogling the long-legged, suntanned shoppers strolling from yacht to store and back to yacht again.

Make your way down one of the narrow and charming streets that run perpendicular to the harbor and you'll soon reach the town's main square, Place des Lices. A pretty pause in the madness of this town, it's edged by 100-year-old plane trees and lovely buildings, many of which are now hotels, cafés, and stores. Perhaps the most photographed is the hotel **White 1921** (formerly Maison Blanche), which was bought by the prestigious LVMH company (of which Louis Vuitton is part) as its first venture into the hotel sector. It's a gorgeous building that looks like a mini château, and is priced accordingly (page 196).

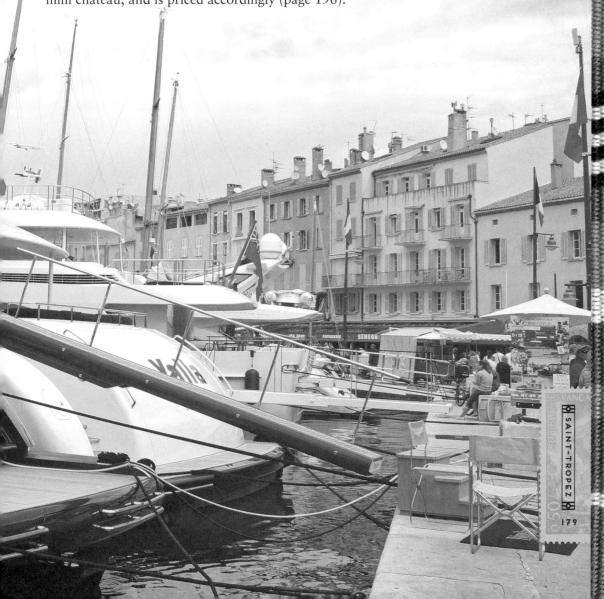

Try to visit Saint-Tropez on either Tuesday or Sunday, when an open-air market takes over the Place des Lices from 8 a.m. until just after midday. The market vendors offer all kinds of food and wares here, ranging from typical Provençal products such as lavender sachets, tablecloths, and soaps to beach gear, sun hats, straw bags, towels, and even bikinis. There is also a small antique section where you can find furniture, silverware, vintage bags, and jewelry. However, like most things in this town, everything is quite expensive, so don't plan to do your weekly grocery shopping here: just take in the atmosphere, and perhaps one or two souvenirs. You'll have to dig to find a bargain, but the atmosphere is still free.

Once you've filled up on market sights, and perhaps grabbed a coffee from one of the cafés surrounding the square, you can wander through the rest of the town, which really only takes half an hour to circumnavigate. As most of the streets are barely wide enough for two people, though, you'll be going at a snail's pace, so it may take longer. Peer into real estate brokers' windows to gawk at property prices, take photos of cute houses squeezed into tiny side streets, then sit at a bar with a good view of the passing crowds and toast the fact that you're here, in marvelous Saint-Tropez. That's all there really is to do here. The town is made for drinking, slinking along in designer shades, sliding onto yachts, or kicking up your heels after dark at the Byblos hotel's nightclub **Les Caves du Roy.**

The real beauty of Saint-Tropez is actually outside the village. There are spectacular places high atop the wooded, rocky peninsula that offer a great vantage point to see the entire area, including across the sea to the mountains of the Massif des Maures. A great view can be had from the 16th-century **Citadelle** at the top of the village, reached via a climb up a green and wooded hill. The interior has been transformed into a museum of Saint-Tropez's maritime history.

The beaches, too, are long and wide, and worth at least one look. **Le Club 55** on Plage de Pampelonne is still one of the places to go for some serious celeb spotting, although you'll need a car to reach it as it's about four miles/six kilometers out of town. The beaches of Saint-Tropez are not actually in Saint-Tropez but on the territory of the neighboring commune, Ramatuelle. A few shuttle buses run there, but only from the more upmarket hotels. You can walk to the beaches from Saint-Tropez along the **Sentier du Littoral**—a good three-hour hike around the headland that takes you past some charming little beaches, such as Plage Graniers, Plage des Canebiers, and Plage de la Moutte. You can also start the walk at **La Ponche** in Saint-Tropez—a rather cute neighborhood that was once the fishermen's quarter.

But the best bet is to rent a bicycle or scooter. That way you can zoom through both Saint-Tropez and the beach streets without worrying about traffic or parking. If you're looking for a quieter sandy stretch, or a cheap one, the southern end of the coastline, around **Bonne Terrasse**, is worth checking out.

However, perhaps the best way to see this flashy place is from the water. Transports Maritimes Tropéziens (Promenades-en-Mer, Vieux Port) offers one-hour boat trips that will help you truly appreciate what this place is all about.

P. PASCAL, PINXT

RÉPUBLIQUE FRANÇAISE

CÔTE D'AZUR VAROISE

1963

0.50 POSTES

R. CAMI

FRANÇAISE

5 c

ur Rennes

ERNÉE (Mayenne). - Dolmens de la Contrie

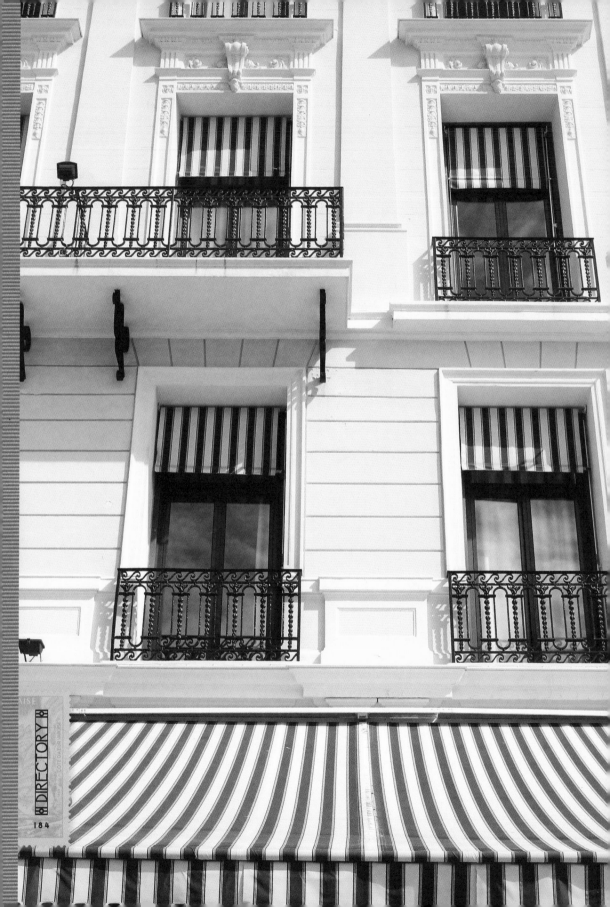

Hotels and guesthouses

Provence has lured romantics, aesthetes, and stressed-out city professionals to its idyllic landscapes, chic-rustic homes, and sun-and-wine-filled lifestyles for decades. They dream of finding a welcoming little guesthouse where the owner pours them a fine red and tells them where to find the best beaches, restaurants, vineyards, and views. Here is a selection of delightful hideaways that promise truly memorable stays.

BASTIDE ROSE

A rose by any other name

If you're seeking the perfect Provençal guesthouse, this might just be it. A former mill set in a stunning river setting, it's owned by one of the most engaging ladies to ever run a French guesthouse, Poppy Salinger. Poppy is the widow of John F. Kennedy's former media adviser Pierre Salinger, and her library is full of photo albums of JFK and Jackie in all their Camelot glory. She also has a Kennedy Museum set up in the old mill. The guesthouse is rather grand, but still has an intimate, homey feel, thanks to all the personal photos and books. The rooms are similarly splendid: a mix of spacious proportions and welcoming furnishings (including desks), with wonderfully large bathrooms, high ceilings, and elegantly tall windows that open onto the courtyard. There's a pretty pool with a wisteria arbor, a stunning deck with seating beside the fast-running stream, and a garden full of sculptures. But perhaps the most beautiful part is the island; the mill sits over the river that used to run its machinery, and the waterways have split into tributaries, creating a tranquil island in the garden. The gurgle of the streams and the sound of birdsong is pure bliss, especially in summer. You could check in and happily spend your week here without going anywhere else.

99 Chemin des Croupières, Le Thor; +33 4 90 02 14 33; bastiderose.com

DOMAINE DE LA BAUME

A domain

When *Condé Nast Traveler* magazine starts crowing about a place, you know it must be special. This hotel, owned by the "Martha Stewart of France" (*Condé Nast's* words, not mine), is the sister property to La Bastide de Marie, a very stylish place that attracts —and satisfies—fussy guests, so you know this place will have the same attention to detail. It's an 18th-century manor house near the pretty village of Tourtour, and sits so well in its surroundings it almost looks like a painting. (No surprise that its former owner was painter Bernard Buffet.) With an ocher façade and sky-blue shutters, it looks at one with the wide-open Provence skies and fertile landscape. Like its sister property it's tricky to find, but absolutely worth the drive through the countryside.

2071 Route d'Aups, Tourtour; +33 4 57 74 74 74; domaine-delabaume.com

FIVE SEAS HOTEL

High five

Going by name alone, the Five sounds very modern, minimalist, and slick, but thankfully it's not one of those cutting-edge-design places staffed with sneery hipsters in all-black Comme des Garçons. This is a hotel with substance and style. Situated just off the bustling La Croisette, close to all the action, it offers both a restaurant and a tearoom created by the pastry chef Jérôme De Oliveira. On top of this (if you'll forgive the pun) is the rooftop pool, and if you want more aquatic luxury there's also an 88-foot yacht. All this and yet rooms start at only 180 Euros.

1 Rue Notre Dame, Cannes; +33 4 63 36 05 05; five-seas-hotel-cannes.com

GRAND-HÔTEL DU CAP-FERRAT

Glamour, grandeur, and grace

From its name alone, you expect the Grand-Hôtel du Cap-Ferrat to be an impressive place. Well, it's more than impressive—people struggle for superlatives here. It is the *Titanic* of hotels; a splendid illustration of what you can create with enough money, enough time, and enough taste. The kind of guests who come here are the kind with a Prince in their title, or an Oscar on their mantel. You can barely imagine that the hotel started life as the dream of a coachman's son from the north. (Mr. Péretmère built it in 1908 after buying almost seven hectares of land right on the end of the promontory.) The hotel is very private, but you can see glimpses of it from the public path that winds around the coast. The hotel isn't the only thing that's aged well: The cellar holds more than 140 vintage bottles of Château d'Yquem dating from 1854, and a couple of dozen bottles of Château Lafite Rothschild dating from 1799—just the thing to open on the terrace of your majestic suite while you contemplate how good life is.

71 Boulevard du Général de Gaulle, Saint-Jean Cap-Ferrat; +33 4 93 76 50 50; grand-hotel-cap-ferrat.com

GRAND HÔTEL NORD-PINUS

Due nord

The owner of the Grand Hôtel Nord-Pinus, Anne Igou, has a penchant for art, particularly the photographic medium. It's featured strongly here, from the Peter Beard safari photos in the lobby of the hotel to Helmut Newton's portrait of Charlotte Rampling in Suite 10. But the views outside aren't too shabby either. If you stay in Suite 34, you'll be rewarded with a striking panorama over the rooftops of the Old Town. A lovely hotel for those who appreciate beauty, both inside and outside their rooms.

Place du Forum, Arles; +33 4 90 93 44 44; nord-pinus.com

HÔTEL BELLES RIVES

Bellisimo

So you like F. Scott Fitzgerald? You want to follow in the writer's footsteps? Maybe pen your own bestseller? Well, you could find inspiration here, at the villa where he wrote much of the iconic novel *The Great Gatsby*. Scott and Zelda rented this waterfront hideaway and the house next to it in order to concentrate on writing, and, okay, drinking. They'd already spent time in Saint-Raphaël, but when they arrived at this small corner of Juan-les-Pins they were immediately enchanted by the sea view, the pine trees, and the peace. Thankfully, the over-development that has blighted other parts of the coast has not taken hold here. Blink, and you could be back in the 1920s. The view overlooking the Med is so idyllic that people set up a sun lounger on the private beach and stare out to sea all day—usually with drink in hand. (The water is so calm and shallow that waterskiing was supposedly invented in the bay.) The interior is decorated in Fitzgerald-style glamour, including a red-and-leopard-print bar, and there is a library full of memorabilia celebrating the author. A sublime hideaway.

33 Boulevard Édouard Baudoin, Juan-les-Pins; +33 4 93 61 02 79; bellesrives.com

HÔTEL BRISE MARINE

Back to basics

Hotel recommendations can be a perilous undertaking. You can offer a suggestion, but your friends may not agree when they check in. Or the hotel may have changed. Or the owners may be grumpy that day. This is the category that the Brise Marine falls into. It's not for everybody, yet for many it's a great little find. Set deep in the lush foliage of Cap Ferrat's millionaire-filled peninsula, a mere stone's throw from the water, it's a jolly-looking place that's easy to spot—look for the cheery gelato-lemon building on the hill. Tourists often walk past, look up, and think: What's that pretty place? (I know, because I did, too.) The gardens are the first hint that you may have stumbled upon something lovely, but it's the views that really woo people. Most of the balconies and terraces offer a panorama that takes in the same sights as nearby hotels that cost five times the price. Inside, the Brise Marine is a little on the simple side, but it's the kind of place my parents would love: pleasant and down-to-earth, not too expensive, but with a location that feels like a million Euros.

58 Avenue Jean Mermoz , Saint-Jean-Cap-Ferrat; +33 4 93 76 04 36; hotel-brisemarine.com

HÔTEL BYBLOS

Boogying at the Byblos

The Byblos is one of Saint-Tropez's throbbing hubs; a village-like cluster of red and yellow stucco buildings surrounded by ancient olive trees and bright bougainvillea. It includes two Mediterranean restaurants (one managed by Alain Ducasse) and the renowned Les Caves du Roy nightclub. This is where half of Hollywood has come and kicked up their Christian Louboutins, including Beyoncé and George Clooney (perhaps not together). The rooms are, as you can imagine, fairly impressive, with a smattering of antiques and big baths to sink into, but the real action is by the pool. Wear your darkest sunglasses so you can spy.

20 Avenue Paul Signac, Saint-Tropez; +33 4 94 56 68 00; byblos.com

HÔTEL DE L'IMAGE

Snapshot

I loved the idea of this when I first read about it: a hotel created from an old movie theater. Then I saw it and realized the owners had done a cinematic job restoring it. Easily spotted by the grand façade, it features an equally stylish interior that continues the visual theme with walls of interesting photography. The terrace is a chic place for drinks, while the pool overlooks two acres of lush gardens and a mesmerizing view of the Alpilles beyond: surprising for a hotel that's right in the center of town.

36 Boulevard Victor Hugo, Saint-Rémy-de-Provence; +33 4 90 92 51 50; hotel-image.fr

HÔTEL DU CAP-EDEN-ROC

Hollywood on the Riviera

Travelers talk about the Hôtel du Cap in hushed tones of awe and envy. "Did you stay there?" they ask the fortunate few who get to spend a night between these sacred sheets. This is because the hotel is like no other. Having been the favored escape for Hollywood names for decades (the black-and-white photos by Slim Aarons on the walls attest to the star-studded guest list), it now sits comfortably with its celebrity status. It even looks glamorous, with its sweeping drive, iconic pool, Beverly Hills–style gardens, and cliff-top restaurant overlooking the diving platforms on the Med. Visitors can peek in by booking lunch in the restaurant and then wandering around the gardens afterward, but without a reservation, the hotel itself is strictly off-limits. Still, we can only imagine . . .

Boulevard John F. Kennedy, Antibes; +33 4 93 61 39 01; hotel-du-cap-eden-roc.com

HÔTEL LE MAS DE PEINT

Design and style

With an interior that looks like a spread from a high-gloss, coffee-table design book, Le Mas de Peint is one for design lovers. It's not surprising that the owner's wife is an architect: Good lines are evident in everything from the building to the interior design. But the most refreshing part of staying here is the kitchen garden, which supplies farm-grown produce for meals. The in-house chef loves using the garden ingredients to create new and unusual dishes. Owned by the Bon family for centuries, this lovely hotel is near Le Sambuc, south of Arles.

Le Sambuc; +33 4 90 97 20 62; masdepeint.com

HÔTEL MARTINEZ

From A to Cannes

The Hôtel Martinez is to Cannes what Château Marmont is to LA: the coolest place on the coast for celebs to crash. It's long been a favorite with the A-listers, both for its gilded interior (sweeping staircase, Art Déco finishes) and its gilded service. There's also the requisite palm-fringed pool, private beach, and spa (for when you're having those close-ups at the film festival).

73 Boulevard de la Croisette, Cannes; +33 4 93 90 12 34; cannesmartinez.grand.hyatt.com

HÔTEL NEGRESCO

Dressed to impress

An over-the-top monument to 18th-century French luxury, the Negrescro is something of a legend. Presidents in particular like to stay here, as it has the kind of opulence they've become accustomed to. Named after its founder, Henry Negresco, a Romanian who (ironically) died broke in Paris in 1920, the hotel was inspired by France's most ostentatious châteaux. There is the fancy, Belle Époque façade, a grand mansard roof, a domed tower, miles of gilt, and rooms the size of small countries. Recently renovated, many of the suites pay homage to famous names: The Napoleon III suite has swagged walls, a leopard-skin carpet, and a half-crown pink canopy. If that's not enough to satisfy your appetite for opulence, there's also an art museum within the hotel.

37 Promenade des Anglais, Nice; +33 4 93 16 64 00; hotel-negresco-nice.com

HÔTEL PRULY

Pruly cheap

If you want a cheap hotel that still comes with a measure of chic, check in here. The relatively new Pruly is a great little bargain number tucked inside a gorgeous white town house. Rooms are simple but bright, with lovely toile fabrics, and names like "Agatha" (a sunny Cannes-yellow shade) and "Hortense." The main foyer and breakfast areas, meanwhile, are sleek modern pictures of monochrome sophistication. There's also a sunny garden with stylish seating. The rates—from 70 Euros—are unbeatable.

32 Boulevard d'Alsace, Cannes; +33 4 93 38 41 28; hotel-pruly.com

HÔTEL SAINTE VALÉRIE

Quirky charm

It's difficult to find a reasonably priced hotel on the French Riviera, especially in summer. It's even more difficult to find one that's close to the beach and has some degree of style. The Sainte Valérie is one of those secret finds that friends pass on, because it's cheap and chic! Set down a charming street behind the pine-tree-lined park on the beach at Juan-les-Pins, this quaint French guesthouse is slightly Fawlty Towers, but it has bucketloads of charm. The pool, which is set into a lush garden, is a picture of prettiness, and the rooms, especially those that overlook the pool, are a delight. Some are rather austere on the furnishing side, but they make up for it with wonderful balconies—and really, you can't complain for the price.

13 Rue de l'Oratoire, Antibes; +33 4 93 61 07 15; hotel-sainte-valerie.fr

L'HÔTEL PARTICULIER

Quite particular

L'Hôtel Particulier is the epitome of a Provence hotel. The entrance: an elegantly grand black door with gilt knockers and black Versailles planters either side. The interior: all-white rooms with ornate white fire-places and touches of gold and black. The garden: a green retreat that is both simple/minimalist and full of astonishing beauty. The ambience: delightfully overwhelming. The hotel is actually an aristocratic town house built in 1824 by the mayor of Arles. It was converted to a hotel in 2002 and quickly became one of the most talked-about in the area. It's still fairly much a secret, although the word is getting out. New additions include a hammam.

4 Rue de la Monnaie, Arles; +33 4 90 52 51 40; hotel-particulier.com

LA BASTIDE DE MARIE

La sanctuary

La Bastide de Marie is one of those places you really only hear about through word of mouth—or luck—and once you've been here, you feel reluctant to pass on its details in case popularity ruins it. Set deep in the heart

of Provence (so deep it's a challenge to find) this splendid guesthouse makes you feel like you're staying with a very chic, very wealthy French aunt. Surrounded by vineyards and hills and a charming garden of pretty parterres and pencil pines, it's made for relaxing. There are few people, no bars or clubs, and the nearest village is a drive away. Come here, open a bottle of wine, and remember what the beauty of life feels like.

Route de Bonnieux, Ménerbes; +33 4 57 74 74 74; labastidedemarie.com

LA COLOMBE D'OR

La legend

La Colombe d'Or is one of the hotels that made the Riviera what it is. Many people travel to the Côte d'Azur just to dine here—and then boast about it afterward. It's a legendary hotel that is as famous for its extraordinary private collection of art, featuring works from the likes of Picasso, Matisse, and Braque, as it is for its setting and cuisine. Located in the golden hills of Saint-Paul-de-Vence, the hotel was a favorite place for painters. When the painters couldn't pay their bill they offered up their work instead. Decades on, La Colombe has become a mecca for people who love art as much as food—and the menus are just as amazing as the canvases. Sit out on the terrace where the light is pure Provence and take in the atmosphere, and history, of one of the most picturesque villages in France. A truly inspiring place.

Place du Général de Gaulle, Saint-Paul de Vence; + 33 4 93 32 80 02; la-colombe-dor.com

LA MIRANDE

Worthy of a palace

Some fans of La Mirande argue that it's the most beautiful hotel in Provence. Facing the famous Palace of the Popes, this sumptuous, spectacularly decorated 18th-century mansion has been restored and decorated with great care—and style—by Achim and Hannelore Stein and their son, Martin. Each room is different, but they're all decorated in exquisite antiques, sublime period tiles, and designer fabrics by the likes of Pierre Frey and Manuel Canovas.

4 Place de l'Amirande, Avignon; +33 4 90 85 93 93; la-mirande.fr

LA PAULINE

For a romantic rendezvous

A graceful allée of plane trees leads to this serene Directoire-style mansion built for Napoleon's sister, Pauline Borghese, who was famous for her romantic escapades. It is still romantic today, thanks to the care of its owners, who have created a superb guesthouse out of Pauline's old love shack. Each of the splendid rooms has a terrace, and there's also a guesthouse and a small pavilion in the gardens above the main house, should you want something really private. A perfect hideaway yet blissfully close to the charms of Aix.

Les Pinchinats, Chemin de la Fontaine des Tuiles, Aix-en-Provence; +33 4 42 17 02 60; lapauline.fr

LE PAVILLON DE GALON

A secret garden

Garden lovers will be in absolute horticultural heaven at this lovely place, which is a garden disguised as a guesthouse. And what a garden it is! Owned and restored by French photographer Guy Hervais and his wife, Bibi Gex, this former 18th-century hunting pavilion (thus the name) in the dramatic Luberon region of Provence is so beautiful it was awarded a "Remarkable Garden" status by the French Ministry of Culture and Environment.

Galon, Cucuron; +33 4 90 77 24 15; pavillondegalon.com

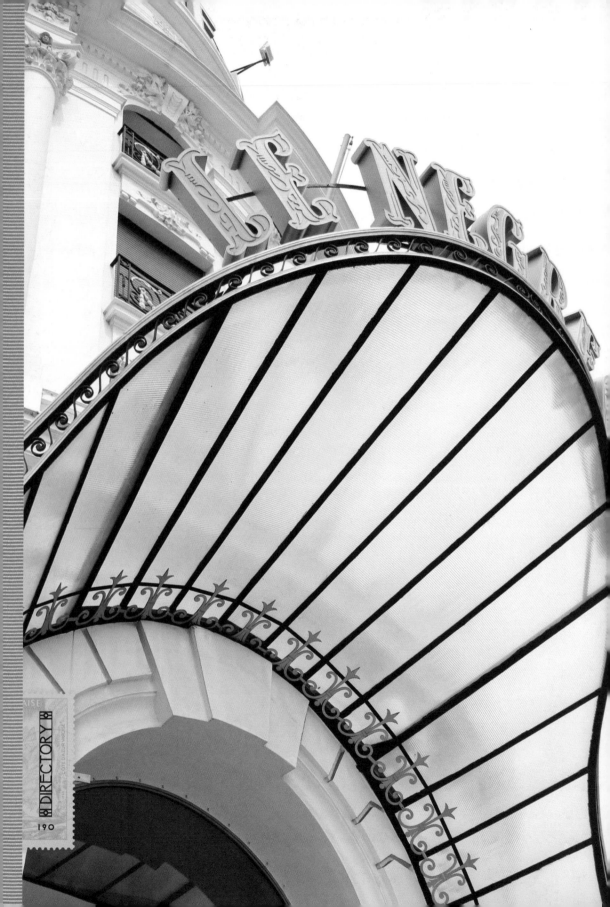

LA RÉSERVE

Make a reservation

People looking for seclusion love it here. The 1970s building has recently been updated for the modern generation while still retaining its original lines, but what guests really love is the privacy factor. La Réserve is a truly private retreat hidden in the hills behind Ramatuelle. This isn't to say that all you see are trees and the back of someone's parasol beside the pool. All of the villas face the sea, so you can look over the coast secure in the knowledge that it will take a very long lens to find you. Pack lots of books and check in for a good, long rest.

Chemin de la Quessine, Ramatuelle; +33 4 94 44 94 44; lareserve-ramatuelle.com

LA VOILE D'OR

A grand old soul

For a while, the Voile d'Or was the place to stay in this part of the world—if you couldn't afford the Grand-Hôtel du Cap-Ferrat, that is. With a magnificent site overlooking the gentle Saint-Jean-Cap-Ferrat harbor and its bobbing yachts, the hotel offers glorious views. The sheen has come off the glamour a little since its heyday, but it is still beloved. The day I was there, a Rolls-Royce and a brand new Bentley were parked outside; their owners had popped in for lunch. The pale-green restaurant is surprisingly stylish, in a rather nostalgic way, but the rooms could do with a refresh. Nevertheless, the views are still glorious. Sip your Champagne on the famous terrace and revel in being one of the lucky ones to have visited this grand old gem.

7 Avenue Jean Mermoz, Saint-Jean-Cap-Ferrat; +33 4 93 01 13 13; lavoiledor.fr

LE CAVENDISH

Bella hotel-a

This sumptuous Belle Époque beauty was built in 1897 and still hasn't lost her style. Now owned by Christine and Guy Welter, who are making a name for themselves as impressive hoteliers, it echoes the Côte d'Azur's glory days. There are charming half-moon balconies overlooking the boutiques on the boulevard below, rooms outfitted in pretty Provençal style, and a lobby that winks to the glamour of the good old days. (Look for the vintage 1920s elevator.) If you want to treat yourselves, ask for the grand Rotonde room, with polished parquet floors, high ceilings, and whimsical "winter garden" bathrooms.

11 Boulevard Carnot, Cannes; +33 4 97 06 26 00; cavendish-cannes.com

LE PIGONNET

Picture perfect

Le Pigonnet has been the lodging of choice for decorators, designers, and garden lovers visiting Aix-en-Provence for some years now, and it's easy to see why. It's quiet and filled with the kind of inspirational style those elegant French do so effortlessly. The rooms are the right side of sophisticated, and the grand, orangery-style restaurant offers glorious windows that look out to the beautiful garden, which is reminiscent of a country estate. The hotel's grounds are so extensive that it feels like you're out in the countryside, yet you're right in town. It's a short walk to the center of Aix, so leave your car at the hotel (you'll never find a parking spot anyway). Le Pigonnet is the perfect base to explore this oh-so-gorgeous place.

5 Avenue du Pigonnet, Aix-en-Provence; +33 4 42 59 02 90; hotelpigonnet.com

PASTIS HÔTEL

More than novel

If the name sounds familiar, it might be that you've read Peter Mayle's *Hôtel Pastis*. This hotel wasn't the basis for the narrative but Mayle does love it here, and the owners are, like him, English. So, too, is the interior design. There are framed Sex Pistols and Rolling Stones album covers (very Saint-Tropez), David Hockney prints, and flea-market finds that give the place a lovely sense of English whimsy. It's all very tasteful, of course, as the owners are designers, but is very entertaining just the same. The decor makes the hotel feel like a private house, and that may be why people love it so much. Even the much-photographed pool area

(it's often in magazine shoots) feels like a private villa. Colorful and absolutely full of character.

75 Avenue du Général Leclerc, Saint-Tropez; +33 4 98 12 56 50; pastis-st-tropez.com

PAVILLON DE LA TORSE

Pavilion pretty

The Pavillon de la Torse looks like something you'd see in a French film—one of those sweet, pull-you-in-with-its-heavenly-scenery movies about a couple who find an abandoned house deep in the French countryside and lovingly restore it. A picture-book house with a façade the color of egg yolks, shutters the shade of summer geranium leaves, and a garden that is pure charm. It's so perfect, you half expect a director to wander in from the side and yell "cut." In fact, the story of the Pavillon de la Torse could be a film. Its owners bought this abandoned château and transformed it into a beautiful B&B that surely boasts the most idyllic setting in Aix. The building may look petite but the rooms are plump with comfort and quiet style. However, it's the garden that really enchants, and guests love heading outside to spend the day by the pool in a horticultural dream.

69 Cours Gambetta, Aix-en-Provence; +33 9 50 58 49 96; latorse.com

ROYAL-RIVIERA

Pure glam

The Royal-Riviera hotel is everything you imagine the French Riviera to be. Striped awnings, an elegant pool fringed by even more elegant sun loungers and umbrellas, a private sandy beach to escape the crowds, a terrace to toast the sunsets, and a perfect view of the Mediterranean. It is, quite simply, one of the most beautiful hotels on the Côte d'Azur. Of course, its allure could also have something to do with its setting. The Royal-Riviera is tucked into the crook of the bay between the pretty town of Beaulieu-sur-Mer and the tranquil village of Saint-Jean-Cap-Ferrat. (It's a delightful stroll to both.) The views are eye-wateringly gorgeous—you can ogle the villas of Cap Ferrat or simply gaze out to the yachts at sea. The staff is also entertaining—look for the YouTube clip on the hotel: it's what persuaded me to come here. Utter bliss. If I could afford to, I'd stay for a week.

3 Avenue Jean Monnet, Saint-Jean-Cap-Ferrat; +33 4 93 76 31 00; royal-riviera.com

TOILE BRANCHE

What's in a name?

It's a curious name, Toile Branche. A curious place, too. But like most curious places, it's surprising and intriguing and ultimately a satisfying discovery. *Tatler* magazine thought so, too. They called it "one of the best bijoux hotels on the Côte d'Azur." And *bijou* is the perfect word: It's a jewel of a hotel. Set out like a private home—albeit a grand manor—it's exquisitely decorated and set within a sublime garden filled with lavender. And with rooms from 190 Euros, there's money left in the budget to splurge on the French delicacies at the hotel's restaurant. Toile Blanche is famed for its cuisine, you see, which is served on the terrace overlooking the garden and pool. Why go to a Michelin-starred place when you can dine well in your own hotel?

826 Chemin de la Pounchounière, Saint-Paul de Vence; +33 4 93 32 74 21; toileblanche.com

VILLA GALLICI

Va-va (villa) voom

Unlike some of its Spanish counterparts farther south, Aix is not a place that goes for over-the-top decor. This is a city that's a little more understated. It is French, after all. But the Villa Gallici has flipped Aix's traditionalism on its head. This lavish hideaway is the kind you'd ask your lover to book for a sly weekend rendezvous. Everything here is designed to be indulgent, from the discreet service to the dramatic interior design, which is a mix of Marie Antoinette-ish fabulousness and modern luxe. Think gorgeous urns, richly decorated furnishings, and silk canopies draped over beds the size of lap pools. The suites, meanwhile, are a study in boudoir beauty, with stylish wicker day beds and private gardens or terraces in which to take your room-service breakfast. The hotel also has a spectacular seven-acre oasis beside it with a stunning terrace and swimming pool. No wonder *Condé Nast Traveler* readers voted it the 7th Best Hotel in the World for 2012.

Avenue de la Violette, Aix-en-Provence; +33 4 42 23 29 23; villagallici.com

VILLA GARBO

I vant to be alone

Garbo would have loved it here. She could have holed up in this place without a worry. And it is so lovely, she might never have left. After they worked their magic on Le Cavendish, Guy and Christine Welter turned to this little gem, a former 1884 villa in the heart of Cannes. Converting it into sumptuous apartment-style suites, they mixed the Belle Époque with a little modern luxury, adding a hammam and spa, improving the delightful garden and—best of all—offering free drinks in the evening.

Villa Garbo, 62 Boulevard d'Alsace, Cannes; +33 4 93 46 66 00; villagarbo-cannes.com

VILLA MARIE

Tropezian treat

The Villa Marie is the perfect balance between high luxury, superb design, and affordability. It's small, stylish, friendly, reasonably priced yet still has a lovely luxe look. Set against the backdrop of a stunning pine forest in Saint-Tropez's neighboring village of Ramatuelle (which is where the "in" crowd go as it's closer to the beach), this beautiful bolthole is beloved by low-key travelers looking for an endearing—and enduring—place to go each year. (*Harper's Bazaar* editors loved it.) The interior design is the kind that gets noticed in *Architectural Digest*, while the garden is a Mediterranean haven where you can laze away the day.

Route des Plages, Chemin de Val Rian, Ramatuelle; +33 4 94 97 40 22; villamarie.fr

VILLA RIVOLI

Shuttered charm

The Villa Rivoli's German owner is perhaps one of the loveliest people you'll ever meet behind a hotel reception desk. She is, quite simply, charm personified. So, too, is her hotel. Decorated in tasteful shades, it has a touch of the Gustavian (Swedish) decorating style about it (lots of muted grays and pale, painted furniture), mixed with some 19th-century French flair. The salon is a proper salon; a place to read (there are fabulous books on architecture and gardens), play the piano, have breakfast or afternoon tea (always fresh biscuits for guests), sit before the fire in winter or wander out to the pretty garden in summer. The rooms, while small, are similarly engaging. If you can't afford the largest ones, done in blue toile, opt for those on the street side. They come with the kind of faded turquoise shutters we all dream about when we stay in France, and tiny balconies that look out over the street. Best of all, it's only a block from the promenade, the beach, and the just-as-delightful Masséna Museum of Art and History. The kind of place you love at first sight, staffed with people who delight.

10 Rue de Rivoli, Nice; +33 4 93 88 80 25; villa-rivoli.com

WHITE 1921

All white on the night

This dazzling white hotel had a dazzling reputation for a few years there, especially if you were the kind who liked a good time. People came for the location (on the marvelous Place des Lices), for the superb drinks in the former Maison Blanche bar (considered one of the best bars in Saint-Tropez), and for the incredible-looking building (think: mini château). It became so popular that the luxury brand conglomerate LVMH (of which Louis Vuitton is part), noticed it and thought it would be the perfect hotel to start their new portfolio of hideaways. So they bought it, and began renovations. In the process, White seems to have lost some of its personality, much like a face that's had too much plastic surgery. It's still a magnificent building, and the setting and courtyard are faultless (there are even designer boutiques at the entrance should you need new shoes for dinner), but the rooms are just a little too pared back for some people's liking. Still, have a look. If you are a minimalist, you may be someone who loves its new lines.

Place des Lices, Saint-Tropez; +33 4 94 45 50 50; white1921.com

Must-see destinations

There are hundreds of sights worth seeing in the South of France. Here are a few stand-outs.

COMMUNE LIBRE DU SAFRANIER

Community spirit

Hidden inside the Old Town of Antibes, a few blocks south of the Château Grimaldi, is a smaller village—a village within a village, if you like. It's the Commune Libre du Safranier (Free Commune of Safranier); an eccentric but utterly captivating little neighborhood that has its own personality, and even its own mayor. Here, residents chat over their balconies, water bright flowers in window boxes, and generally live the kind of life we all dream about. The stone-stepped Rue du Bas-Castelet is particularly pretty.

CORNICHE DE L'ESTÉREL

Vroom with a view

The Côte d'Azur is famous for its memorable drives, many of them hair-raising. Most visitors know about the corniches that follow the coast near Monaco, but fewer people realize that there is an even more dramatic drive, the Corniche de l'Estérel, farther along the Riviera. Also known as the N98, this road from Saint-Raphaël to La Napoule makes for a spectacular journey. On one side is the mountain; on the other the Mediterranean, and all the way along, the road clings to sheer rock faces that seem to plunge down to the tiny rocky inlets (calanques), bays, and coves dotted with yacht sails and beach umbrellas. It's a drive that the passenger may enjoy more than the driver. Tip: Try to leave early in the morning, as the route can become congested with afternoon traffic.

HAUT-DE-CAGNES

High-in-the-clouds

Steer clear of the congested mess of freeways and tacky beachfront eateries of Cagnes-sur-Mer, but do follow the brown signs directing you inland to "Bourg Médiéval," for they will take you to one of the most beautiful *villages perchés* (perched villages) along the Riviera: Haut-de-Cagnes. This steeply cobbled Old Town feels like a fairytale village built in the clouds. Think tiny, cuter-than-cute piazzas, winding alleys, and charming stone streets that abruptly change to stairways. You could happily lose yourself here for hours.

SENTIER DU LITTORAL

The height of hikes

Like Saint-Jean-Cap-Ferrat, Cap d'Antibes doesn't show its prestigious properties to the average person driving by. You really need to walk the cape to discover its secrets and peek down its side streets. One of the best ways to see this spectacular part of the Riviera is the *Sentier du Littoral* (a.k.a. *Sentier Tirepoil*), which is also one of the most spectacular footpaths in the world. It stretches about three miles/five kilometers along the outermost tip of the peninsula, beginning at the pretty Plage de la Garoupe (where Cole Porter and Gerald Murphy used to hang out). Here, there are dazzling views over the Baie de la Garoupe before the route becomes a little rockier, eventually reaching 50-foot cliffs and dizzying switchbacks. (Note: the signs that read "Attention: Mort" mean "Beware: Death," so don't attempt the walk in windy or stormy weather.) It's a two-hour hike so wear comfy shoes. At the tip, you can continue past some truly gorgeous coves and some even more spectacular villas to reach Juan-le-Pins for an afternoon cocktail. From there, it's a short taxi ride or walk back to Antibes. Or you can pause at the tip of the cape and make your way to Boulevard Kennedy for a well-deserved lunch at the restaurant of the famous Hôtel du Cap-Eden-Roc. (There are amazing views

over the ocean.) Or, if you have the energy, you can visit the extraordinary Villa Eilenroc (open Wednesdays, September to June). Designed by Charles Garnier, who created the Paris Opéra, this lavish display of wealth and style commands the tip of the peninsula from a grandly landscaped grounds featuring one of the loveliest rose gardens on the coast. The villa has been owned or rented by a string of the *über*wealthy including King Leopold II of Belgium, King Farouk of Egypt, Aristotle Onassis, and Greta Garbo, some of whom are said to still haunt it.

Cap d'Antibes; +33 4 93 67 74 33; antibesjuanlespins.com

LUBERON VILLAGES

More than a Sunday drive

The hilltop villages of Provence's Luberon region may not have been designed for cars, but the roads between them certainly were. The landscape between Ménerbes, Lourmarin, Bonnieux, Cucuron, Gordes, and L'Isle-sur-la-Sorgue, to name just a few of the villages, is spectacularly beautiful, with its gentle vineyards, charming stone farmhouses, dramatic mountains, and tranquil valleys. For one of the best views, drive the road from Cavaillon to Gordes via the D2 and D15 roads. As you approach Gordes, you'll see tour buses and cars pull over into a parking area, and beyond that, the village perched high on the mountain, with a green valley spread out before it. The drive to the Sénanque Abbey is a must, too, especially in high summer when the lavender fields around the abbey are in full bloom. (If you're lucky, you might see the monks picking it.)

PLACE GARIBALDI, NICE

Café society

Encircled by grand vaulted arcades stuccoed in rich yellow, this grand, pentagon-shaped square is an example of just how superbly the French do architecture. (With perhaps a little Italian influence, in this case.) In the center, the fountain sculpture of Garibaldi seems almost understated in comparison to the grandeur of its surroundings. Add in a sprinkling of cafés under the arcades, and a delightful antiques market on Saturday mornings, and you have one of the most splendid squares on the Riviera.

PLACE MASSÉNA, NICE

Simply marvelous

Place Masséna is the heart of Nice. Framed by early 17th-century, Italian-style arcaded buildings, their facades stuccoed in rich red ocher, this incredibly beautiful square is reminiscent, in a way, of the Piazza San Marco in Venice. There's always something happening here, too, which adds to the atmosphere. The high point of the year falls in mid-February, when the city hosts one of the most spectacular carnival celebrations in France—it ranks among the world's top three (nicecarnaval.com).

PLAGE DE PASSABLE, PLAGE DE LA PALOMA & SAINT-JEAN-CAP-FERRAT

Luxe for very little

The lush peninsula of Saint-Jean-Cap-Ferrat is no secret, but the villas scattered around the point are, with most of them hidden behind high gates or extravagant tropical gardens. The few hotels here also seem to be exclusive to the point of no entry. However, there is a way to see this famous peninsula's beauty without paying anything for the privilege. Take the coastal walking path, the Chemin de la Carrière, and you will pass some of the richest real estate in the world. Start at the village of Saint-Jean-Cap-Ferrat, itself one of the prettiest on the Riviera, and buy a baguette or salad for a picnic lunch. Then, after you've taken in the yachts and sailboats, the pretty harbor, and the view back to Beaulieu, walk the short distance to Paloma Beach (Plage de la Paloma), a stunning cove that's long been a favorite with the jet set (although they usually pull up in their yachts). There's a waterfront café here if you feel like a meal but the baguette-on-the-beach idea is cheaper and more fun. (Tip: Print out a Google map of the peninsula before you go. It will make navigating the area easier.) After lunch and a swim, make for Avenue des Fosses, turn right on Avenue Vignon, and

follow the Chemin de la Carrière, six miles/eleven kilometers past the millionaires' villas and around the cape. When you've traced the full outline of the peninsula, you'll eventually reach Plage de Passable, where you can cool off with another swim in yet another idyllic cove that only locals know about.

QUARTIER DE LA PONCHE

The flip side of Saint-Trop

When the show-offy summer crowds of Saint-Tropez start to become too much, head for the curious-sounding Quartier de la Ponche. Here, in this maze of backstreets with buildings painted sunny shades of gold, pink, ocher, and sky blue, you'll see a different side of the glitzy village. Many of the tiny streets finish at the sea, so you won't get lost; and in any case, the winding, narrow alleys open to tiny squares with fountains, so you can pause and catch some spray to cool you down. The main street, Rue de la Ponche, leads into Place de l'Hôtel de Ville, which can be recognized by the pink and green Mairie (Town Hall). You'll also find the Fishermen's Port here, and the beach where Bardot did her thing in *And God Created Woman*.

VILLA EPHRUSSI DE ROTHSCHILD

Gilding the (pink) lily

Between the sparkling blue of the Med and the lush green of Saint-Jean-Cap-Ferrat is another color: the beautifully florid pink Villa Ephrussi de Rothschild. Don't come here if you're averse to rose shades. But do come here if you love drama in gardens and architecture. The Villa Ephrussi has it in spades. Constructed in 1905 in neo-Venetian style, the flamingo-pink villa was baptized "Île-de-France" by its owner, the Baroness Béatrice de Rothschild, in homage to her favorite ocean liner. (In keeping with the theme, her staff wore sailing costumes and her ship travel case is on view in her bedroom.) If you can, time your visit for midday, when there's a private tour of her upstairs apartments. The most beautiful part, however, is the garden, which is landscaped with no fewer than seven gardens. There is also a fountain display set to classical music, which mirrors that of Versailles. It's all very over the top, of course, but so gorgeous you can't help but be drawn into the pink fantasy. A true example of the Belle Époque flamboyance of the South of France.

Avenue Ephrussi, Saint-Jean-Cap-Ferrat; +33 4 93 01 33 09; villa-ephrussi.com

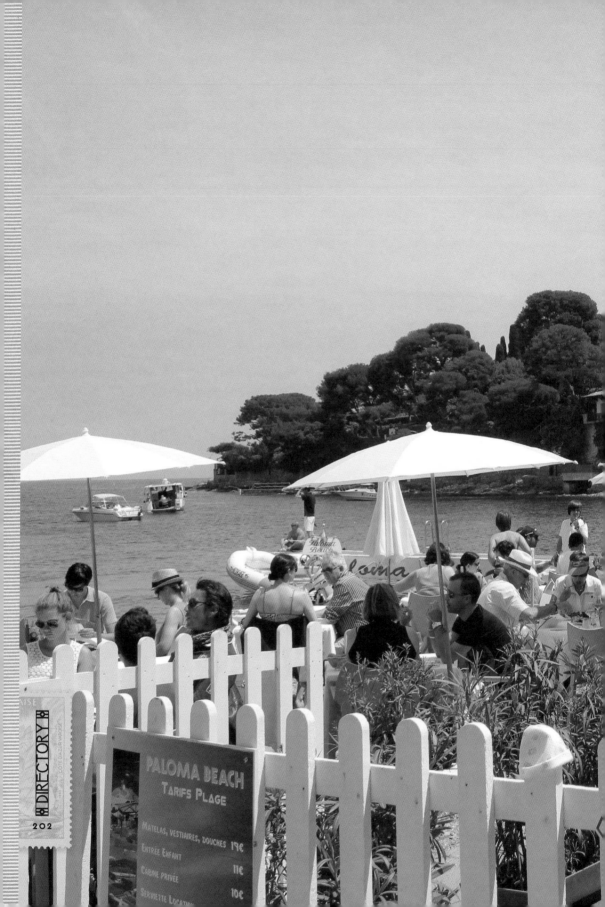

DIRECTORY

PALOMA BEACH
TARIFS PLAGE

MATELAS, VESTIAIRES, DOUCHES 19€
ENTRÉE ENFANT
CABINE PRIVÉE 11€
SERVIETTE LOCATION 10€

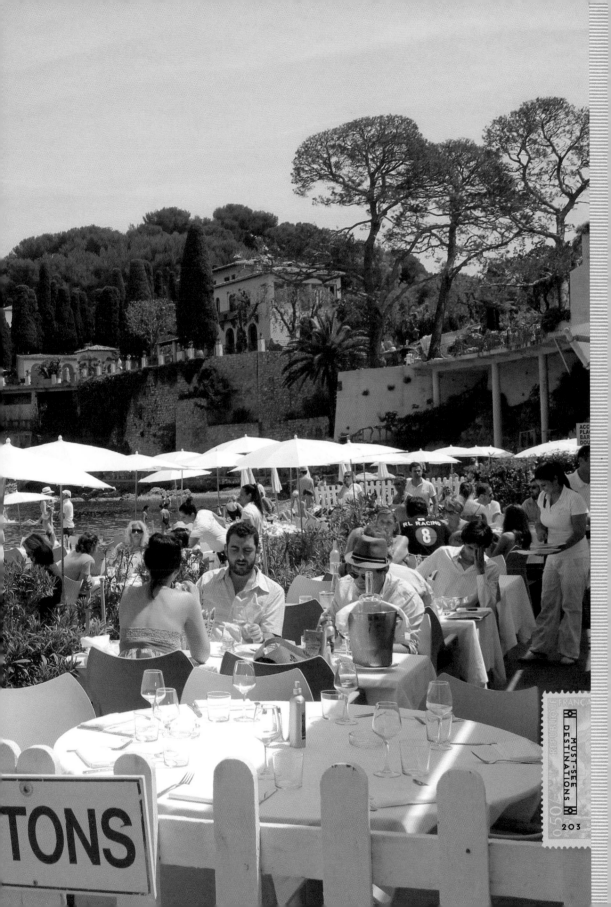

TONS

Major museums

Provence has long been a destination for artists. They come for the quality of light, the spectacular landscapes, the mild seasons, and of course the proximity to good food and wine. Many artists who drifted to this part of France in the early 20th century ended up staying, and their paintings of the area became some of the most famous—and most valuable—in the art world. Consequently, the South of France is full of museums and galleries dedicated to great names, making it a mecca for art lovers.

ATELIER CÉZANNE

Artful lodger

The Atelier Cézanne is a must for art history buffs. This is where Paul Cézanne lived and painted (and immortalized) the Aix landscape. Restored in 1970, the museum is perhaps in need of another restoration, but you can still get a sense of the great artist. His painting smock, his paints, his easel, and his still-life pieces are all there, but what's more evocative is the garden and surrounding landscape. Wandering around outside, you can distinctly see where he painted many of his famous canvases. (Try to find the view of Montagne Sainte-Victoire, the mountain that he painted so often.)

9 Avenue Paul Cézanne, Aix-en-Provence; +33 4 42 21 06 53; atelier-cezanne.com

FONDATION MAEGHT

Aesthetic pleasures

This is a great museum. Highly regarded by many designers, artists and creative types, it not only has superb exhibitions but the people behind the shows are also dealers, so there is an impressive archive of pieces to invest in. Plus—and this is always important—there is a very good bookshop of art and design titles. And once you're done admiring the art you can wander around the lovely garden and admire its beauty.

623 Chemin des Gardettes, Saint-Paul de Vence; +33 4 93 58 03 26; foundation-maeght.com

MUSÉE D'ART ET D'HISTOIRE DE PROVENCE

The extraordinary of the ordinary

Housed in an elegant 17th-century mansion, the Museum of the Art and History of Provence portrays everyday life in eastern Provence since prehistoric times. It's a mesmerizing look at the beauty of the ordinary.

2 rue Mirabeau, Grasse; +33 4 93 36 80 20; www.museesdegrasse.com

MUSÉE DES BEAUX-ARTS DE NICE

Fine lines

The Musée des Beaux-Arts (Fine Arts Museum) in Nice is housed in a fantastically glamorous 1878 Belle Époque villa that was the former mansion of the Ukrainian Princess, Elisabeth Vassilievna Kotschoubey. What a truly fitting place to showcase flamboyant and fabulous works by the likes of Fragonard, Monet, Sisley, Dufy, and Rodin. The late Impressionist pieces by Bonnard, Monet, and Sisley are dazzling, the works by Rodin are as masterful as you'd expect, but it's the room full of Raoul Dufy's works that really impresses.

33 Avenue des Baumettes, Nice; +33 4 92 15 28 28; musee-beaux-arts-nice.org

DIRECTORY

MUSÉE MARC CHAGALL

Modernist marvel

The Musée Marc Chagall is dedicated to the work of painter Marc Chagall. Although not as well known as other painters who have museums dedicated to them on the French Riviera, Chagall is certainly worthy of his own tribute. The building, designed by architect André Hermant, has a modern, geometric look, as befitting a Modernist artist, and is still magnificent 40 years after it was built. It was meant to create a peaceful atmosphere in which to view Chagall's spectacular and incredibly detailed paintings that borrow from Fauvism, Expressionism, Surrealism, and Cubism. The Russian artist loved this part of France for its bold colors and bright skies. Picasso once said: "When Matisse dies, Chagall will be the only painter left who understands what color really is."

Avenue Docteur Ménard, Nice; +33 4 93 53 87 20; musee-chagall.fr

MUSÉE MATISSE

Master of color

The brilliant ocher-red of the Matisse Museum is the perfect backdrop for this artist's extraordinarily vibrant paintings, sculptures, drawings, engravings, paper cut-outs, and illustrated books. Much of the collection has been left to the museum by Matisse's heirs as a tribute to both Matisse and the place he loved. (Matisse lived and worked in Nice from 1918 until 1954.) It's a must-see if you're an art lover. Simply joyful.

164 Avenue Arènes de Cimiez, Nice; +33 4 93 81 08 08

MUSÉE NATIONAL FERNAND LÉGER

Striking

Léger doesn't get as much media coverage as his contemporaries and that's a shame. Come to this museum near Biot, north-west of Antibes, and you'll see what a talent he was. Housed in a splendid building marked by two of Léger's huge murals on the outside, the collection encompasses paintings, drawings, ceramics, and tapestries.

Chemin du Val de Pome, Biot; + 33 4 92 91 50 20; musee-fernandleger.fr

MUSÉE PICASSO

Squared up

Set high on the Old Town overlooking the artist's beloved blue sea, the Picasso Museum is an architectural ode to the man who is arguably one of the world's most famous artists. Despite the building's grand old age (it's actually a 16th-century château that once belonged to the Grimaldis), it's a geometric, modern-looking building that perfectly suits Picasso's work. The painter lived here for six months and left behind a number of pieces as a thank-you when he left. The building was eventually converted to a museum as a thank-you to Picasso in return. Unfortunately, the collection isn't extensive—two dozen or so paintings, forty or so drawings, some oils, ceramics, and sculptures—but a highlight is *La Joie De Vivre*—a painting of pure joy. Look out the window and see the view of the Med and it will elicit the same feeling. No wonder Picasso was inspired!

Place Mariejol, Antibes; +33 4 92 90 54 20; pablo-ruiz-picasso.net/museums

MUSÉE RENOIR

The light of his life

Renoir was a master of light, and the Riviera, with its open blue skies and clear bright days, was a place he loved to paint. He lived here in the last years of his life and did some of his best work at his farmhouse at Cagnes-sur-Mer. This is the same house that's now a museum dedicated to his life and work. Although closed for renovation in 2013, it features original furniture and decoration, as well as the painter's studios, almost a dozen original paintings, various sketches, lithographs, many old photographs, and of course personal possessions.

19 Chemin des Colettes, Cagnes-sur-Mer; +33 4 93 20 61 07

Art galleries, decorating stores, and other design destinations

During the 18th century, which was the high tide of French furniture design, much of the best Provençal furniture came from the wealthy environs of Arles and Avignon. Two centuries later, antique dealers flocked here to satisfy a growing international market for fine Provençal pieces. The region is still home to some of the best antique dealers in France, and also some of the best flea markets, although, as authentic Provençal furniture from the 18th and early 19th century is harder to find, reproductions are now common. Even high-end dealers sell reproductions alongside the rare antiques. But the area is also known for many other kinds of design, from architecture to home furnishings, and linen to landscape photography. Here are a few destinations for lovers of design.

ANTIQUITÉS MAURIN

Antiques in Arles

Antiquités Maurin is an old family business with an impressive pedigree and an even more impressive reputation. The Maurins manage a business comprising three shops that carry an extraordinary collection of antiques and vintage collectibles, including armoires, tables, commodes, 18th-century mirrors, and even collectible paintings by Provençal masters. Don't come here if you're on a budget. But do come if you're on the hunt for something very fine.

4 Rue de Grille, Arles; +33 4 90 96 51 57; antiquites-maurin.com

CAROLYN QUARTERMAINE

Well scripted

If you're a fan of textile and interior designer Carolyn Quartermaine's spectacular, hand-printed fabrics, including the famous silk taffetas with swirly script designs, you can now shop from her collection in the intimacy of her own home. An exquisite getaway that's been featured in *Vogue Living*, Carolyn's vacation home is worth seeing as much for the architecture as for the goodies displayed inside. The building was originally a 17th-century woodworker's house and then became a modern art gallery (associated with artists such as Matisse and Picasso), thanks to the French designer Jacqueline Morabito. Carolyn spent four years renovating it, adding a light-filled studio where she designs the fabrics that are for sale from her London studio and through other sources. Visit by appointment only, as she divides her time between London and the Riviera.

La Colle-sur-Loup; +44 20 73 73 44 92 (London); carolynquartermaine.com

DIOR

J'adore Dior

You may think all Dior stores have the same sophisticated finishes and sleek façades. Well, the Saint-Tropez Dior does all that, but it's also a little different. It's one of the prettiest designer stores in the world. Dior's designers have taken their cues from the distinctive architecture of the Côte d'Azur and fashioned a store that looks more like a chic private villa on the coast than a generic boutique. Created out of the grand shell of the 18th-century Jardins de l'Ambassade, it combines classic 18th-century French style with contemporary elements, all of it dressed in a sophisticated palette of Dior gray. There's also a café in the front garden, where Dior-gray chairs nestle among the greenery and gray gravel backdrop, and food is served on Lily of the Valley Dior crockery. From the chic shutters to the stylish front gate, it's a store that entices as much for its clever design as for what's inside. Oh—and Dior loves the town so much it named one of its nail lacquers "Saint-Tropez."

13 Rue François Sibilli, Saint-Tropez; +33 4 98 12 67 63

EBENE

French decorating

Ebene is one of the many home-decorating stores in Saint-Rémy-de-Provence. Who knows why this village is a shrine to design boutiques? Perhaps it's a sign of the stylish locals? Whatever the reason, there are streets full of them, and Ebene is up there with the best. The showroom features sofas, chairs, lamps, home furnishings, beds, headboards, screens, lanterns, and other French-style pieces, but the prettiest are the drapes and curtains—guaranteed to make your living room at home look as charming as a Provençal B&B. You'll have to search to find it—it's tucked away at the end of a courtyard off Boulevard Victor Hugo—but it's worth meandering through the town to discover its decorating riches.

38 Boulevard Victor Hugo, Saint-Rémy-de-Provence; +33 4 90 92 36 10; ebene-deco.net

EDITH MÉZARD

Linen loveliness

Many linen lovers are aware of Edith Mézard's store tucked inside her home, the Château de l'Ange, in the lovely village of Goult. It's only open for a few hours every day, but it's so popular that those wishing to buy fabrics usually rearrange their travel schedules to suit. Edith sells all sorts of linen, and can make to order, but is most famous for her delicate hand-stitched embroidery. She and her staff embroider beautiful script (including elegant monograms) onto the equally beautiful French linen fabrics that they stock. You can't imagine how popular they are. There are exquisite tea towels with the names of herbs embroidered onto them, bed linen with beautiful phrases, and even blue linen coatdresses. It's all very French. And all very coveted.

Château de l'Ange, Lumières Goult; +33 4 90 72 36 41; edithmezard.fr

ESPACE BÉCHARD

Antique heaven

Virtually an antiques warehouse, Espace Béchard houses 11 different dealers, each offering staggering (and sometimes staggeringly big) antiques and other pieces. Be warned: it's a highly seductive source of gorgeous French goods. You may not be able to carry these things home on the plane, but you'll certainly consider it.

1 Avenue Jean-Charmasson, L'Isle-sur-la-Sorgue; +33 4 90 20 81 40

FABRIQUE DES FLEURS

Scented pleasures

The Fabrique des Fleurs grows the aromatic plants it uses for its perfumes and other products in the superb gardens that surround the modern factory building.

Les 4 Chemins, Route de Cannes, Grasse; +33 4 93 77 94 30

GALERIE BRAUNSTEIN

Déco delight

Art Déco is making a huge comeback, thanks in part to Baz Luhrmann's film *The Great Gatsby*. Lovers of this glamorous age will adore visiting this gallery, managed by Alain Braunstein, whose remarkably good eye makes for a remarkably good collection. The window displays are particularly beautiful and look more like a stylish apartment than a storefront. There are always exceptional pieces inside, including many from Lalique.

26 Rue de la Liberté, Nice; +33 4 93 87 96 28

GALERIE DU CHÂTEAU ESPACE GRAPHIQUE

Line and light

A local favorite for modern art and design, this great gallery is tucked away in Nice's Old Town, where there are many fantastic places to buy art. Château Espace Graphique has a fine collection of graphic works and photography, and often exhibits the work of talented newbies—a welcome chance for them to show their illustration and photography skills to a larger audience.

9 Rue Droite, Nice; +33 4 93 85 94 36

GALERIE JACQUELINE PERRIN

Remembering the eras

Just a short walk from the Museum of Modern and Contemporary Art (Musée d'Art Moderne et d'Art Contemporain, known as MAMAC), Galerie Jacqueline Perrin showcases magnificent work, mostly from the 20th century but also some from the 19th century. Both French and international artists are shown, and the exhibitions are always a standout.

14 Avenue Saint-Jean-Baptiste, Nice; +33 4 93 92 57 47; galerie-perrin.com

JACQUELINE MORABITO

Pièce de résistance

Ms Morabito's showroom is full of fine pieces. The interior designer whose homes and projects have appeared in *Vogue Living* has an astute eye when it comes to decorating. You're liable to pick up some beautiful things here, in her store, but you're also liable to walk away with a couple of new ideas. And she doesn't just deal in furniture—there's also ceramics, china, and a few unusual pieces. Eclectic, yet still elegant.

65 Rue Yves Klein, La Colle-sur-Loup; +33 4 93 32 64 92

JEAN-LOUIS MARTINETTI

Impressive imagery

Tucked in among all the art galleries that make Nice such an art lover's city, this small gallery is dedicated to a different medium: photography. It displays the artistic legacy of Jean-Louis Martinetti, a renowned photographer who loved Nice as much as he did photography, and delighted in trying to capture his favorite town through his lenses. His work is beautiful, and captures well-known landmarks such as the Promenade des Anglais, as well as rare moments such as the Mediterranean during a storm. The gallery also has a little shop with great gift ideas, from photo albums to postcards and diaries.

17 Rue de la Préfecture, Nice; +33 4 93 85 61 30; martinetti.fr

JEAN CHABAUD LES MATÉRIAUX ANCIENS

A treasure trove of château-esque pieces

With design lovers seeking more and more unusual pieces with which to decorate their newly restored vacation home—or their own houses back home—Jean Chabaud has become the go-to man for great statement pieces. Think grand fireplaces and Louis XV limestone mantels. There are also impressive château gates, huge stone fountains, and other items that wouldn't look out of place in Versailles. Just incredible.

20 Route de Gargas, Apt; +33 4 90 74 07 61; chabaud-materiaux-anciens.com

L'ÎLE AUX BROCANTES

Brocante bliss

There are dozens of antiques shops in L'Isle, but this place concentrates 40 or so dealers into one convenient location. It's a great source of different items, too, from unusual garden pieces to rare home furnishings.

7 Avenue des Quatre Otages, L'Isle-sur-la-Sorgue; +33 4 90 20 69 93; www.lileauxbrocantes.com

LA COLLINE

Sweet as sweet

Is this the prettiest store in Provence? It's certainly one of the most photographed. With an endearingly aged façade that's topped—in picturesque style—with wisteria vines, and a welcome sign that says simply "Jardin des Chats," you have to go in to see what such a store could sell. Well, the interior is just as sweet as the outside, with cute garden ornaments, delightful furnishings, and things you'd never expect. It's slightly different from the usual linen-and-lavender fare, and the kind of store that's popping up a lot in Provence. Wander in and be enchanted. (Lourmarin is lovely to visit anyway.)

6 Rue Henri de Savournin, Lourmarin; +33 4 90 09 95 21

LA MAISON BIEHN

Fabulous fabrics

Michel Biehn is the gentleman many designers go to when they want the real deal—authentic vintage French fabrics to upholster their clients' pieces. He's also renowned for his traditional Provençal quilts, which can date from the 18th century and be priced accordingly. These are heirloom pieces; fabrics you keep forever. Biehn also offers some faded, rustic-style, contemporary linens and household accessories, but it's the antique fabrics people really love. The shop is housed in a stunning home with a walled garden. One or two people have mentioned that he closes regularly, so do check before you go.

7 Avenue des Quatre Otages, Isle-sur-la-Sorgue; +33 4 90 20 89 04

LA MAISON DES LICES

De-licious

Saint-Tropez may not be the place to shop for bargains, but it is the place to shop for goods with a wow factor. This store has a gorgeous selection of merchandise, from an impressive range of furniture (in case you want to furnish your new villa), to tabletop pieces, bedware, flatware, dinnerware, pretty summer clothing (lots of linen), and household trinkets. A fab one-stop-shop if you're in need of a chaise and a casual summer dress—all at once.

18 Boulevard Louis Blanc, Saint-Tropez; +33 04 94 97 11 34

LE VILLAGE DES ANTIQUAIRES DE LA GARE

A mini village of antiques

There are numerous antique dealers in L'Isle-sur-la-Sorgue, and wandering through them all (or even contemplating it) can be exhausting. This place makes it easier by clustering more than 100 small dealers in a warehouse, so you can see them all at once. It's a good source of great pieces, including gilt-framed mirrors, zinc-top tables, crystal liqueur-glass sets, grand old lamps, and fine heirloom silver.

L'Isle-sur-la-Sorgue

LES OLIVADES FACTORY OUTLET

Fabric from the source

Many people know and love Les Olivades. And there are many copies around. Indeed, go to any French market and you'll see fabrics in bright Provençal designs that are cheap imports rather than the authentic thing. Olivades, which is reportedly the only company still manufacturing traditional fabrics in Provence, has shops in Aix, Avignon, Carpentras, Nîmes, Saint-Rémy, and Vaison, but this factory outlet is the best source for these famous fabrics at cheap prices. As well as fabrics by the yard/meter, there are napkins, table runners, tablecloths, and other items. There are also guided morning tours of the fabric printing workshop (in English)—although call first to arrange an appointment.

Chemin des Indienneurs, Saint-Étienne-du-Grès; +33 4 90 49 18 04; olivades.fr

SACHA DÉCORATION

Slick interiors

You know those sleek, Flamant-style interiors you often find in luxurious homes? The ones with linen slipcovers in that perfect French gray-beige shade? Where the furniture is distressed timber but still looks modern? And where everything is perfect, from the topiary trees to the coffee-table displays? Well, Sacha Décoration excels in such perfection. The aesthetic of this fiercely stylish store is one of understated luxury. It's a surprise to come across a store like this in the tiny village of Ménerbes; you'd usually see this "look" in boutiques off Saint-Germain or on the Upper East Side. But it shows how far Ménerbes has come since Peter Mayle put it on the map.

Place Albert Roure, Ménerbes; +33 4 90 72 41 28; sachadecoration-designers.com

SAVONNERIE DE BORMES

Soap star

Traditional soap making is still practiced in Provence, and foreigners adore it. They come here and they buy soap in bucketloads. (The scent reminds them of their time in the South of France.) Savonnerie de Bormes still makes soap the old-fashioned way, though the soaps themselves are far from boring. The range of scents includes almond, fig, lavender, jasmine, and seaweed. There's also a huge range of bath and body products. Stocked in various places, or phone the factory in Bormes-les-Mimosas for a visit.

Bormes-les-Mimosas; +33 4 94 01 03 00; savonnerie-bormes.com

SAVONNERIE MARIUS FABRE

Soapie drama

This company has been producing blocks of traditional all-purpose soaps by hand for more than a century. Visiting here is a complete sensory experience: sight, smell, and touch. There is also a shop and a little soap museum, which is oddly interesting.

148 Avenue Paul-Bourret, Salon-de-Provence; +33 4 90 53 24 77; marius-fabre.com

SYLVIE T.

Putting art into architecture

Sylvie T.'s drawings are just delightful. They're the kind of drawings we all wish we could do, if we had the time, the skill, and the patience to sit in one place for an hour. With her love of architecture, she naturally gravitates toward the gracious lines of the French Riviera's most famous cities, but she's also adept at capturing the scenery of the coast—old fishing boats, ancient winding streets, even the markets. Her work makes for a great memento; she's also illustrated a book about the cultural heritage of *Vieux Nice* (Old Nice).

14 Rue Droite, Nice; +33 4 93 62 59 15; sylvie-t.com

THÉATRE DE LA PHOTOGRAPHIE ET DE L'IMAGE—CHARLES NÈGRE

History in print

Charles Nègre is well known in Nice, certainly among the artistic community. The photographer spent the main part of his life here, and his legacy is an enormous portfolio of photographs that depict the beauty and history of this celebrated seaside town. This venue shows the depth of his talent, and the incredible images he took. Apart from the large selection of Nègre's photos, the museum also displays the works of famous 20th-century masters of photography from all over the world.

27 Boulevard Dubouchage, Nice; +33 4 97 13 42 20; tpi-nice.org

TRUFFAUX

Hats off to you

Ever wondered why all the locals in Saint-Tropez always look so stylish, even in the sweltering, high-summer heat? They buy their hats at Truffaux. Milliners Oska and Imogen Truffaux were originally from Ecuador, but have brought their award-winning, hand-woven hats to Saint-Tropez, sensing (quite rightly) that there would be a market here for them. Panama hats, fedoras, and trilbies are fitted to your head in the shop with the help of the on-site steamer. The result? A hat that looks like it was tailor-made for you. Just see if you can resist.

44 Rue de la Citadelle, Saint-Tropez; +33 6 69 55 86 54; truffaux.com

VAN HALEWYCK

Channeling the masters

Van Halewyck is a tiny shop crammed with Old-Master–style paintings. It's the kind of place you go to when you want some of those gilt-framed pieces that have become fashionable again, the ones that make your home's interior look more handsome—and highbrow. The only problem is getting them home in your luggage. Some people have been known to carry them in their totes, all the way from Provence to New York City.

15 Quai de Rouget de L'Isle, L'Isle-sur-la-Sorgue; +33 4 90 38 65 25

VILLA NOAILLES

Villa aristocrat

Anyone with an interest in 20th-century design will be fascinated by the avant-garde 1920s home of art patrons and aristocrats Marie-Laure and Charles de Noailles. It's an early Modernist house built by architect Robert Mallet-Stevens between 1923 and 1933 in the hills above Hyères. Throughout the 1920s and 1930s, the two were important patrons of Modern art, particularly Surrealism. They supported Man Ray, Salvador Dalí, Luis Buñuel; and commissioned paintings, photographs, and sculptures by many others. They were also friends with Pablo Picasso and Jean Cocteau. Many of their friends (including Buñuel and Man Ray) came to stay, and many left something behind. The result is a villa brimming with beauty and history.

Parc Saint-Bernard, Hyères; +33 4 98 08 01 98; villanoailles-hyeres.com

XAVIER NICOD

Xanadu

Xavier Nicod's extraordinary boutique is like walking into a book by L. Frank Baum. You almost expect the Wizard to greet you from behind the front counter. Think grand trees lining the entrance, gravel on the floor instead of carpet, and almost cinematic flower displays in a huge copper bath. It's retail, but not as you know it. (Another worth seeing when you're popping in to experience Xavier's Xanadu is Gérard Nicod.) Both stock beautiful designs but with a twist.

9 Avenue des 4 Otages, L'Isle-sur-la-Sorgue; +33 4 90 38 35 50/07 20; xavier-nicod.com

Markets and flea markets (a selection)

Some people travel to Provence for one reason: the markets and shopping. The area has become famous for its antiques, fabrics, vintage furniture, and markets. Unfortunately, the influx of tourists has meant that in the last few years those places that had the best antiques, such as L'Isle-sur-la-Sorgue, have become increasingly overrun with old bric-a-brac (brocante). Nevertheless it's still fun to hunt for treasures, so don't discount a place just because you see a stand there with "I Partied Hard in Saint-Tropez" T-shirts.

AIX-EN-PROVENCE

Aix is so fond of markets that it scheduled three different markets on three different days: Tuesday, Thursday, and Saturday. The first is a very large general market that spreads across Place des Prêcheurs, Place de la Madeleine, the Quartiers d'Encagnane, and Jas de Bouffan. The second is a flower market on the Place Hôtel de Ville. The third is a flea market on the Place Verdun near the Palais de Justice. There's also a daily farm market in Aix, on the Place Richelme near the City Hall. If you're after high-end antique pieces, time your visit for high summer in July and August, when antique dealers and artisans gather on the Place Jeanne d'Arc and Cours Sextius. Or you can shop the antiques stores that are permanently open in Aix: There is a cluster on Rue Manuel and Rue Emeric David, just to the west of Boulevard Carnot in the center.

ANTIBES

The daily covered market in Antibes' Cours Masséna is an ebb and flow of produce and promise. Sometimes it's great; other days not so good. But the atmosphere on a good day can't be beat. Just try to resist the olives and tapenade, and the vendors' persuasive charm. A better market in Antibes is the Brocante market, held from 8 a.m. to 7 p.m. at Place Jacques Audiberti and Boulevard d'Aguillon in Old Antibes on Thursdays and Saturdays.

ARLES

Arles has a weekly market on Saturday and a flea market on the first Wednesday of every month, both on the Boulevard des Lices. As these are some of the largest markets in Provence, they can get congested, so watch your belongings. But they're still great occasions that celebrate markets in true grand style.

AVIGNON

Avignon hosts a flea market on Sunday mornings in Place des Carmes. It starts at 6.30 a.m. and it's worth getting there early. There's also a market across the river in Villeneuve-les-Avignon, held every Saturday morning in Place du Marché and Avenue de Verdun (similar goods, better value). For a really colorful—and scented—experience, try the Avignon Flower Market, held on Place des Carmes on Saturdays.

L'ISLE-SUR-LA-SORGUE

One of the most concentrated sources of vintage bits and bobs is L'Isle-sur-la-Sorgue's market, held every Sunday from 8 a.m. until 1 p.m. or so. (There's also a smaller one on Thursday, if you can't make Sunday.) Most of the stalls are set up on the series of canals that run through town, creating a picturesque walk. It has become very touristy, but it's still a great experience on a warm sunny day. If it's more "serious" goods you're after, then hit the antique arcades and stores that are scattered throughout L'Isle, most of which are open during the week as well. They offer a more high-end selection of goods, with prices to match.

NICE

Many regard Nice's market as one of the best on the French Riviera. It's certainly one of the most atmospheric. Held in the stunning Cours Saleya square daily (except Mondays), it's a riot of colorful awnings surrounded by even more colorful buildings. Unlike many other markets that are held only once or twice a week, this is a morning festival of food, flowers, scents, color, conversation, laughter, and the joy of life. The flower stalls are as marvelous as the food stalls, especially in spring/summer when the peonies overflow from every bucket. The market is held from Tuesday through Sunday, 6 a.m. to 1 p.m. On Mondays, when the food and flowers are packed away, the Cours Saleya becomes one big beautiful outdoor antiques market, with an endless array of period furniture, vintage jewelery, and collectible porcelain.

SAINT-RÉMY-DE-PROVENCE

The attractive town of Saint-Rémy-de-Provence holds its weekly market on Wednesday mornings, when the streets of the Old Town become crammed with scores of stalls. There's both food and other fare here, so you can nibble on some cheese while you're looking for souvenirs of Provence. One of the most popular markets in Provence.

SAINT-TROPEZ

Saint-Tropez isn't known for its bargains, and the town's market is no exception. However, it's still great to browse because the range is so interesting. There's everything from bikinis to straw bags for sale here under the canvas awnings. Saint-Tropez's outdoor market has clothes, food, and brocante (secondhand goods), and takes place on Tuesday and Saturday mornings on Place des Lices from 8 a.m. until noon.

UZÈS

Uzès' market is held in the impossibly romantic setting of the medieval square, known as Place aux Herbes, in the heart of town. The square comes to life every Saturday morning with stalls selling local produce and crafts, although there are yet more stalls that fill the narrow side streets. From 8 a.m. until midday.

VILLENEUVE-LES-AVIGNON

The convivial Marché à la Brocante in Villeneuve-les-Avignon takes place every Saturday morning on the Place du Marché. There is always a tempting assortment of merchandise, from lovely vintage quilts to monogrammed linens and printed fabrics and also Art Déco jewelry—very fashionable after the success of *The Great Gatsby*.

CONTENTS

Introduction
Discovering the spirit of
the South of France 8

PART 1:
PROVENCE

L'Isle-sur-la-Sorgue:
The emerald river 21

Ménerbes:
The reluctant star 31

Lourmarin:
The gourmet town 41

Saint-Rémy-de-Provence:
The aesthete 51

Aix-en-Provence:
The elegant beauty 59

Avignon:
The arts town 69

Arles:
The historical beauty 79

Lotto:
The hideaway 87

PART 2:
THE CÔTE D'AZUR

Nice:
The grand dame 93

Cap Ferrat:
The ambitions 109

Beaulieu-sur-Mer:
The secret delight 119

Èze:
The excelsior 127

Menton:
The garden lover 133

Saint-Paul de Vence:
The artist 141

Cannes:
The film star 149

Antibes and Cap d'Antibes:
The lit set 157

Juan-les-Pins:
The beach beauty 167

Saint-Tropez:
The glamour puss 175

PART 3:
DIRECTORY OF
INSPIRATIONAL PLACES

Hotels and guesthouses 185

Must-see destinations 195

Major museums 205

Art galleries, decorating stores and
other design destinations 217

Markets and flea markets
(a selection) 221

Captions 226

Index 240

Merci 264

Pages 4–5

A quiet cove at Cap d'Antibes,
which has barely changed for
a century.

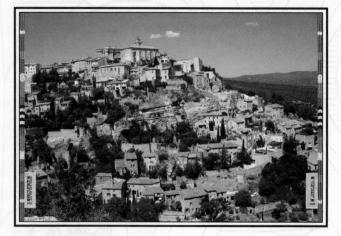

Pages 6–7

The mountaintop village of
Gordes.

DISCOVERING THE SPIRIT OF
THE SOUTH OF FRANCE

Pages 8–9

One of the many charming roads
that wind through Provence.

........

Page 11

The Hôtel du Cap-Eden-Roc,
Cap d'Antibes.

........

........

Pages 12–13

The Riviera is dotted with grand
villas; some of the most beautiful
are located at Cap Ferrat
and Cap d'Antibes.

........

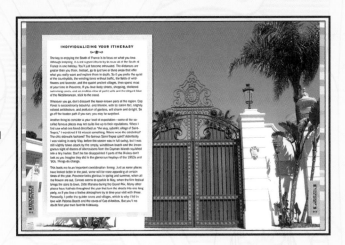

........

Page 14

A vintage Citroën just manages
to squeeze through a lane in the
village of Ménerbes.

........

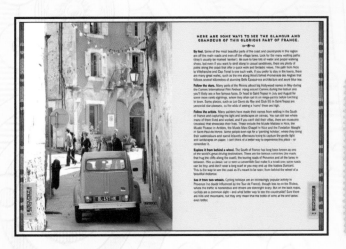

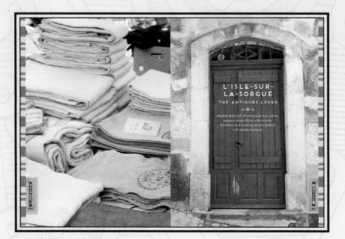

.........

Page 20

L'Isle-sur-la-Sorgue's weekly markets have become world-famous.

.........

.........

Pages 24–25

One of the splendid bridges in L'Isle-sur-la-Sorgue.

.........

.........

Page 27

L'Isle's markets offer everything from vintage conservatories to château shutters.

.........

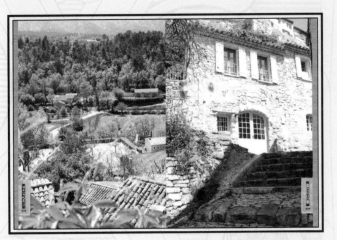

........

Page 30

The ancient, narrow lanes of
Ménerbes offer a delightful
exploration on a spring day.

........

........

Pages 38–39

Left: The views from the village of
Ménerbes are as photogenic as the
town itself.

Right: A quiet stone back street of
Provence offers the perfect place for
artists to find inspiration.

........

........

Page 44

An old stone fountain is
a welcome sight on a hot
summer day.

........

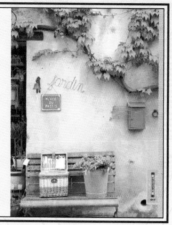

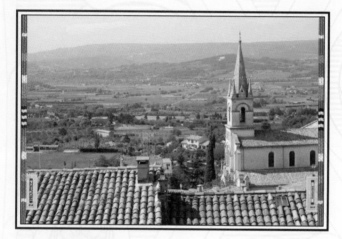

.........

Pages 54–55

With colors this bright, it's not surprising that Saint-Rémy inspired van Gogh to paint again.

.........

.........

Page 60

Aix's architecture is some of the most elegant in the South of France.

.........

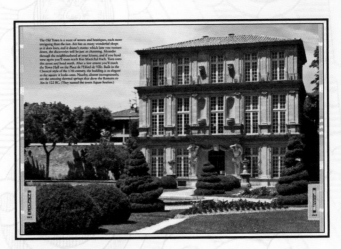

.........

Pages 62–63

The garden of the Pavillon de Vendôme is a lovely place for a picnic lunch on a warm day.

.........

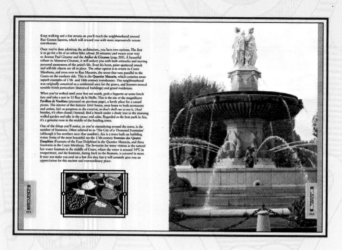

Page 65

The grand fountains of Aix are famous for their beauty.

Pages 66–67

A view over Avignon.

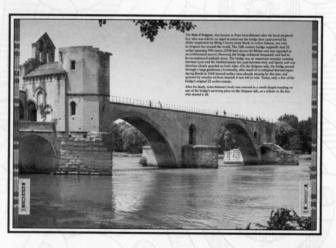

Pages 72–73

The Pont d'Avignon.

.........

Page 75

Architectural magnificence
in Avignon.

.........

........

Page 78–79

Provence is full of gently aging
architecture, still as elegant as ever.

.........

........

Page 86

Beautiful deck-chair canvas in
bright stripes is just one of the
kinds of fabrics created in the South
of France.

.........

Page 88

A typical example of the intricate ironwork on gates throughout Provence.

Pages 90–91

A quiet river in the countryside near Uzès.

Page 96

A glimpse of the garden at the Villa Ephrussi de Rothschild.

PROVENCE
AND THE CÔTE D'AZUR

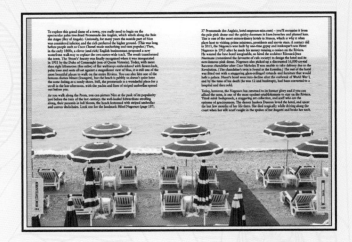

........

Page 98

The iconic pink dome of
Hôtel Negresco on the
esplanade in Nice.

........

........

Pages 102–103

Blue-and-white umbrellas
stretch down the beach at
Nice, creating one of the most
recognizable views on
the Riviera.

........

........

Page 105

Place Masséna in Nice,
a grand square surrounded
by magnificent yellow and
chile-red buildings reminiscent
of Venice's Piazza San Marco.

........

........

Page 106

A salon in the Villa Ephrussi de Rothschild, located just down the road from Nice at Cap Ferrat.

........

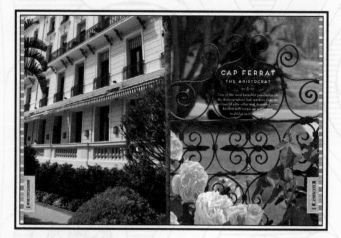

........

Page 108

The Royal-Riviera at Cap Ferrat, one of the most beautiful hotels on the French Riviera.

........

........

Page 110

Paloma Beach, where the rich and famous moor their yachts and stop in for lunch and a swim.

........

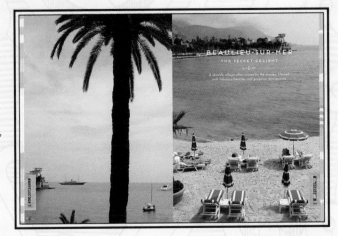

Pages 118–119

Beaulieu-sur-Mer is the Riviera at its most charming: quiet, pretty, and punctuated with palm trees.

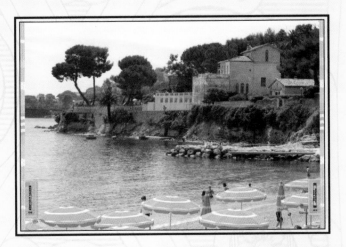

Pages 122–123

The sheltered beach at Beaulieu-sur-Mer, popular with families.

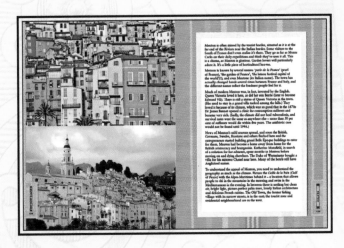

Page 134

Menton's architecture is a riot of colors, a legacy of the Italians, who heavily influenced the shape of this city.

........

Page 140

A tiny window boasts a splendid
horticultural display.

........

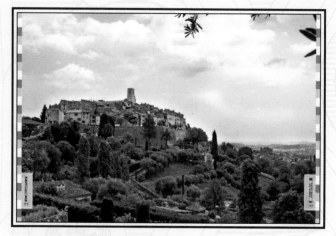

........

Pages 144–145

The views of Saint-Paul-de-Vence
are so beautiful, it's no wonder
artists flock here.

........

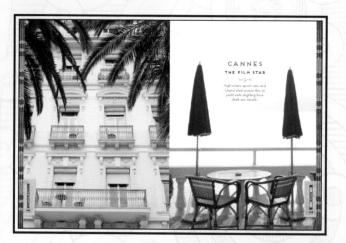

........

Page 148

Some of the best views
in Cannes are seen by
looking up at the architecture.

........

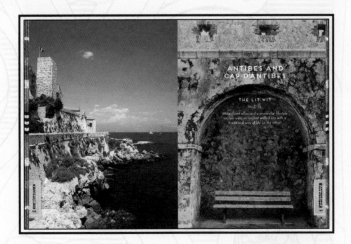

.........

Page 150

The harbors of Cannes
are always filled with
impressive yachts and
amazing motor cruisers,
while the esplanade is just
as eye-catching.

.........

.........

Page 156

Antibes' ancient
fortifications offer a
stunning way to
wander the city.

.........

.........

Page 162

One of the many
luxurious villas of
Cap d'Antibes.

.........

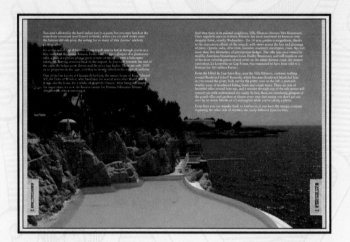

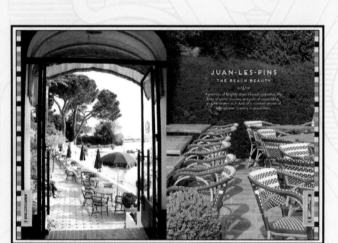

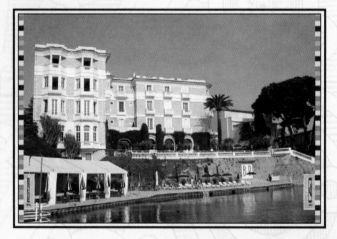

........

Page 176

A chic bistro on Place des Lices, the main square of Saint-Tropez.

........

........

Pages 178–179

Mega-cruisers line the little harbor of Saint-Tropez, looking slightly out of place against the humble architecture of this former fishing village.

........

........

Page 190

The entrance to Hôtel Negresco in Nice.

........

.........

Page 195

The lovely pool of the
Bastide Rose guesthouse
in Provence.

.........

.........

Page 198

Turquoise beach
umbrellas shade the pier at
Juan-les-Pins.

.........

.........

Page 204

The spectacular gardens
of the Villa Ephrussi
de Rothschild.

.........

Page 210

The Dior store in Saint-Tropez comes with its own sophisticated Dior café.

.........

Page 223

Peonies at the flower market in Nice's Old Town.

.........

Pages 250–251

The charming village of St-Jean-Cap-Ferrat.

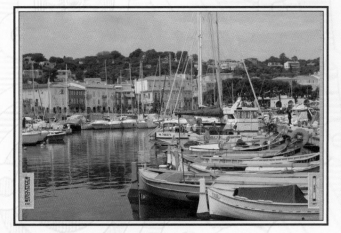

INDEX

A Good Year 33, 45, 46
A Year in Provence (Mayle) 33
Aarons, Slim 164, 187
Abbaye Saint Hilaire 36
Abramovich, Roman 164
accommodation 185–196
Africa Plage 124
The African Queen, Beaulieu 124
Aix-en-Provence 59–64, 221
Albert, Price of Monaco 154
Allen, Paul 113
Alpes-Maritimes 135
amphitheater 84
André, Edouard 104
Antibes 157–65, 221
antiques 21, 23, 25, 26, 180, 211, 212, 214
Antiquités Maurin 211
Aquae Sextiae 62
aqueduct 93
architecture 64, 89, 104, 136, 159, 165
Arles 79–84, 221
Armani, Giorgio 10
Art Déco 169, 172, 212
artists fellowships 36
Atelier de Cézanne 64, 205
Au Petit Jardin, Uzès 92
Avenue des Quatre Otages, L'Isle 23
Avenue du Partage des Eaux, L'Isle 26
Avenue Georges Clémenceau, Antibes 161
Avenue Somerset Maugham, Cap Ferrat 113
Avignon 69–74, 81, 221
Avignon Festival 74
Avignon Flower Market 74

Bac, Ferdinand 138
Bar Absinthe, Antibes 163
Bardot, Brigitte 10
bars 43, 61, 154, 163, 169
Bastide Rose (guesthouse) 185
Bastille Day 104
Bataille de Fleurs, Nice 105
Beaulieu-sur-Mer 119–124
Beaumont, Louis D 165
Beaux Arts 56
Belle Epoque 15, 101, 105, 124, 135, 151
Bennet, Dr James 135
Bennett, Gordon 124
Beyoncé 154
Bonne Terrasse 180
Bonnieux 45
Bono 10, 124
book market 26

Boulevard de Garavan, Menton 138
Boulevard des Lices, Arles 84
Boulevard General de Gaulle 114
boutiques 169, 177, 179
B.Pub, Cannes 154
bric-a-brac 26, 74
bridges 23, 26, 73, 93
The Brown Foundation Fellows Program 36
bullfights 81

Café de France, Lacoste 46
Café de France, L'Isle 26
Café Les Deux Garçons, Aix-en-Provence 61
Café Veranda, Ménerbes 33
Camin deis Anglés 101
Campbell, Naomi 10
canals 23
Cannes 11, 12, 149–54
Cannes Film Festival 10, 12, 15, 97, 151
canoeing 93
Cap d'Antibes 11, 12, 131, 157–165
Cap Ferrat 11, 12, 109–114, 121, 131
Cardin, Pierre 46
Carnaval de Nice 104, 105
Carolyn Quartermaine (fabrics) 211
Cascade de Courmes 46
celebrities 10, 15, 46, 112, 113, 151, 154,
 163–164, 180
Cézanne, Paul 61, 64
Chagall, Marc 15, 101, 143, 146
Chagall Museum, Nice 15, 105, 208
Chanel, Coco 10, 102, 163
Chaplin, Charlie 112, 169
Charly's Bar, Cannes 154
Château de Gourdon 46
Château de la Croë 164
Château de Lacoste 36
Château de Lourmarin 43
Château du Castellet 33
Château Eza 131
Christianity 74
Citadel, Ménerbes 33
Citadelle, Saint-Tropez 180
Club 55, Saint-Tropez 15
Cocteau, Jean 10, 138
Commune Libre de Safranier 163, 199
Corniche de l'Estérel 199
corniches 15
Côte d'Azur 10, 97, 121, 177
Côtes du Luberon winery 46
Cours Masséna, Antibes 163
Cours Mirabeau, Aix-en-Provence 61, 64

INDEX

247

Cours Saleya, Nice 104
cycling 15, 180

Delacroix, Blanche 111
Dierks, Barry 169
Dior store 177, 179, 211
Domaine de la Baume 185
driving 15
Dufy, Raoul 143
Duncan, Isadora 15, 103

Ebene (home-decorating store) 212
Edith Mézard (linen) 212
Edward VII 135, 136, 164
Espace Béchard (antiques) 212
Èze 124, 127–31
Èze-Bord-de-Mer 128

Fabrique des Fleurs (perfume) 212
Festival de la Sorgue 26
festivals 12, 26, 74, 104, 105, 159
Fitzgerald, F. Scott and Zelda 10, 159, 163, 172
Five Seas Hotel 185
flea markets 25, 74, 154, 221–222
floating market 26
Foire International 26
Fondation Maeght 15, 146, 205
Fontaine des Quatre Dauphins, Aix 64
footbridges 23, 26
fountains 53, 61, 64
Fragonard 131
French entrepreneurs 101
French Riviera 8, 10, 11, 12, 97, 113, 131

Galerie du Château Espace Graphique 213
Galerie Jacqueline Perrin 213
Gallerie Braunstein 212
Galleries Lafayette 104
gardens 46, 124, 131, 135, 138, 165, 189
Glanum 53
Gordes 36, 46
Gould, Frank J. 169
Grand Hôtel Nord-Pinus 186
Grand-Hôtel du Cap-Ferrat 113, 186
Grande Corniche, Eze 128
The Great Gatsby 172, 212, 222
Greene, Graham 10, 159
guesthouses 185–196

Haut-de-Cagnes 199
Hemingway, Ernest 159
Hermès 177, 179
history 10, 23, 33, 43, 53, 71, 84, 101,
 121, 180
Hôtel Belles Rives, Cap d'Antibes 172, 186
Hôtel Brise Marine, Cap Ferrat 186
Hôtel Byblos, Saint-Tropez 187
Hôtel de l'Image, Saint-Rémy 187
Hôtel Dongier, L'Isle 26
Hôtel du Cap-Eden-Roc, Antibes 163, 187

Hôtel le Mas de Peint, Le Sambuc 187
Hôtel le Pescador, L'Isle 26
Hôtel le Provençal, Juan-les-Pins 169
Hôtel le Renaissance, Gordes 46
Hôtel Martinez, Cannes 151, 187
Hôtel Negresco, Nice 102–103, 188
Hôtel Pruly, Cannes 188
Hôtel Sainte Valérie, Antibes 188
hotels 185–196
Hugo, Victor 159

Insula 23
Intercontinental Carlton Cannes 151
itinerary 12

Jacqueline Morabito (furniture) 213
Jardin Alexandre III 154
Jardin Botanique de la Ville de Nice 105
Jardin Botanique d'Eze 131
Jardin Botanique Exotique du Val Rahmeh,
 Menton 138
Jardin Fontana Rosa, Menton 138
Jazz Festivals 104, 169
Jean Chabaud les Matériaux Anciens 213
Jean-Louis Martinetti (photography) 213
John, Elton 10
Johnston, Lawrence 138
Juan-les-Pins 159, 165, 167–172

Kann, Fanny 121
Kazantzakis, Nikos 159, 163

La Bastide de Marie (guesthouse) 188–189
La Colline (home furnishings) 214
La Colombe d'Or (hotel/restaurant) 143, 189
La Croisette, Cannes 151
La Leopolda, Cap Ferrat 165
La Maison Biehn (fabrics) 214
La Maison des Lices (furniture/housewares) 214
La Mirande (hotel) 189
La Pauline (hotel) 189
La Pavillon de Galon (garden/guesthouse) 189
La Petite Afrique 124
La Ponche, Saint-Tropez 180
La Réserve (hotel) 192
La Tour Fenestrelle, Uzès 89, 92
La Voile d'Or (hotel) 192
Lacoste 46
Lagerfeld, Karl 163
lavender 36
Law, Jude 154
Le Bâoli, Cannes 154
Le Bassin, L'Isle 26
Le Cavendish (hotel) 192
Le Château, Nice 104
Le Chemin de Nietzsche, Èze 128
Le Club 55, Saint-Tropez 180
Le Comptoir du 7, Uzès 92
Le Galoubet, Ménerbes 33
Le Massif des Alpilles 53

Le Nid d'Aigle, Eze 131
Le Nôtre, André 46
Le Pigonnet (hotel) 192
Le Suquet, Cannes 154
Le Vieux-Nice 104
Le Village des Antiquaires de la Gare 214
Leopold II 111, 114
Les Arènes, Arles 84
Les Caves du Roy, Saint-Tropez (nightclub) 15, 180
Les Colombières, Menton 138
Les Olivades Factory Outlet 216
Les Pirates (beach) 172
Les Ponchettes, Nice 104
Les Terroirs, Uzès 92
L'Hôtel Particulier 188
L'Ile aux Brocantes 214
L'Isle-sur-la Sorgue 21–26, 221
Lo Scoglietto 112
Louis Vuitton 177, 179
Lourmarin 41–46
L'Oustal, Uzès 89
Luberon mountains 33
Luberon villages 200

Maar, Dora 36
Maison de la Truffe et du Vin 36
Mansfield, Katherine 135
Marché aux Fleurs, Nice 104
Marché Forain, Avignon 74
Marché Forville, Cannes 154
marchés aux puces 25
markets 23, 26, 46, 53, 56, 74, 84, 89, 104,
 146, 154, 180, 221–222
Masséna Museum of Art and History, Nice 104
Matisse, Henri 10, 15, 101, 112, 143
Matisse Museum, Nice 15, 105, 208
Maugham, Somerset 10, 113
Maupassant, Guy de 159
Mayle, Peter 33, 36, 43
Mediterranean 12, 97
Ménerbes 31–36, 43
Menton 12, 124, 133–138
Modigliani, Amedeo 143
Monaco 12, 121
Monroe, Marilyn 169
Monte Carlo 101, 104, 135
Moss, Kate 10
Murphy, Gerald and Sara 159, 163
Musée d'Art et d'Histoire de Provence 205
Musée des Beaux-Arts de Nice 105, 205
Musée Jean-Cocteau, Menton 138
Musée Marc Chagall, Nice 15, 105, 208
Musée Matisse, Nice 15, 105, 208
Musée National Fernand Léger 208
Musée Picasso, Antibes 15, 208
Musée Renoir 208
museums 15, 205, 208

Negresco, Henri 103
Nice 11, 99–105, 121, 124, 131, 222

Nicholas II, Czar 103
Nicholson, Jack 10
Niermans, Edouard-Jean 103
Nietzsche, Friedrich 128
Nîmes aqueduct 93
Niven, David 10, 111–112
Nostradamus 56

Old Town, Aix-en-Provence 61–62
Old Town, Antibes 161
Old Town, Menton 135, 136, 138
Old Town, Nice 104
Old Town, Saint-Rémy 53, 56
Onassis, Aristotle 164
Opéra de Nice 104

painters 15, 54, 56, 64, 74, 101, 112, 138,
 143, 146, 161, 169
Palais des Papes, Avignon 74
Paloma Beach, Cap Ferrat 12, 112, 200
The Paris of the South 61
Parker, Dorothy 159
parks 71, 104, 154
Passage Agard, Aix 61
Pastis Hôtel 192–193
Pavillon de la Torse, Aix 193
Pavillon de Vendôme, Aix 64
pedestrian village 128
Petite Brocante d'Avignon 74
Picasso, Pablo 10, 12, 15, 36, 143, 161
Place aux Herbes, Uzès 89
Place Charles Felix, Nice 104
Place de l'Horloge, Avignon 74
Place des Lices, Saint-Tropez 179, 180
Place des Victoires, Menton 136
Place du Forum, Arles 84
Place Gambetta, L'Isle 23
Place Garibaldi, Nice 200
Place Masséna, Nice 104, 200
Place Nationale, Antibes 161
Place Verdun, Aix 61
Plage de la Garoupe, Antibes 163
Plage de la Paloma, Cap Ferrat 12, 112, 200
Plage de Passable, Cap Ferrat 111, 114, 200–201
Plage du Midi, Cannes 153
Plage du Mourre Rouge, Cannes 153
Plesch, Dr. Arpárd and Etti 124
Pont d'Avignon 71, 73
Pont du Gard, Uzès 93
Pont Saint-Bénezet 73
Port de l'Olivette, Antibes 161
Port Vauban, Antibes 161
Promenade Amiral de Grasse, Antibes 163
Promenade des Anglais, Nice 15, 102
Provence 9, 10–11, 12, 19, 36
Provence-Alpes-Côte d'Azur 10
Puces de Bonpas 74

Quartier de la Ponche, Saint-Tropez 201
Quartier Mazarin, Aix 64

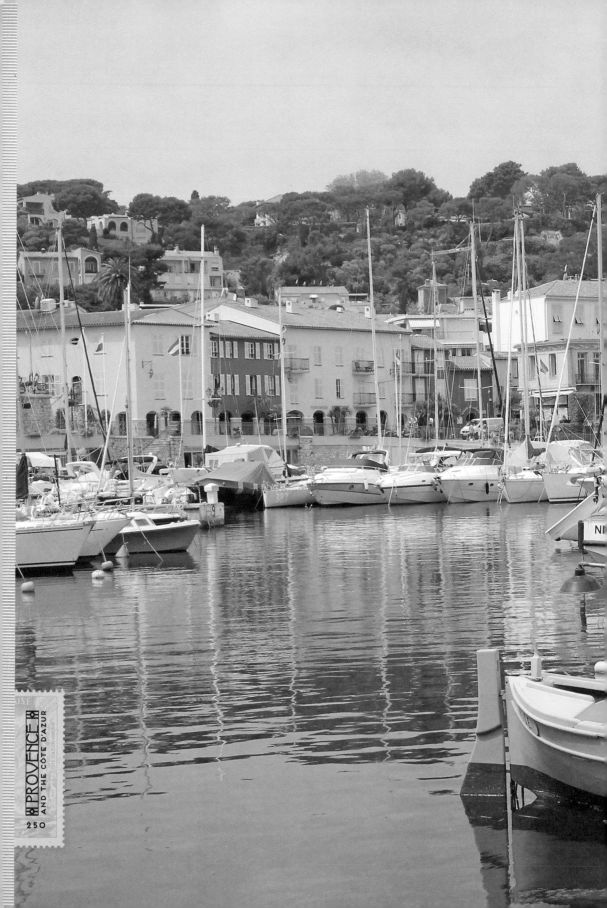

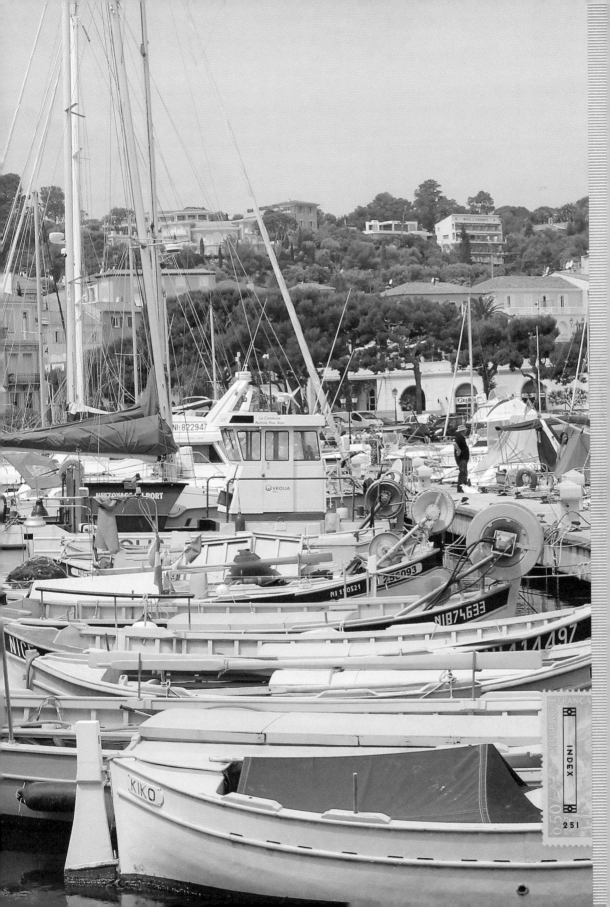

Radcliffe, Sir Percy 138
Ramatuelle 180
Reinach, Theodore 121
Renoir, Pierre-Auguste 143, 208
Rhône river 71, 81
Riviera 8, 10, 11, 12, 97, 114, 131, 151
Rocher des Doms, Avignon 71
Roman settlements 53, 62, 64, 84, 93, 121
Roquebrune-Cap-Martin 138
Rothschild, Béatrice de 10, 114, 201
Roussillon 46
Royal-Riviera 193
Rue d'Antibes, Cannes 154
Rue de France, Nice 104
Rue du Safranier, Antibes 163
Rue Meynadier, Cannes 154
Russian community 101

Sacha Décoration 216
Sade, Marquis de 36, 46
Saint-Jean-Cap-Ferrat 112, 200–201
Saint-Paul-de-Mausole 54, 56
Saint-Paul de Vence 131, 141–146
Saint-Rémi-de-Reims 53
Saint-Rémy-de-Provence 51–56, 222
Saint-Tropez 12, 15, 53, 97, 101, 175–180, 222
Sarstedt, Peter 169
Savonnerie de Bormes (soap) 216
Savonnerie Marius Fabre (soap) 216
Scandinavian community 101
Scott, Ridley 45
Sentier du Littoral, Saint-Tropez 180, 199–200
Sentier du Littoral, Cap Ferrat 111–114
Serre de la Madone, Menton 138
shopping 43, 46, 51, 56, 62, 89, 131, 151,
 154, 169
skiing 135
Snoop Dogg 154
Sorgue, river 26
Staël, Nicolas de 33
Sting 10
swimming 112, 113, 124, 135, 153, 163
Sylvie T. (drawings) 216

Théatre de la Photographie et de l'Image—
 Charles Nègre 217
thermal springs 62, 64
Thus Spake Zarathustra (Nietzsche) 128
timing of visit 12
Toile Branche 193
Tour de France 15
touring 15
tourism 23, 33, 121, 143, 177
Tourrettes-sur-Loup 146
Town Hall, Aix 62
Transports Maritimes Tropéziens 180
Truffaux (hats) 217
truffles 36
tuberculosis 135

UNESCO World Heritage Sites 71, 81
Uzès 87–93, 222

Valentino 33
Valentino, Rudolph 163
van Gogh, Vincent 54, 56, 81
Van Halewyck (paintings) 217
Vence 146
The Venice of the South 23
Verne, Jules 159, 163
Victoria, Queen 101, 135
Vielle Ville, Antibes 161
Vieux Port, Cannes 151
Villa Aujourd'hui, Juan-les-Pins 169
Villa Eilenroc, Antibes 165
Villa Ephrussi de Rothschild, Cap Ferrat 114, 201
Villa Gallici, Aix (hotel) 193
Villa Garbo, Cannes (hotel) 196
Villa Kérylos, Beaulieu 121
Villa Leolina, Beaulieu 124
Villa Marie, Ramatuelle (hotel) 196
Villa Namouna, Beaulieu 124
Villa Noailles, Hyères 217
Villa Rivoli, Nice (hotel) 196
Villefrance 114
Villeneuve-les-Avignon 222

walking paths 15, 26, 102, 104, 111–114,
 124, 128, 159, 163, 180
walled village 31, 33
Warner, Jack 169
waterwheels 23, 26
White 1921 (hotel) 179, 196
window shopping 154, 179
World Heritage Sites 71, 81
writers 135, 159, 163, 169
writers fellowships 36

Xavier Nicod 217

Z-Plage, Cannes 153
Zorba the Greek 159, 163

MERCI

Heartfelt thanks to the following people for their gracious assistance:

Mary Small, Ellie Smith, Jane Winning, Michelle Mackintosh, Miriam Cannell, Margaret Barca, Jo Rudd, and Splitting Image Colour Studio. Thanks also to the kind management and staff of the Royal-Riviera Hotel at Cap Ferrat, Bastide Rose B&B in Provence, and the Hotel Villa Rivoli in Nice.

PROVENCE
AND THE CÔTE D'AZUR

254

First published in the United States of America
in 2015 by Chronicle Books LLC.

First published in Australia in 2013 by Plum,
an imprint of Pan Macmillan Australia.

Library of Congress Cataloging-in-Publication Data available.

ISBN 978-1-4521-4051-3

Manufactured in China

Design by Michelle Mackintosh
Edited by Miriam Cannell
Proofread by Margaret Barca
Index by Jo Rudd

Additional photography credits: Cover / page 85: Claudio Giovanni Colombo /
Dreamstime & Shutterstock; page 60: Alvaroennes / Dreamstime; page 72:
Bunyos / Dreamstime; pages 76 & 80: Adeliepenguin / Dreamstime; page 82:
Robert Paul van Beets / Dreamstime; pages 88 & 90: Bunyos / Dreamstime;
pages 126 & 127: Alysta / Dreamstime; page 129: Travelpeter / Dreamstime;
page 134: Martin Molcan / Dreamstime; pages 134 & 156: Giancarlo Liguori /
Dreamstime; page 144: Yanik Chauvin; page 147: Sean Nel / Dreamstime;
page 150: David Martyn / Dreamstime.

10 9 8 7 6 5 4 3 2 1

Chronicle Books LLC
680 Second Street
San Francisco, California 94107
www.chroniclebooks.com

REPUBLIQUE FRANÇAISE

CÔTE D'AZUR VAROISE

1963

0,50 POSTES

R. CAMI

FRANÇAISE

5c POSTES

ERNÉE (Mayenne). - Dolmens de la Contrie